The Silk Road and
the Shoso-in

Volume 6

THE HEIBONSHA SURVEY OF JAPANESE ART

For a list of the entire series see end of book

CONSULTING EDITORS

Katsuichiro Kamei, *art critic*
Seiichiro Takahashi, *Chairman, Japan Art Academy*
Ichimatsu Tanaka, *Chairman, Cultural Properties Protection Commission*

The Silk Road and the Shoso-in

by RYOICHI HAYASHI

translated by Robert Ricketts

New York · WEATHERHILL/HEIBONSHA · Tokyo

This book was originally published in Japanese by Heibonsha under the title *Shiruku Rodo to Shoso-in* in the Nihon no Bijutsu series.

A full glossary-index covering the entire series will be published when the series is complete.

First English Edition, 1975

Jointly published by John Weatherhill, Inc., 149 Madison Avenue, New York, New York 10016, with editorial offices at 7-6-13 Roppongi, Minato-ku, Tokyo 106, and Heibonsha, Tokyo. Copyright © 1966, 1975, by Heibonsha; all rights reserved. Printed in Japan.

Library of Congress Cataloging in Publication Data: Hayashi, Ryōichi, 1918– / The silk road and the Shoso-in. / (The Heibonsha survey of Japanese art; v. 6) / Translation of Shiruku Rōdo to Shōsōin. / 1. Shōsōin, Nara, Japan. 2. Art, Ancient—Nara, Japan—History. 3. Art—Nara, Japan—History. 4. Silk Road. I. Title. II. Series. / N3750.N36H3713 / 708′.952′18 / 75-23081 / ISBN 0-8348-1022-0

Contents

The Silk Road and
the Shoso-in

Preface

IN ANCIENT ROME, the naturalist Pliny (A.D. 23–79) records, the thin, translucent silk robes that draped the fashionable ladies of the day were very much admired. During the reign of the emperor Aurelian two centuries later, silk brought its full weight in gold on the Roman market. Silk was known to the Greeks and the Western world from as early as the fifth century B.C., but it was not until the time of the Roman Empire that people realized that silk came from the East, from China. Both the Greeks and the Romans referred to China, the silk-producing land in the East, as Seres, and it is from this that the word silk is derived. Silk came from China via a long trade route, a continental bridge that spanned a distance of seven thousand miles linking East and West. Silk accounted for most of the Chinese exports in this far-reaching commercial undertaking, though it was the nineteenth-century German geographer Ferdinand von Richthofen who first coined the word *Seidenstrassen,* or Silk Road, in reference to this trade route of antiquity.

On its western end, the Silk Road began on the Mediterranean coast, in such ports as Antioch and Alexandria, and worked its way east, first through caravan cities in Mesopotamia and Iran, and then through western Turkestan, notably the city of Samarkand in Sogdiana. The arterial route then scaled the Pamir range, the Roof of the World, and it became the T'ien Shan South Road, which skirted the Takla Makan Desert, passing through such oasis towns as Kashgar and Kucha along the

way. Entering China through Lou-lan or Tun-huang, the Silk Road finally reached Ch'ang-an, the city known today as Sian.

Another road turned south from Samarkand and went through Bactria toward Gandhara in northwestern India. This was the route taken by Alexander the Great in his campaigns to conquer the East. It has since been used frequently as the road from either western Asia or China to India.

The journey along the Silk Road was not an easy one. The road passed through an extremely arid area of innermost Asia, where fierce nomads of the northern steppes looted caravans or levied heavy taxes on unfortunate travelers. But the merchants of the caravans were willing to risk the dangers of the journey, for they profited greatly from the trade: silk and lacquerware from China were bartered for valuable goods from the West, such as precious gems, silver and gold containers, glassware, and aromatics and medicine.

Until the eighth century, the merchants who took this perilous route were for the most part Sogdians, an Iranian people; but thereafter the Uighurs, a Turkic people of Central Asia, took on a more active role, establishing settlements along the way. Not all the people who traveled the Silk Road, however, were merchants. A number of Buddhist monks on pilgrimage to India also used the route. One such was the famous Hsuan-chuang, a Chinese monk, translator, and philosopher, who took the hazardous journey through the Western

Region to India in search of the true teachings of Buddhism. The perils met before arriving at one's destination caused little fear to the pilgrims, for theirs was a journey inspired by religious devotion and fervor. It was in this way that the Silk Road brought to China Buddhism from India, Zoroastrianism from Iran, and Nestorian Christianity from Syria. And accompanying these religions were the cultural, artistic, and musical traditions in which these religions were born.

At the turn of the twentieth century, numerous archaeological excavations in Central Asia were carried out by European scholars. From the ruins and temple remains of such oasis towns as Khotan, Kucha, and Turfan a large number of treasures, including Buddhist statues and paintings, were unearthed, revealing the rich artistic traditions of the religions once practiced there. The significant role the Silk Road has played in the cultural exchange between East and West cannot be overemphasized, and this ancient caravan route has now rightly secured a prominent place in world history.

In China, during the Six Dynasties and T'ang periods (third to tenth century), the influence of cultures west of China was at its peak. In Ch'ang-an, a city said to have rivaled the contemporary Abbassid capital of Baghdad as the world's most cosmopolitan city, there was a prevailing taste for things Persian. People delighted in the Persian style of dress: men adopted trousers, while women fancied floor-length skirts, and both men and women wore tops with tight-fitting sleeves and folded collars. Men gallantly rode around on horseback, and a pololike game originating in Persia became one of the most popular pastimes.

Tempyo Japan (eighth century), considered the golden age of Japanese antiquity, is known as a period of borrowing from T'ang China. Chinese goods, religions, and govermental and other systems were studied and eagerly applied in Japan. The cosmopolitan culture of T'ang China also found its way to Japan in the form of exotic designs and craftwork. Japanese embassies and students returning from China came laden with gifts from distant lands. There were Chinese felt carpets modeled on those made by the nomads of Central and North Asia, Persian-style glass or metal goblets and ewers, and Indian- and Iranian-style harps and lutes. Ivory, sandalwood, ebony, and lapis lazuli—such rare and precious materials were used in forming and embellishing these objects. And adorning them were hunting motifs, sacred-tree-and-animal motifs, grapevine arabesques, and other Persian and foreign motifs. These gifts were the wonder of their day, and the Japanese who received them seem to have delighted in them and cherished them. Emperor Shomu's (r. 724–49) large collection of imported belongings were dedicated to the Great Buddha of the Todai-ji upon his death. The Todai-ji's chief repository, the Shoso-in, has stored these dedicated items and others in excellent condition for over a thousand years, and today it stands as a veritable museum of a priceless assemblage of objects from T'ang China and from a once-prosperous trade route. Thus the Silk Road actually stretched farther east than China, carrying exotic gifts and treasures to Japan, and it is for this reason that I have called the Shoso-in the "final destination" of the Silk Road.

CHAPTER ONE

---•---

The Shoso-in
Past and Present

A HISTORICAL SKETCH The Todai-ji, the grandest of temple-monasteries in the Heijo capital at Nara, was completed about 751 under the supervision of its first abbot, Roben (689–773). The emperor Shomu (r. 724–49) had decreed the construction of this monumental structure some years earlier as the foremost temple of the provincial-temple (*kokubunji*) system, created in an effort to unify nation and religion in an uncertain, troubled time. Sheltering a large population of resident monks, the temple boasted many fine halls and pagodas and is estimated to have included nearly fifty storehouses where Buddhist regalia, provisions, and other paraphernalia were kept. The Shoso-in served as the Todai-ji's chief repository and was under temple administration for a very long time.

The Shoso-in sits inside a compound enclosed by a white rammed-earth wall northwest of the Todai-ji's Daibutsuden, the Great Buddha Hall. Originally located behind the Daibutsuden, the storehouses once stood in a wide area that began north of the former lecture hall and refectory (*jikido*), stretching to the eastern foot of Mount Chisokuin. The early Todai-ji complex comprised several buildings, no longer extant, which included storehouses attached to the supreme administrative councils (*mandokoro*) of the Todai-ji and the store-houses sealed by imperial decree. These repositories stood side by side, storing temple treasures and Buddhist regalia, but all eventually fell into disrepair, and today only the storehouse now known as the Shoso-in remains.

The word *shoso* was a common noun originally designating storehouses where rice and other grains, collected by the state as rice-field taxes, were kept. The compound housing these *shoso*, or *okura* (signifying chief repository), was called the *shoso-in*, *in* meaning precinct. *Shoso-in* complexes were ubiquitous features of early Japan and were found in the central administration of the Nara court, the Ministry of the Treasury, provincial seats of government, and large temples. For example, the *Saidai-ji Shizai Ruki-cho*, a register of temple property owned by the Saidai-ji in Nara, dating from 780, notes that the refectory precinct (*jikido-in*), the supreme-administrative-council precinct (*mandokoro-in*), and the chief-repository precinct (*shoso-in*) each had its own storehouse within its compound. The temple register also records that the Saidai-ji's *shoso-in* complex included six *azekura* storehouses (see below), eight wooden plank storehouses, one auxiliary plank storehouse, and seven others, or twenty-two buildings in all. From this description, we are able to form a general idea of the original size and composition of the Todai-ji *shoso-in*. Noth-

ing remains of the *shoso-in* precincts in the major temples at Nara, and the repository of the original Todai-ji complex alone has survived to lay undisputed claim to its distinctive name. Today it is the only edifice in Japan to which this special term refers.

It is not certain when the *shoso-in* complex, or even the single remaining storehouse that carries its name, was first built at the Todai-ji, for precise records of their construction have not survived. But we do know that gift offerings made by the empress dowager Komyo to the Todai-ji were kept in the repository's north storeroom, which places the approximate date of construction at around 756. The Todai-ji's *Tonan-in Monjo* (Tonan-in Archives), a collection of old manuscripts now housed in the Shoso-in, includes fragments of a document dated the twenty-second day of the ninth month of 756 and signed by, among others, imperial inspectors sent from the court, representatives of the Office of the Commissioners for the Construction of Todai-ji, high-ranking ecclesiastical officials, and the three priestly administrators of the Todai-ji. The explanation has thus been advanced that this document was drawn up at the time of the original transfer of gifts to the Shoso-in. Further evidence is found in the *Narabi-kura Kita Zatsubutsu Shutsuyo-cho* (Register of Withdrawals of Miscellaneous Objects from the North Narabi-kura), compiled by the commissioners of Todai-ji's construction, which notes that a 50-*kin* (11-kilogram) measure of ginseng was removed from the Shoso-in on the third day of the tenth month in the year 756, indicating that the repository had been built at the very latest sometime before this date.

The Todai-ji was an official temple managed by the state during its early history and was overseen by the Daijokan, the Great Council of State, which directed the civil bureaucracy. Because all treasures dedicated by the imperial household were preserved in the Shoso-in's north storeroom, removal of its contents required imperial consent. In the earliest period, the official seal of the *Kemmotsu*, an office within the Ministry of Central Affairs charged with the entry and removal of articles from state repositories, is believed to have been placed over the lock of this storeroom. During the Kamakura period (1185–1336), the repository was sealed by imperial messengers, and later, after the Muromachi (1336–1568), a slip of paper bearing the emperor's personal seal was affixed to the storehouse lock.

Of the three storerooms that constitute the Shoso-in, the central one (Chu-so) appears to have been used to sort and arrange treasures and to store medicines temporarily. It is not clear when the middle room came to be used as a permanent repository, but this may have occurred in the year 1116, when important Nan-so (south storeroom) objects were transferred to the northern and central sections. The *Todai-ji Chokufuzo Mokuroku-ki* (Todai-ji Inventory of Imperial Seal Repositories, 1288) notes that the Chu-so was opened and its holdings were inventoried in the presence of an imperial envoy in the year 1193, telling us that like the north storeroom (Hoku-so), the middle storeroom was considered an imperial-seal repository at least by this time.

In the year 950, treasures previously held in the *narabi-kura* (long double storehouse) of Todai-ji's Sangatsudo were removed to the southern storeroom of the Shoso-in. This *narabi-kura* was sealed by high-ranking ecclesiastical officials responsible for the administration of large state temples, and by priests from the three executive offices of the Todai-ji. This practice was carried over to the Nan-so, which became known as a priest-sealed repository. Thus the southern storeroom came to be regarded as the repository of Todai-ji's valuable treasures and Buddhist paraphernalia.

The three Shoso-in storerooms were thus closed by imperial and priestly seals, and the repository was strictly controlled. After the Meiji Restoration in 1868, however, the Shoso-in was removed from direct Todai-ji management and placed under the protection of the new Meiji government. In 1875, this responsibility was given to the Ministry of Home Affairs, and in 1881, it was delegated to three different ministries to ensure more complete protection of the Shoso-in's holdings. The Ministry of Agriculture and Commerce was accountable for all art objects, the Ministry of Home Affairs for

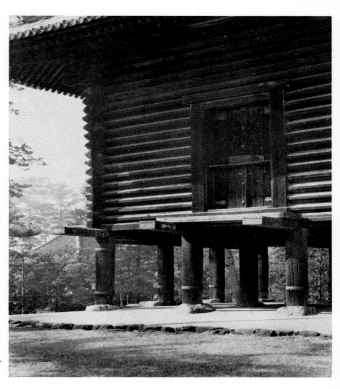

1. *The Nan-so, the southern storeroom of the Shoso-in. Height, 14.24 m. C. 756. Todai-ji, Nara.*

archives, documents, calligraphy, and other papers, and the Ministry of the Imperial Household for opening and closing the repository. These functions were soon brought under the unified administration of the Ministry of the Imperial Household, and the Imperial Museum in Tokyo became the principal custodian of the collection. Meanwhile, all three storerooms became imperial-seal repositories and their contents were designated Shoso-in Gyobutsu, or Imperial Household Properties in the Shoso-in.

After World War II, these holdings became national property, and today, as in the recent past, management of the Shoso-in falls under the jurisdiction of the Imperial Household Agency's Archives and Mausolea Department, although it is directly assumed by the Office of the Shoso-in Treasure House. In 1953, a ferroconcrete store-house was constructed in the compound of the Shoso-in, and the entire collection was transferred to this new temperature- and humidity-controlled building. Exhibitions of selected treasures are held annually in the fall at the Nara National Museum, at which time the original storehouse can also be viewed from a distance.

ARCHITECTURE OF
THE SHOSO-IN

The Shoso-in repository is built of Japanese cypress, its roof is hipped and covered with alternately laid flat and round tiles, and the storehouse is a fine example of raised-floor architecture. The façade measures 33 meters, the ends are 9.4 meters wide, the building stands 14.24 meters tall, and the distance from floor level to ground is 2.72 meters. The Shoso-in is aligned lengthwise on a north-south axis and faces east

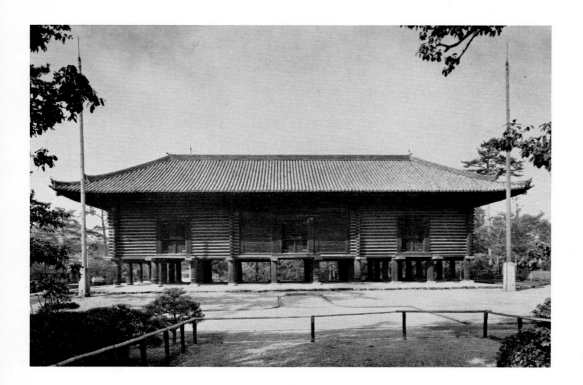

(Figs. 1, 2). Forty round base posts, each 93 centimeters in diameter and approximately 2.42 meters high, are set in rows atop natural stone rests, and the sight of forty pillars upholding this monumental structure is truly impressive. The repository is divided into three sections, which are, from right to left (Fig. 2), the north storeroom, the central storeroom, and the south storeroom. Both the north and south sections are built with giant timbers shaped in such a fashion that the cross section forms an isosceles triangle. The outer edge of each timber is blunted, and the logs are set at the corners in a type of lap joint that gives this distinctive building style its name, *azekura-zukuri* (Fig. 3). All four sides of the north and south storerooms are built in this fashion, but in the central storeroom, the outer walls on the east and west faces are constructed by fitting thick wooden planks one on top of another between two heavy bay pillars, to form a plank-walled storehouse (*itakura*). There is one entrance for each section built in the eastern, or front, façade of the repository. When the attic is included, the interior has three stories.

The Shoso-in is the only example of this architecture still in existence, and three different explanations have been advanced concerning its original shape. Tadashi Sekino* (1868–1935), a well-known architectural historian, thought that the early Shoso-in consisted of three storehouses joined, like the present structure, under one roof. Mosaku Ishida (b. 1894) of the National Cultural Properties Protection Commission has suggested that the Shoso-in was originally two independent store-

* The names of all modern (post-1868) Japanese in this book are given, as in this case, in Western style (surname last); those of all premodern Japanese are given in Japanese style (surname first).

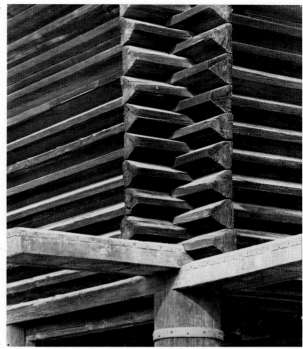

3. Interlocking corner joint of the Shoso-in.

houses with separate roofs to which a third, connecting room was later added. Jiro Murata (b. 1895), professor emeritus of architecture at Kyoto University, proposes two structures under the same roof with an open space in between that eventually became the central storeroom. During the Nara period, *shoso-in* compounds like that at the Saidai-ji included two types of repository, the *kokura* and the plank-formed *itakura*. The *kokura* was an *azekura* building, like the Shoso-in repository, constructed with triangular timbers, and, as one explanation would have it, the term itself may have meant "excellent storehouse." From ancient times, the Shoso-in treasury was known as a *narabi-kura*, but archives dating from 760 speak of a *narabi-kokura* consisting of two storehouses united under a single roof and separated by a covered way, which would lend credence to Murata's hypothesis. Volume one of the *Shotoku Taishi Den Shiki* (A Private Account

of the Life of Prince Shotoku), written during the Kamakura period by the monk Kenshin, notes the existence of a similar treasury in the Horyu-ji *shoso-in* that measured nine bays long and comprised a north and south section. Each storeroom measured three bays, and the three-bay midsection was, according to the source, simply left empty. The *narabi-kokura* thus appears to have included two *azekura* storehouses connected under one roof with an open central section, wall-less and fully exposed, like a breezeway.

Just when the Shoso-in's middle room was boarded up with planks to become the Chu-so we see today remains a problem. According to a Shoso-in document that dates from 761, a Chinese chest containing cassia bark and other medicines intended for the benevolent treatment of the sick was transferred to the "*naka no ma* of the *narabi-kura*," evidence that the *naka no ma*, an intermediary

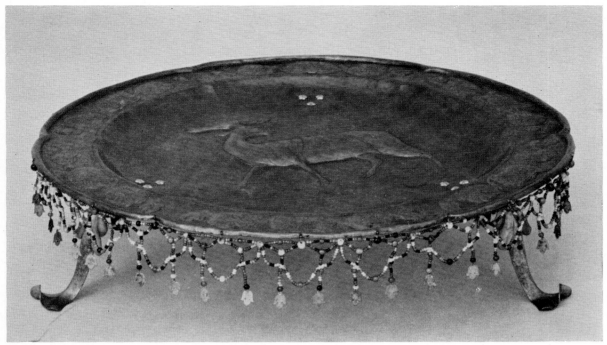

4. *Gilded silver flower-shaped tray with embossed design of stag. Partially gilded silver; diameter, 61.5 cm. C. 751, T'ang. Shoso-in. (See also Figure 12.)*

space between two buildings, served as a storage area. The floor of the *naka no ma* is described as earthen by some scholars, while others argue it was paved with boards or was of the raised-floor variety, but it seems only natural that a storeroom for precious medicines would at least have walls and a protected floor. In any event, we know that sometime between the twelfth and thirteenth centuries, the Chu-so was closed with imperial seals and the Shoso-in came to be called the *mitsukura,* the triple storehouse. There is little doubt that the *mitsukura* is an example of architecture of the Nara period, and as befits the Todai-ji's chief repository, it stands as a living monument to the grandeur of the past.

It was once widely held that the triangular timbers set in cross-notched *azekura* fashion served to prevent moisture from penetrating the interior of the Shoso-in, as they supposedly expanded and contracted with changes in the humidity. Today this explanation is no longer acceptable because of experiments carried out over a three-year period, which show conclusively that the degree of such expansion and contraction is negligible. A more plausible hypothesis is that the building's raised-floor construction allows for ample ventilation and that the long triangular logs, which are joined at the corners, touch along a surface 10 centimeters wide to bar the outside weather. While the Nara region is not known for its dryness, the annual fluctuation in humidity levels is relatively small. It is more likely that the well-preserved state of the Shoso-in treasures owes a great deal to the skillfully built chests that house them. Inside these coffers, which are fitted with lids and made of wood nearly 2 centimeters thick, there is scarcely any change in

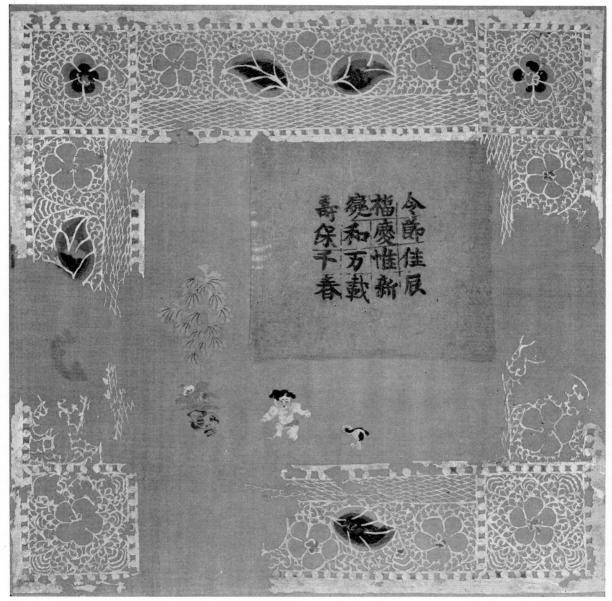

5. Jen-sheng *fragment. Silk gauze, plain-weave silk, and paper; height, 33.2 cm.; width, 33 cm. Eighth century. Shoso-in. (See also Figure 30.)*

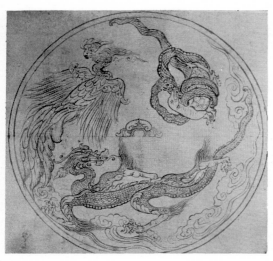

6. *Ink sketch for mirror-back design depicting three of the four directional divinities. Ink on paper; diameter, 29.7 cm. Late eighth century. Shoso-in.*

7. *Detail of gold and silver* hyomon *cittern. Lacquer on paulownia and red sandalwood; frame length, 12 cm.; full length of instrument, 114.5 cm. 735, T'ang. Shoso-in. (See also Figure 10.)* ▷

the humidity, and they are thus ideally suited for the protection of valuable objects.

TEMPYO CRAFTWORK IN THE SHOSO-IN Treasures bequeathed to the Shoso-in include most Tempyo-period (710–94) craftwork still in existence. The collection owned by the Gallery of Horyu-ji Treasures attached to the Tokyo National Museum is next in importance, although it consists of far fewer items. Some treasures have been preserved by Todai-ji, Horyu-ji, Toshodai-ji, and other Nara temples, but these are so few they hardly merit comparison. Several excavated objects designated "buried cultural properties" are also preserved. These include articles unearthed from ancient tumuli and palace and temple ruins, "pacifying" altar implements discovered beneath altars in the main halls of Todai-ji, Kofuku-ji, and other temples, where they were placed to appease spirits of the earth disturbed during construction, and articles found with reliquaries placed beneath pagoda foundations. Few earthenware and tile objects have been handed down, and by way of compensation the recovered objects are highly valued for the data they offer.

Tempyo no Chiho (Excavated Treasures of Tempyo), an excellent reference book compiled by the Nara National Museum (1961), is recommended for a complete summary of the articles, which are beyond the scope of this book.

Among the treasures in the Shoso-in are quite a large number of foreign-made articles. Most of these are probably gifts and other items brought back to Japan from China by the numerous Japanese embassies dispatched to the T'ang (618–907) court between the seventh and late ninth centuries. The seemingly endless wonders of T'ang-period arts and crafts are well known from the extant literature describing them, but few actual treasures from this era survive today. A number of relics have in fact been excavated on the Chinese mainland in recent years, but many of these have been found in damaged condition or the original colors have faded. Very few specimens of woodwork or dyed and woven fabric have been preserved; only articles made of durable substances that deteriorate slowly, such as semiprecious stone, earthenware, porcelain, and metal, remain. This is not true of the Shoso-in treasures, however, which consist of art objects handed down from generation to

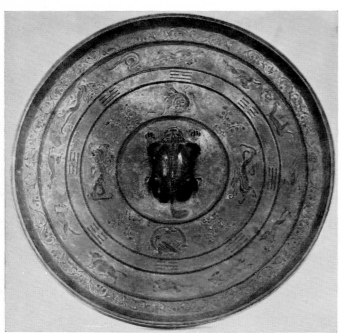

8. Round mirror backed with the Twelve Branches and the Eight Divinatory Trigrams. White bronze; diameter, 59.4 cm. Eighth century. Shoso-in.

9 (below). Detail of mirror with bird, animal, and grapevine motifs. White bronze; diameter, 29.5 cm. Eighth century. Shoso-in.

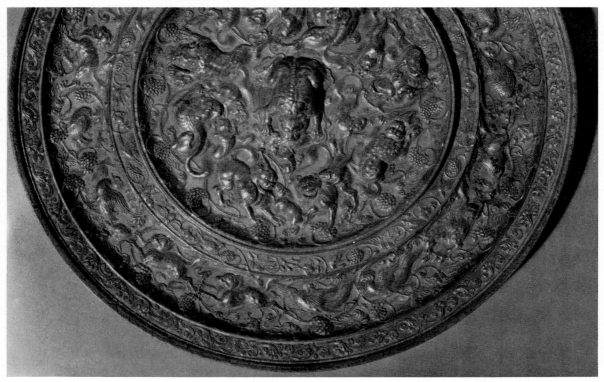

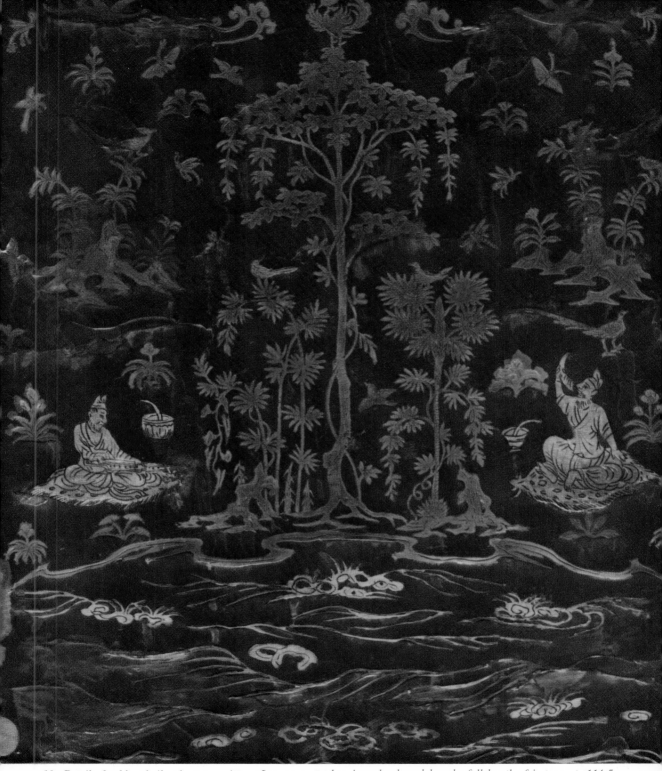

10. *Detail of gold and silver* hyomon *cittern. Lacquer on paulownia and red sandalwood; full length of instrument, 114.5 cm. 735, T'ang. Shoso-in. (See also Figure 7.)*

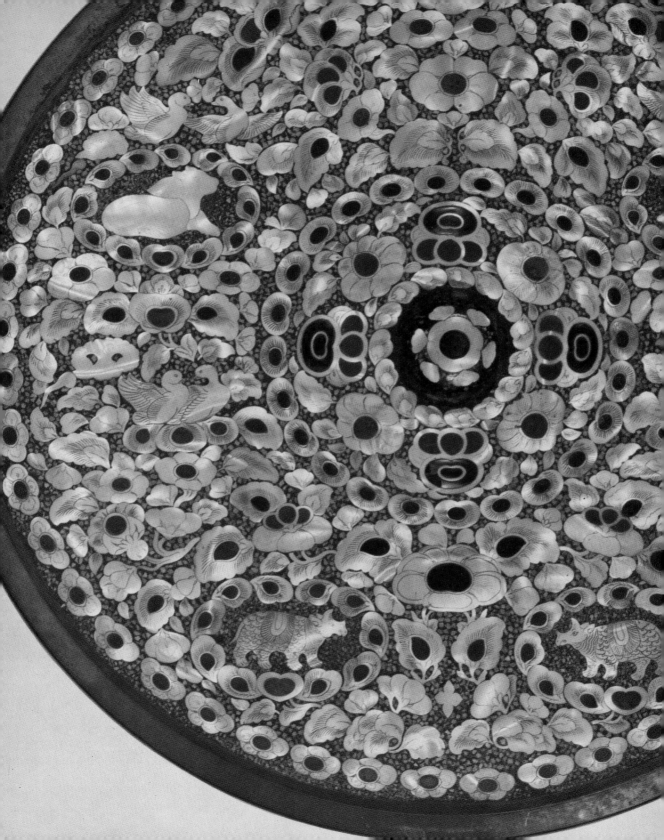

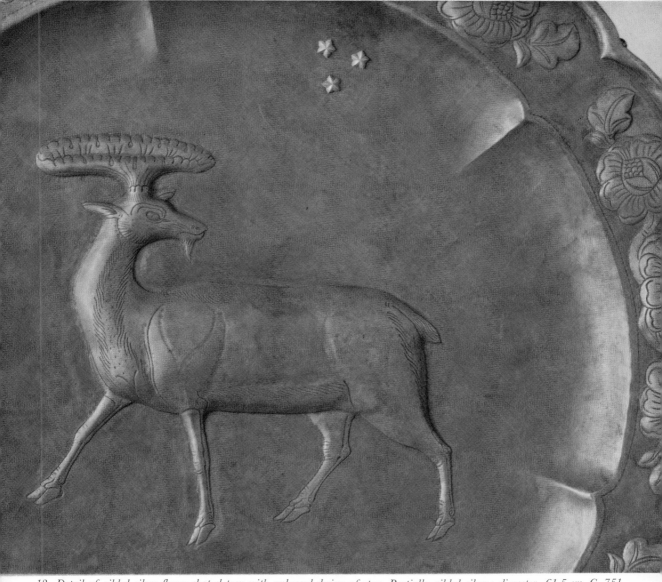

12. *Detail of gilded silver flower-shaped tray with embossed design of stag. Partially gilded silver; diameter, 61.5 cm. C. 751, T'ang. Shoso-in. (See also Figure 4.)*

◁ 11. *Detail of round mirror backed with inlaid design in mother-of-pearl. White bronze; diameter, 39.5 cm. Eighth century, T'ang. Shoso-in.*

13 (*overleaf*). *Brocade with hunting motif on blue ground. Silk brocade. Eighth century, T'ang. Shoso-in.* ▷

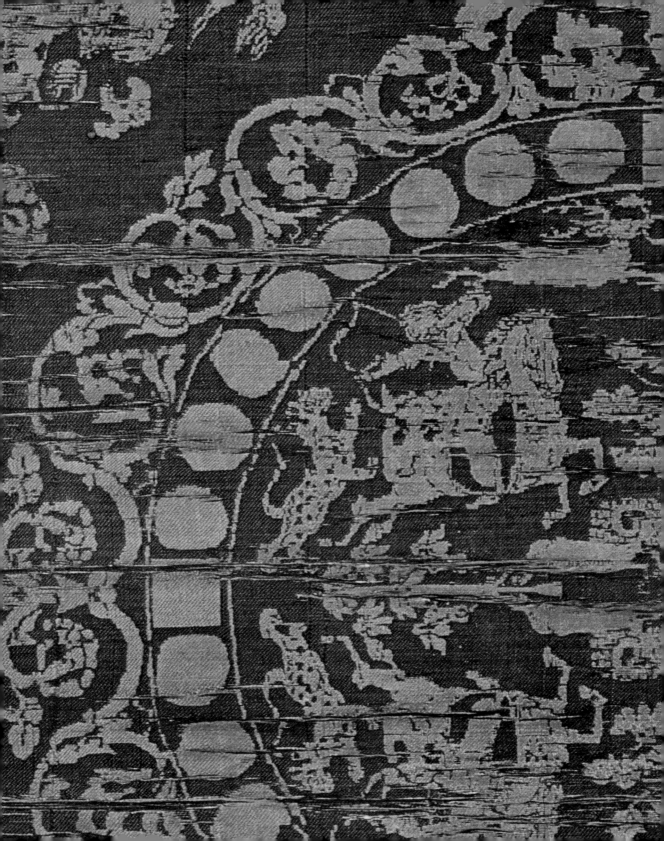

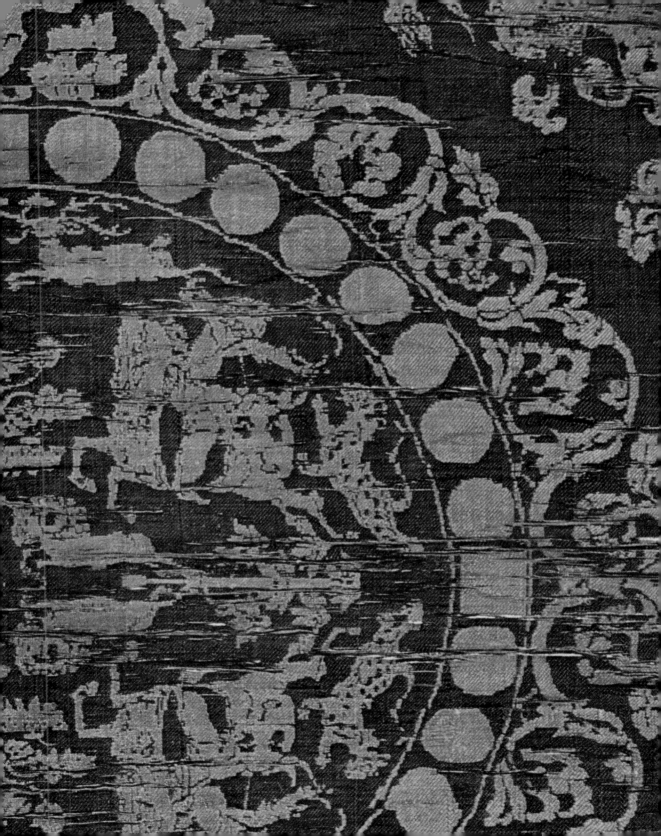

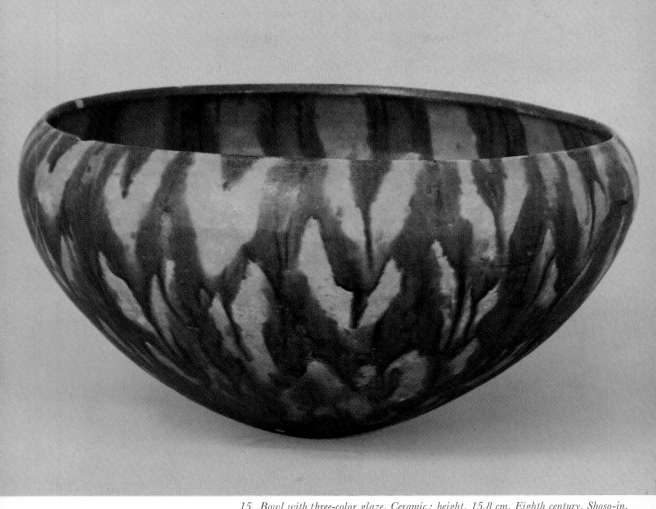

15. *Bowl with three-color glaze. Ceramic ; height, 15.8 cm. Eighth century. Shoso-in.*

◁ *14. Detail of flower-patterned rug. Felted sheep's wool ; height, 276 cm. ; width, 139.5 cm. Shoso-in.*

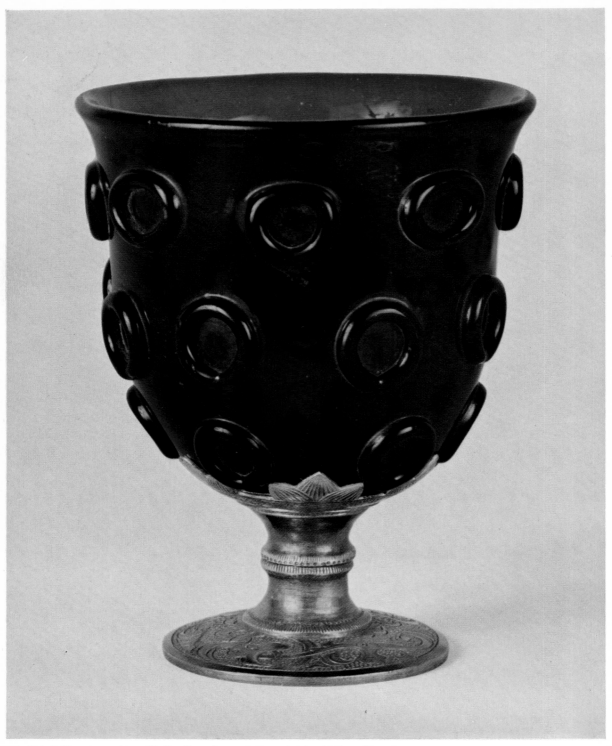

16. Cobalt-blue glass goblet. Alkaline lime glass and silver; height, 11.2 cm. Shoso-in.

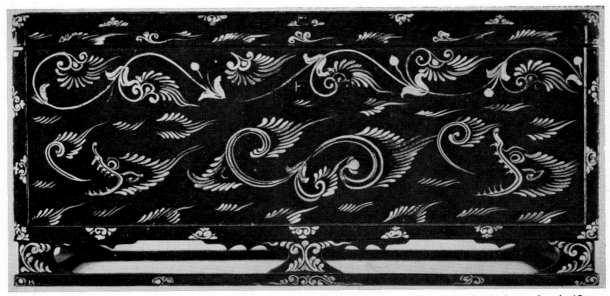

17. *Side view of small chest with arabesques and dragon heads in oil colors. Lacquer on wood; height, 21.3 cm.; length, 45 cm.; width, 30 cm. Early eighth century. Shoso-in. (See also Figure 87.)*

generation for over a thousand years. These treasures have been preserved in nearly perfect condition, and their myriad colors are as bright as they were the day they were applied. It is no exaggeration to suggest, therefore, that these imported objects compensate in some measure for the art treasures lost in China, and that from this unique collection, the history of T'ang arts and crafts may be reconstructed.

JEN-SHENG FRAGMENTS "How cleverly the golden blossoms on the *sheng* / withstand the cold." This verse, from a poem composed by the venerable poet of the T'ang period, Tu Fu (712–70), was written in 768 to mark the occasion of Jen-jih, People's Day, a festival celebrated on the seventh day of the lunar New Year. From ancient times, the Chinese are said to have cut flower shapes and human silhouettes from varicolored silk and decorated them with overlays of gold leaf to paste on folding screens, use as hair

ornaments, or exchange between friends, a practice that may have resembled our modern custom of sending Christmas cards. Even today, the art of paper cutting is a Chinese folk craft that often astonishes by its intricate handiwork. In T'ang times, these hand-cut patterns were referred to as *sheng* (in Japanese, *sho*); human shapes were called *jen-sheng* and flower patterns were known as *huasheng*. As people exchanged their *sheng* on that freezing winter's day, the glittering beauty of golden flower ornaments must have warmed the heart of the wandering Tu Fu, weary from his travels south of the Yangtze.

This festival, popular during the T'ang period, is cited here because of a miscellaneous *jen-sheng* fragment (Figs. 5, 30) that has been preserved unaccountably in the Shoso-in. According to the *Zatsu-zaimotsu Jitsuroku* (Inventory of Miscellaneous Properties), a register of the Shoso-in art treasures compiled in 856, two separate *jen-sheng* were originally presented to the repository in the year 757,

18. Mitsuda-e tray. Lacquer on wood; diameter, 38.8 cm. Eighth century, Shoso-in.

but fragments of these have since been pieced together and today comprise a single item. On the light green field of silk gauze with lozenge patterns, sixteen black lacquer Chinese characters spell out the auspicious verse, "On this propitious occasion, may happiness be renewed. May you find the peace of ten thousand years, and may life last a thousand springs." The characters had been composed with foil on lacquer, but the gold leaf appears to have peeled off, leaving only the black lacquer. The full features of the original design are not clear, and only a few colored silk cuttings, such as a rock, from which issue a flowering orchid and what might be a paulownia tree, and a child and the tail of a dog remain. The original may have included the figure of a woman and similar details more appropriate to the name *jen-sheng*. Through the lacelike paper trim over which gold leaf has been superim-

posed may be seen the details of flowers and leaves, formed by juxtaposing light and dark shades of red and green silk gauze from behind in a halolike gradation of color known as *ungen*. The *hua*, or flower, *sheng* may have looked something like this. In any event, we know from this fragment that the gaily colored *sheng* used in China at New Year's reached Japan, and were it not for this vestige, we might never have set eyes on the kind of silk ornament Tu Fu celebrated in verse.

FOREIGN GOODS FROM THE T'ANG COURT In addition to relics from the Chinese *jen-sheng* festivities, the Shoso-in owns a number of ceremonial objects used in annual T'ang rites and adapted by the Japanese court for its own purposes. Among these are ritual implements used to honor the god of the

19. Mitsuda-e tray. Lacquer on wood; diameter, 39 cm. Eighth century. Shoso-in.

silkworm on the First Day of the Rat, observed on the third day of the New Year, 758. Two ceremonial brooms made of a stiff brushwood, which were used by the empress Koken (r. 749–58) in the ritual sweeping of silk threads, have been preserved (Fig. 191). The brooms' bristles are decorated in places with green glass beads. On this day, Otomo no Yakamochi (718–85), the renowned *Man'yoshu* poet, attended the celebrations in the imperial palace and, deeply moved by the occasion, wrote the following lines: "Taking the beaded broom in hand / On this first-born day of spring, / How the strings of jewels dance gently / To and fro!"

Two authentic T'ang imports, a gold and silver *hyomon kin* (Figs. 7, 10) and a gilded silver flower-shaped tray (Figs. 4, 12), tell us that the art objects brought to Japan during the T'ang period were of fairly high quality, even by Chinese standards. The

kin (in Chinese, *ch'in*) is a seven-stringed Chinese cittern decorated with gold and silver *hyomon*, a refined lacquer inlay technique, and is thought to date from 735, the height of the T'ang. Inside the body is the maker's inscription, which reads, "Made in the last month of spring in [the year] *i-hai*." The gilded silver flower-shaped tray carries two inscriptions: one, that of the T'ang maker on the back, giving dimensions, designation, and weight; and the other, an inscription dating from the presentation of the tray to the Todai-ji, which reads, "Todai-ji flower platter. Weight, 6 *kin*, 8 *ryo*."

A recent excavation at Sian that unearthed an object with a striking resemblance to the Shoso-in tray confirms the authenticity of the Shoso-in's imported treasures. This is a gold and silver flower-shaped tray with an embossed lion in the center,

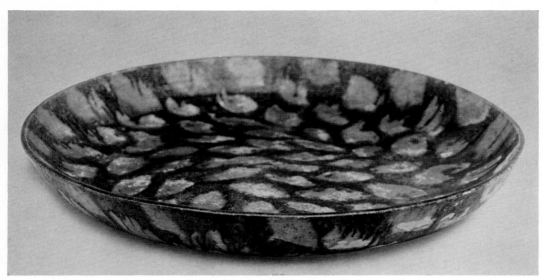

20. *Two-color ceramic dish. Ceramic; height, 37.5 cm. Eighth century. Shoso-in.*

with a designation similar to that on the Shoso-in tray mentioned above. Along with it, a silver censer was found, and this again is similar to the censer that is kept in the Shoso-in collection (Fig. 33).

IMITATION AND INNOVATION Although the great majority of Shoso-in treasures were without a doubt T'ang in style, not all, of course, were imported from China. When the Japanese of the Tempyo period first encountered the marvels from the T'ang court, they were astonished by their superb quality and were almost certainly seized with a desire to fashion such objects for themselves. Most of the T'ang objects exhibit a degree of technical excellence that sets them apart from work produced by Tempyo artisans, but some articles are scarcely distinguishable from their T'ang prototypes, and Tempyo craftsmanship cannot be lightly dismissed. Tempyo craft arts developed under the remarkable tutelage of T'ang art and, taken as a regional idiom, cannot be considered substantially different. For these reasons, the arts of T'ang and Tempyo are normally assigned to the same family and treated

concurrently, but as further study of treasures in the Shoso-in clarifies these stylistic differences, the history of Tempyo craft arts will have to be rewritten.

The famous *Shoso-in Monjo* (Shoso-in Archives) records a production estimate, for the manufacture of bronze mirrors, entitled *Todai-ji Chukyo-yodo Chumon-an* (Expenses and Requisitions for Mirrors To Be Cast at the Todai-ji). On the reverse side of the document is a sketch for the back of a mirror (Fig. 6). Only three of the four directional divinities of Chinese mythology appear in the design: Ch'ing Lung, the blue dragon of the east; Chu Chueh, the red phoenix of the south; and Shen Wu, the tortoise entwined by a serpent, a combination known as Dark Warriors, of the north. For reasons unknown, Pai Hu, the white tiger of the west, has been omitted, but the sketch is clearly an attempt by Japanese craftsmen to cast a mirror taking the Chinese mirrors as a model. There are many foreign-cast mirrors in the Shoso-in, one of which is a round mirror whose back design portrays bird and animal motifs interspersed with grapevines (Fig. 9). In contrast to most foreign-made mirrors,

models like the round mirror in Figure 8, which displays the Twelve Branches of the Chinese zodiac and the Eight Divinatory Trigrams, may be considered Japanese imitations, for the quality of the bronze is different, the designs are deformed, and the finished cast is dull, lacking in sharply defined detail.

Other Japanese imitations include a box and tray (Figs. 17–19, 87) sporting bird and flower motifs, deftly executed with light brushstrokes in typical T'ang fashion using *mitsuda-e*, a painting technique employing pigments dissolved in oil to which a lead oxide desiccant has been added; ceramics emulating the T'ang green, brown, and white three-color ware, known as *shoso-in sansai* (Figs. 15, 20, 21); and twill silk and brocades, interwoven with raised arabesques of grapevines, believed to be of Western origin. These treasures generally lack the intensity and severity that characterize Chinese art and evince a lighter, more fluid sensitivity. There are, of course, limits to imitation, and as a culture tends to adapt elements to its own tastes, this difference is hardly surprising; moreover, articles produced by Japanese craftsmen display a certain charm in their own right. Examining the fabulous bird and animal motifs from foreign lands that they incorporated into these works, one senses the great delight of Tempyo Japanese at having fashioned with their own hands the coveted art objects then in vogue at the T'ang court.

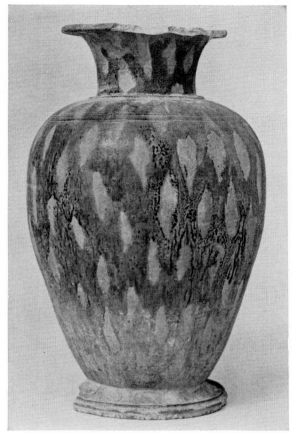

21. Ceramic vase with two-color glaze decor. Ceramic; height, 42 cm. Eighth century. Shoso-in.

CHAPTER TWO

The Shoso-in Legacy

THE DEATH OF SHOMU The abdicated emperor Shomu passed away on the second day of May, 756. At the ceremony ending the forty-nine days of official mourning prescribed by Buddhist law, Shomu's widow, the empress dowager Komyo, dedicated the favorite personal and household belongings of the late emperor to the Rushana (Vairocana), or Universal, Buddha enshrined at the monastery-temple of Todai-ji. The first volume of the *Todai-ji Kemmotsu-cho* (Catalogue of Gifts Dedicated to the Todai-ji) is a memorandum of dedication, the *Kokka Chimpo-cho* (Catalogue of Rare National Treasures). Introducing and closing the memorandum is a petition addressed to the Vairocana Buddha, written by the empress dowager herself, entitled "Prayer at the dedication of national treasures and other objects to the Todai-ji for the sake of the deceased emperor."

In her doleful prolegomenon, the bereaved dowager, asserting that faith in the Buddha and votive offerings to him confer merit and destroy all sins, praises the virtuous emperor for the good he did on earth and laments his untimely death: "Alas! who could have anticipated the dark river of death that separates this world from the next? To our great sorrow, there could be no prolongation of his august life on earth, and the trees have shed their leaves. Time ceaselessly flows on, and nine and forty days have now elapsed; I was unaware of the passage of time, since my grief was growing ever deeper and my sadness ever heavier.

Opening the earth will reveal no sign; and to appeal to heaven brings me no solace. So I desire to give succor to his august spirit by the performance of this good deed, and therefore, for the sake of the late emperor, these various articles which he handled—girdles, ivory scepters, bows and arrows, collection of calligraphy, musical instruments, and the rest, which are in truth rare national treasures —I donate to the Todai-ji as a votive offering to the Vairocana Buddha, various other buddhas, bodhisattvas, and all the saints." (Adapted from J. Harada, trans.: "The Shoso-in, or Imperial Repository at Nara," in *A Glimpse of Japanese Ideals*.)

This concludes the main body of the empress dowager's prayer, but added to the index of objects dedicated is a closing comment (Fig. 22): "The list given above contains treasures that have been handled by the late emperor and articles that served him in the palace. These objects remind me of the bygone days, and the sight of them causes me bitter grief."

Komyo's prayer contains many gracefully composed couplets written in four-six *p'ien wen,* the formal T'ang narrative style, but behind the elegant words, we sense the empress's longing for her husband, and her keen sense of loss at his death. Reminded whenever she saw the departed's favorite belongings of the happy days they had spent together in the imperial palace at Heijo, Komyo must have determined to remove these articles,

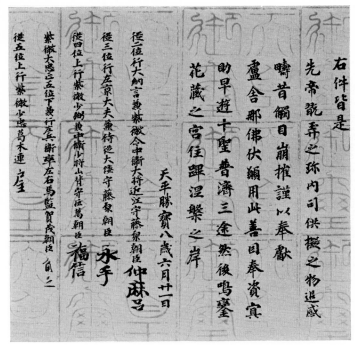

徒五位上行紫微少忠葛木連戸主

紫微大忠正五位下黄行左兵衛率左馬監賀茂朝臣　自之

従四位上行紫微少弼兼中衛少将山背守従四位下萬朝臣　福信

従三位行左京大夫兼待従大倭守藤原朝臣　永手

従三位行大納言兼紫微令中衛大将近江守藤原朝臣　仲麻呂

天平勝寶八歳六月十一日

花藏之宮住踴涅槃之岸

助早遊十聖普濟三途然後鳴鑾

盧舍那佛伏願用此善因奉資寶

疇昔鋼目崩摧謹以奉獻

先帝說弄之弥内司供擬之物退藏

右件皆是

22. The closing lines of the Kokka Chimpo-cho, *Empress Komyo's dedication to the Todai-ji. Ink on paper; scroll width, 25.8 cm. 756. Shoso-in.*

which only deepened her grief, from sight. Thus sadness and a desire to give comfort to the dead emperor's spirit probably prompted the empress's decision to dedicate Shomu's personal effects to the Todai-ji.

Gifts dedicated by Komyo, other than those mentioned above, were presented to the monastery-temple over a period of time. In order of presentation, the offerings, accompanied by memoranda of dedication, were:

1. Memorandum of assorted medicines. Twenty-first day of the sixth month in the year 756.

2. Memorandum of folding screens and patterned carpets. Twenty-sixth day of the seventh month of the same year.

3. Memorandum of autographed calligraphy by Elder and Younger Wang. First day of the sixth month in the year 758. This scroll, in the superb hand of Wang Hsi-chih (321–79) and his son Wang Hsien-chih (344–88), the famous Chinese calligraphers much admired by the Nara court, was treasured by Emperor Shomu as a priceless heirloom and kept for his personal use. Komyo discovered the scroll lying in a case after Shomu's death and dedicated it to the Todai-ji in his memory.

4. Memorandum of screen with calligraphy in the hand of the late Fujiwara. First day of the tenth month in the year 758. The calligraphy was the work of Fujiwara Fubito (659–720), Great Councilor of State and father of Komyo, and the screen was cherished by the empress dowager, who donated it to the Todai-ji for the repose of her deceased father's soul.

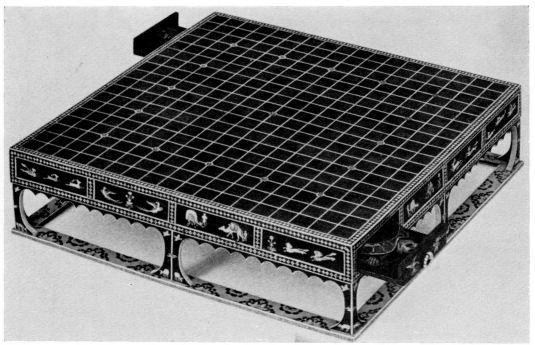

23. *Go board with wood marquetry. Red sandalwood; height, 12.7 cm.; length, 48.7 cm.; width, 48.7 cm. Eighth century. Shoso-in.*

PATRONESS OF THE SHOSO-IN In addition to these gifts, Komyo divided treasures and presented several kinds of each to eighteen temples, including the Horyu-ji, on the eighth day of the seventh month, 756. The *jen-sheng* and other articles appear to have been donated to the Todai-ji the following year, 757. The treasures listed in the *Kemmotsu-cho* indicate that Todai-ji alone received some seven hundred items. Not surprisingly, most of these were offerings dedicated on the forty-ninth day of mourning and are enumerated in the *Kokka Chimpo-cho*. The gifts became mixed in the three storerooms that comprise the Shoso-in and were sometimes lost among other articles. Fortunately, those treasures certified as to origin and listed in the *Kemmotsu-cho* have remained together in the north storeroom. For this reason, too, we must acknowledge the empress dowager

Komyo as patroness of the Shoso-in. Not all of the articles listed in the *Kemmotsu-cho* index have survived, and this is the case with the more than six hundred items recorded in the *Kokka Chimpo-cho*, of which approximately five hundred were checked out of the repository and never returned. For the most part, however, these were weapons used in civil uprisings led by Emi no Oshikatsu (Fujiwara Nakamaro, 706–64) in 764, and a large number of "rare treasures handled by the late emperor" have survived down to the present day.

The entries in the *Kemmotsu-cho* index also teach us a great deal about the designation of techniques used to produce these objects and of their uses. For example, we find the following description of a red sandalwood (*shitan*) go board (Fig. 23) kept in the north storeroom: "Ivory boundary lines, flower-shaped eyes, ivory legs. Ring handles attached to

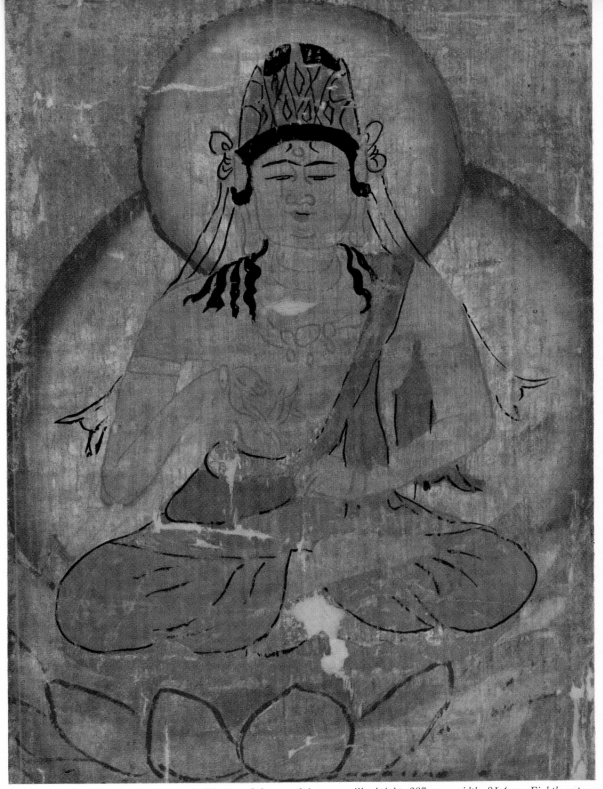

24. *Detail of banner with painting of a bodhisattva. Colors on plain-weave silk; height, 237 cm.; width, 31.4 cm. Eighth century. Shoso-in.*

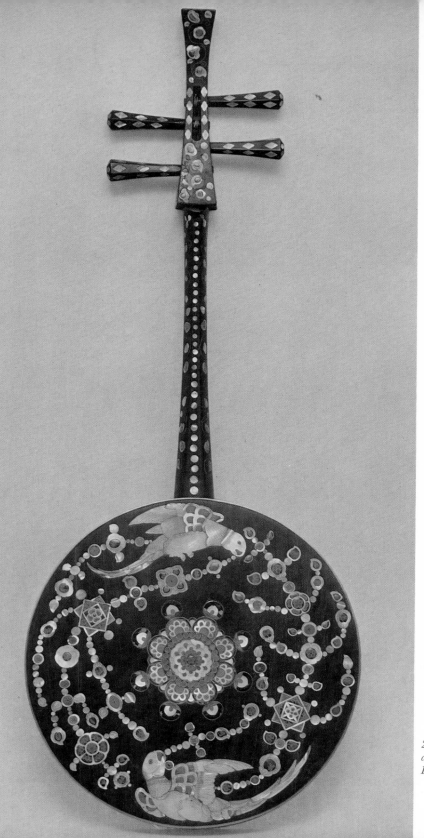

25. *Red sandalwood* genkan *with inlaid mother-of-pearl ornamentation showing two parrots in flight, each holding in its beak a jeweled streamer. Red sandalwood; length, 100.4 cm. Eighth century, T'ang. Shoso-in.*

26. *Embroidery with flowering tree* ▷ *and peacock motifs. Silk twill. Eighth century. Shoso-in.*

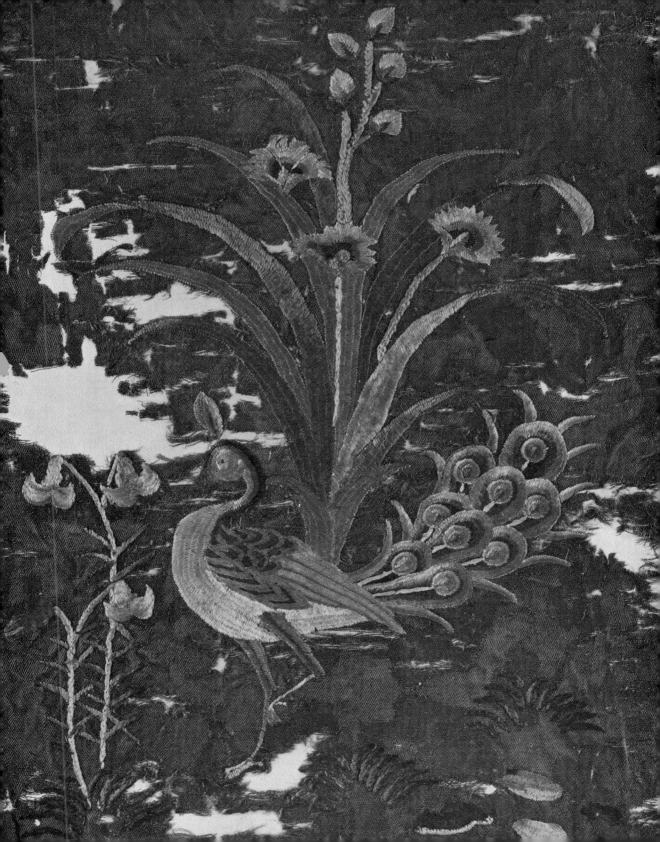

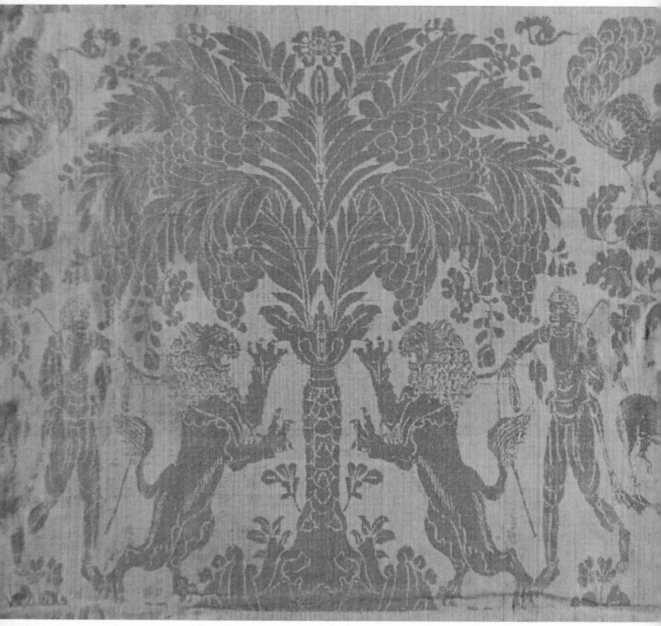

27. *Offering cushion showing symmetrical arrangement of lion tamers with lions under a central tree. Silk twill; length, 99 cm.; width, 52.2 cm. Eighth century. Shoso-in.*

28. *Plectrum guard on five-stringed lute with inlaid mother-of-pearl ornamentation of tropical tree and musician on camelback.* ▷ *Swamp chestnut, tortoise shell, and red sandalwood; height, 30.9 cm.; width, 13.3 cm.; length of instrument, 108.1 cm. Eighth century, T'ang. Shoso-in. (See also Figures 44, 45.)*

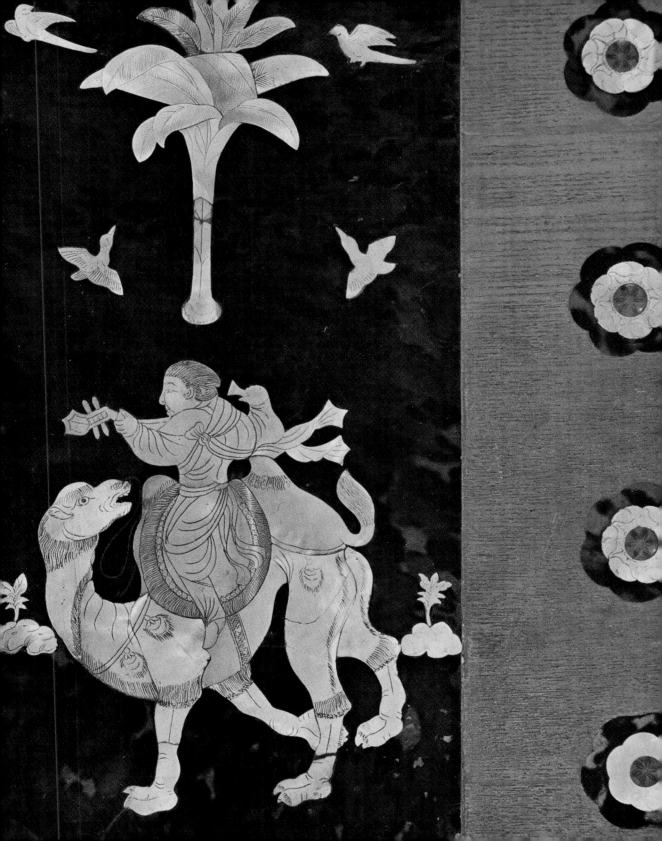

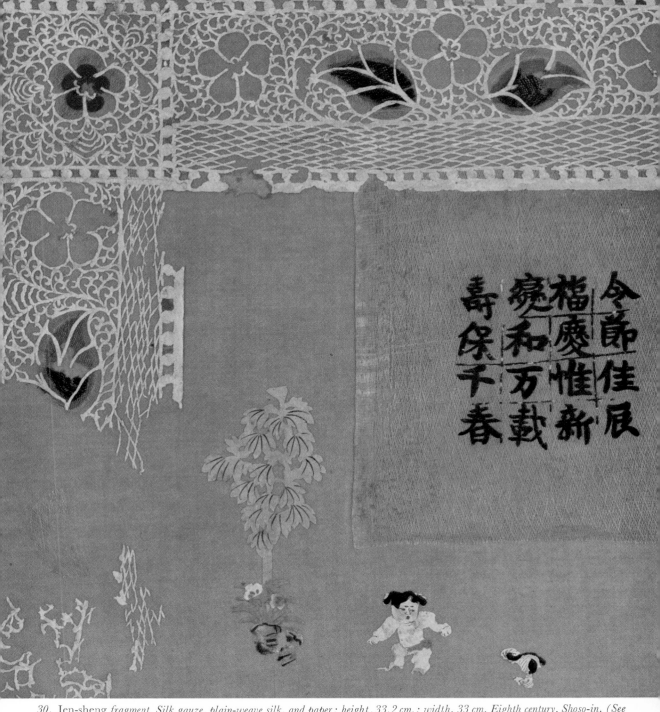

令節佳辰
福慶惟新
癈和万載
壽保千春

30. Jen-sheng *fragment. Silk gauze, plain-weave silk, and paper; height, 33.2 cm.; width, 33 cm. Eighth century. Shoso-in. (See also Figure 5.)*

◁ 29. *Screen panel with seal-script* (tensho) *characters decorated with bird feathers. Plain-weave silk; height, 149 cm.; width, 56.5 cm. Eighth century. Shoso-in.*

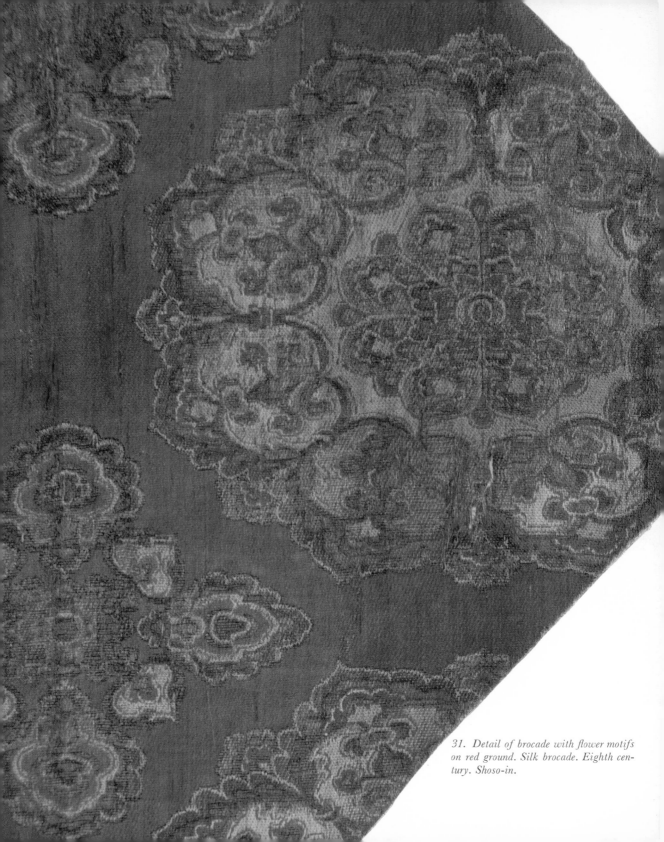

31. *Detail of brocade with flower motifs on red ground. Silk brocade. Eighth century. Shoso-in.*

32. Box with hexagonal patterns and gold- and silver-leaf flowers. Container for go *board in Figure 23. Wood; height, 15.6 cm.; length, 53 cm.; width, 53.5 cm. Eighth century. Shoso-in.*

both sides of board. Tortoise-shaped receptacles for *go* pieces contained in board. Stored in gold and silver tortoise-shell-patterned box." Unlike game boards made today, the Shoso-in board is thin and stands a mere 12.7 centimeters off the ground. Ivory sectional lines and flower-shaped rosettes placed where the lines intersect are inlaid in a playing surface of red sandalwood. The human, animal, and floral motifs that decorate the side panels of the board are also rendered in ivory inlaid in red sandalwood, and the description tells us this technique was known as *mokuga* (literally, wood picture), a variety of marquetry work. The description also notes two drawers to the left of the side panel at either end of the board, each complete with gilt-bronze drawer rings and containing a

turtle-shaped receptacle for storing the playing stones. The board is equipped with a clever device that causes both drawers to spring open simultaneously the moment one is drawn.

The box (Fig. 32) in which the *go* board is stored is even more stylishly crafted. The design is composed of a diaper of hexagonal tortoise-shell motifs enclosed by lines made of deer antler. Inside each figure, flowers in gold or silver leaf, impressed on a green background in alternating sequences, may be seen through a thin translucent overlay.

COURT LIFE IN THE HEIJO PALACE

Komyo followed the emperor Shomu like a shadow during his lifetime. Born in the same year, 701, they were rarely apart, Komyo

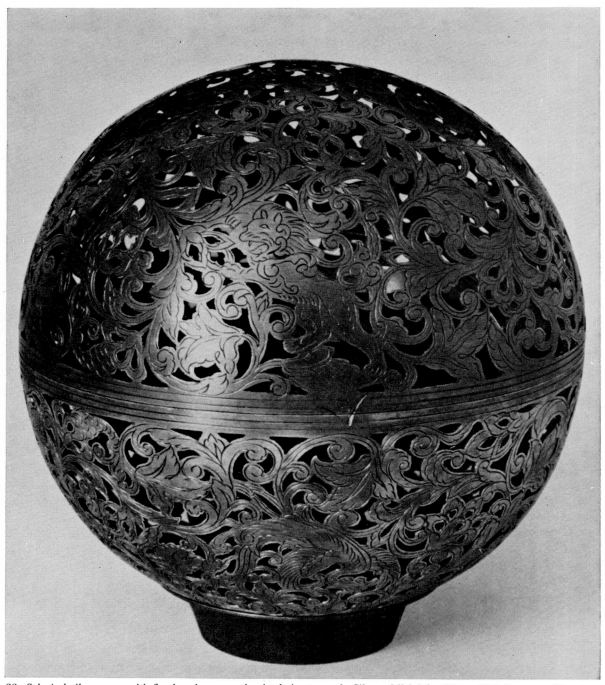

33. *Spherical silver censer with floral arabesques and animals in openwork. Silver; full height, 21 cm. Eighth century. Shoso-in. (Lower half replaced during Meiji era.)*

34. *Pillow of white glossy silk. Silk twill; height, 28.5 cm.; length, 68 cm.; width, 33 cm. Eighth century. Shoso-in.*

35. *Bedstead. Wood; height, 39.4 cm.; length, 233.3 cm.; width, 118.3 cm. Eighth century. Shoso-in.*

accompanying Shomu on imperial visits to all parts of the realm. "How joyous this falling snow to see, / Were my husband beside me." This poem, composed by the empress while gazing at the falling snow on one of the rare occasions of the emperor's absence, is a heartwarming tribute that speaks of the deep affection Komyo had for her husband. The Shoso-in treasures themselves can help us capture something of those bygone days, affording us a glimpse, however fleeting, of the life led by the royal pair in the inner palace complex.

Archaeological surveys of the former Heijo palace, built at Nara after 710, have made steady progress in recent years, and we now know that the emperor's quarters were located behind the Chodo-in, or Courts of Audience, and enclosed by a tiled cloister of rammed clay. In the center of the com-pound stood the *seiden,* the main edifice and forerunner of the Shishiden, the Hall of Public Ceremonies in the Heian palace built later in Kyoto. Four small pavilions, built facing each other, stood to the right and left at the southern end of the compound. The residential quarters were located behind the main edifice. All of the palace buildings were constructed with massive wooden pillars embedded in the ground, and the *seiden* appears to have been roofed with cypress bark rather than tiling. But we do not know for sure how the palace looked. This can only be imagined by turning to contemporary buildings, such as the Dempodo, a lecture hall in the East Precinct of the Horyu-ji. What kind of life did the royal couple lead behind these walls, and what personal effects did they own?

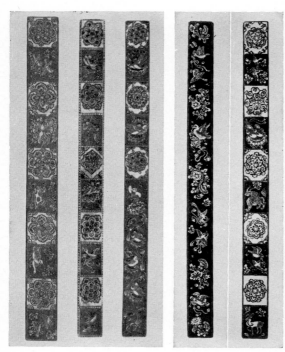

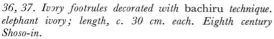

36, 37. *Ivory footrules decorated with* bachiru *technique. elephant ivory; length, c. 30 cm. each. Eighth century Shoso-in.*

38. *Red cabinet with wood-grain designs. Zelkova wood, lacquer, and gilt bronze; height, 100 cm. Late seventh century. Shoso-in.*

The first faint light of dawn enters the palace complex, announcing the break of day. There in the imperial bedchamber, which is partitioned off from the private hall by folding screens decorated with paintings and calligraphy, stands of all things a wooden Chinese-style bed (Fig. 35). Opening their eyes, the emperor and empress, resting comfortably on the woven rice-straw tatami mats and mattresses piled on top of the wooden frame, raise their heads from a large pillow covered with white silk twill (Fig. 34) and push back the coverlet trimmed with brocade. Holding up the round mirror (Fig. 11), whose back is decorated with lacquer inlaid with mother-of-pearl, they comb their hair. The cold touch of the blue nacre- and amber-colored mirror must have brought them wide awake. Draping their regal finery of bright

brocade and silk twill over the silver incense burner decorated with floral arabesques entwined around the figures of a lion and phoenix executed in openwork (Fig. 33), they allow fragrant wafts of smoke to permeate the royal garments. Next, opening the red lacquer cabinet (Fig. 38) of zelkova wood, once owned by the emperor Temmu (r. 673–86) and bequeathed to his successors, they find their favorite possessions. Inside are the emperor's *obi* from which hang several knives and an incense pouch; flat ivory and whalebone scepters; ivory footrules (Figs. 36, 37) in red and green *bachiru*, a T'ang technique in which designs were carved in dyed ivory with a picklike instrument; and a leather box for keeping *go* stones and playing pieces of rock crystal and colored glass used in *sugoroku*, a game resembling backgammon. Although they no longer exist, in the

39. *Leather belt. Lacquer, lapis lazuli, and silver on hide; width, 3.3 cm. Shoso-in.*

40. *Glass fish pendants. Glass; length, c. 6.5 cm. each. Eighth century. Shoso-in.*

cabinet were also small gold and silver knives, rhinoceros-horn cups, and a rhinoceros-horn box used to store a wide assortment of prayer beads of pure gold, rock crystal, amber, and pearl.

CALLIGRAPHY AND THE IMPERIAL CHARACTER

Another object once kept in the red lacquer cabinet was a box decorated in silver *heidatsu* inlay, an ornamental lacquer technique resembling *hyomon*, which contained twenty scrolls of calligraphy in the inimitable hand of Wang Hsi-chih, presented by the bride's party as a gift upon Komyo's first entry into court. The scrolls are thought to have been borrowed frequently and used as models for practicing the art of calligraphy. The emperor's calligraphy, as seen in his *Zasshu* (Miscellaneous Verse), a collection of 140 Chinese poems (Fig. 42); writings in the empress's hand, notably the *Gakki-ron* (in Chinese, *Lo I Lun*), a part of which may be seen in Figure 41; and the *Toka Rissei* (in Chinese, *Tu-chia Li-ch'eng*, Fig. 179), which might be translated as "The Tu Guide to Successful Letter Writing," a collection of seventy-two model letters and appropriate replies, are presently kept in a box of white woven vine (Fig. 50). Although they are practice attempts, something about these scrolls must have pleased the royal couple, for they were set aside and kept.

The *Gakki-ron*, a dissertation on Lo I, the famous Chinese general of the Warring States era (403–221 B.C.), was copied by Komyo from an original manuscript penned by Wang Hsi-chih, and the style is remarkable for its unusual vitality. The scroll bears the date, "The third day of the tenth

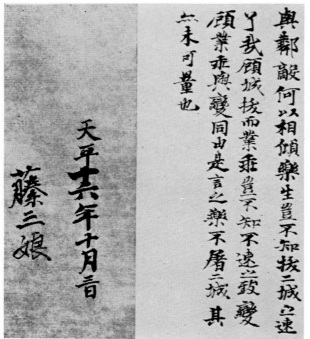

41. Treatise on Lo I (Gakki-ron), calligraphy by Empress Komyo. Ink on paper; scroll width, 25.3 cm. 744. Shoso-in.

42. Portion of Zasshu (Miscellaneous Verse), calligraphy by Emperor Shomu. Ink on paper; scroll width, 27 cm. 731. Shoso-in.

month in the year 744," and is signed by the third daughter of Fujiwara Fubito. Though graceful, the calligrapher's hand shows an uninhibited liveliness of style, and every brushstroke carries the unmistakable imprint of the empress's personality. By way of comparison, the emperor's *Zasshu* is executed in *kaisho*, the standard block script, and the fine brushwork betrays a delicate sensitivity. To what extent calligraphy is an accurate judge of character remains uncertain, but were it so, these manuscripts might reveal much about the emperor and empress and their attitudes toward life.

When Komyo, whose full name was Fujiwara Komyoshi, became the first commoner chosen imperial consort in August, 729, the emperor proclaimed, "The affairs of State must not be known by me alone. My consort shall have affairs to govern." The emperor expected the empress's help; "as there are the sun and the moon in the heavens, mountains and rivers on earth," so they would complement each other. The *Kokka Chimpo-cho*, to which the emperor's seal is affixed, was signed by the minister Fujiwara Nakamaro and his subordinates. As the *Kokka Chimpo-cho* was completed after Shomu's death, the use of the emperor's seal indicates that Komyo reigned as empress dowager and leading figure of her court, governing in place of her daughter, the young empress Koken. We may suppose that even during Shomu's lifetime, Komyo, as consort, assisted him considerably with court affairs. Here, an interesting parallel offers itself between Komyo and two women who

43. Sugoroku *board with wood marquetry. Red sandalwood; height, 17 cm.; length, 55 cm.; width, 31.3 cm. Eighth century. Shoso-in.*

emerged to play determining roles in the T'ang court. The empress Wu (623–705) usurped the throne and held the reins of government after the court of Kao-tsung, and Yang Kuei-fei, the legendary beauty, dominated the court of Ming Huang (the emperor Hsuan-tsung, 713–55).

THE T'ANG MOOD The *sugoroku* pieces and *go* stones shut away inside the red lacquer cabinet suggest that the emperor and empress often took down the beautiful *mokuga sugoroku* board of red sandalwood (Fig. 43) and the *go* board (Fig. 23), and we can imagine the royal pair amusing themselves at games. Four *shakuhachi* (Fig. 46), vertical flutes, carved from bamboo and serpentine, might suggest a certain fondness for flute

solos, and the large number of musical instruments found among Shomu's personal effects should not be forgotten. Among these are a silver *hyomon kin* with the T'ang maker's inscription, which was removed from the Shoso-in in 814 and replaced by the gold and silver *hyomon kin* in the present collection; a five-stringed *biwa* (Figs. 44, 45) and a *genkan* (Fig. 25), both of red sandalwood with mother-of-pearl inlay; a Chinese panpipe made of hard bamboo; a *sho*, a Chinese mouth organ consisting of several pipes attached to a bowl-shaped air chamber, made of black bamboo; and a transverse flute, a *yokobue*, carved from stone. The imperial collection also included a *wagon*, or Japanese *koto*, made of Japanese cypress and a Silla *koto* of Korean origin, decorated with gold fillings, but most of the

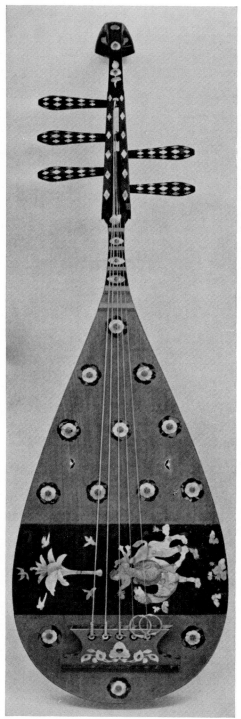

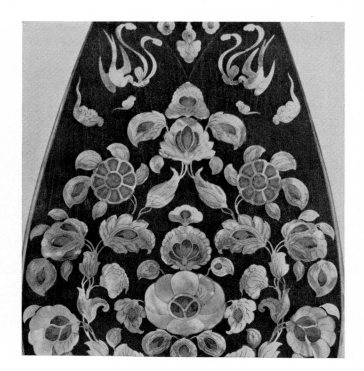

instruments belong to the repertoire of T'ang music of Indian and Chinese origin, and the emperor and empress no doubt enjoyed playing these with court dignitaries and musicians alike.

As listeners cocked their ears to catch the melodic strains of the five-stringed red-sandalwood *biwa,* dressed in a magnificent mother-of-pearl mantle, their eyes must have fallen on the plectrum guard with each pause of the pick, the figure of the foreign musician on camelback carrying their thoughts to exotic lands across the seas. These instruments alone are convincing evidence that life in the Heijo imperial palace was imbued with the spirit of T'ang and had acquired its distinctive flavor. T'ang influence at the Japanese court, then, was no romantic fantasy but a real presence felt in everyday life.

The vitality of palace life was not, of course, sustained by the imperial family and court aristocracy alone. Several thousand soldiers of the imperial

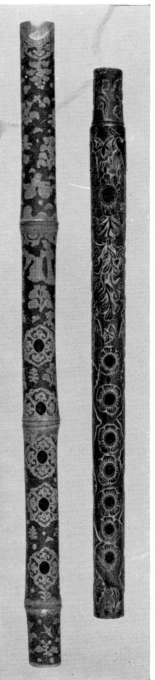

◁ *44, 45. Five-stringed lute with inlaid mother-of-pearl ornamentation. Left: view of plectrum guard and soundboard. Right: detail of back inlay. Red sandalwood and chestnut; length, 108.1 cm. Eighth century. Shoso-in. (See also Figure 28.)*

46. Left: carved shakuhachi. *Bamboo; length, 44 cm. Right: carved horizontal flute. Serpentine; length, 37.5 cm. Eighth century. Shoso-in.*

guard and able-bodied laborers worked inside the palace grounds. In the ateliers attached to government offices like the Imperial Works Bureau, a division of the Ministry of Central Affairs, craftsmen were kept busy turning out the necessities required to satisfy the daily needs of the court. Records in the *Shoso-in Monjo* and finds excavated from the Heijo palace ruins give some idea of the day-to-day life of that period. For example, a great many of the tools and personal articles used by scribes working in the Sutra Copying Bureau have been preserved in the Shoso-in. Among these are coarse hempen garments, such as white robes, outer coats, and long divided skirts, as well as unglazed plates, bowls, and other table utensils, including kitchen knives, long-handled spoons, and chopsticks. These diverse items suggest that even the personal effects of low-ranking civil servants were more often than not Chinese in style and inspiration.

CHAPTER THREE

The Todai-ji and
the Shoso-in

THE EYE-OPENING CEREMONY The Japanese of Tempyo greeted the ninth day of April, 752, with great rejoicing. The Great Buddha of the Todai-ji was to be dedicated in the official eye-opening ceremony, a ritual in which the pupils of the Buddha were painted in in order to invest the statue with spirit. On this day, the abdicated emperor Shomu, his consort Komyo, and the young empress Koken, who had succeeded her father to the throne in 749, set out together for the Todai-ji and arrived at their pavilion, the Fuhando. The area surrounding the Daibutsuden, the Great Buddha Hall, built to house the colossal gilt-bronze image of the Vairocana Buddha, was decorated with artificial flowers, elaborately embroidered banners, and symbolic paper flowers for strewing. To the east and west of the hall were inaugural banners and five-colored pennants, set in every direction, fluttering brightly in the wind (Figs. 48, 49). Right and left of the central platform erected in front of the hall stood a row of majestic "seven jewels trees," each decked with seven different precious substances. The splendor of the occasion was such that one might have thought himself in the Pure Land, the Buddhist paradise.

Like the New Year's observances at the palace, that day saw government dignitaries and military officials in full attendance accompanied by nearly twenty thousand Buddhist monks. Priests from throughout the Eastern world gathered for the investiture of the immense image and were borne inside the temple grounds on palanquins to take up their assigned places in the various pavilions. From the East Gate entered the renowned T'ang priest Tao-hsuan (in Japanese, Dosen), who led the ritual services formally inaugurating the Great Buddha. Next came the high priest of Buddhism, Bodhisena from India, who officiated at the actual eye-opening rites inviting in the spirit of the Vairocana Buddha, and finally, entering through the West Gate, the master of Buddhist asceticism Ryuson made his appearance. After everyone was assembled, Bodhisena, the officiating priest, approached the Great Buddha, and, with everyone in attendance holding the trailing silk eye-opening cords, which measured a full 700 *shaku* (about 208 meters), lifted up the monstrous eye-opening brush and painted in the eyes of the image. Thus, the eye-opening ceremony was completed, fulfilling the emperor's wish to build a temple and invoke blessings on the people, which he expressed in the decree ordaining the casting of the Great Buddha: "If there are those who would help construct this image, though they have no more to offer than a twig or handful of dirt, let them do so."

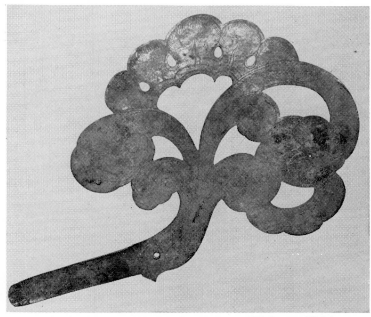

47. Ornamental piece with cloud and flower patterns. Gilt bronze. Eighth century. Shoso-in.

Following the opening of the eyes, a master lecturer and master reciter mounted a platform to interpret and read the *Flower Wreath Sutra* (*Kegon-kyo*), the Buddhist scripture taught at the Todai-ji. They were followed by priests from the Todai-ji and the Four Great Temples of Nara, the Yaku-shi-ji, the Gango-ji, the Kofuku-ji, and the Daian-ji, who stepped forward to present rare and precious gifts, which, together with offerings from other guests, were placed on elegant offering cushions covered with silk brocade and displayed before the Buddha. Next, a lively troupe of dancers and musicians filed through the South Gate with much fanfare. Commencing with a solemn *o-uta* (literally, grand singing) reserved for state occasions and moving next to an ancient dance accompanied by singers and a Japanese orchestra, the *kume-mai*, the troupe paraded before the assembled guests performing from a varied repertory that included

Gigaku, a comic masked dance with drum accompaniment, followed by Togaku, music from China and South Asia, and Komagaku, northern music of Korean and Manchurian origin. After the parade, the entertainers broke into two groups and lined up on either side in front of the hall. The celebration began in earnest with the music and dances each performed in its turn, and when it all ended we cannot say. The authors of the *Shoku Nihongi*, a commentary dealing with this period completed in 792, probably did not exaggerate when they observed, "Never have the sacred rites been celebrated with such pomp and fervor since the teachings of the Buddha came East."

Many items used or presented as offerings at the eye-opening ceremony have been preserved in the Shoso-in, including the long silk cords attached to the eye-opening brush. Of these objects, those with inscriptions alone account for a large number and

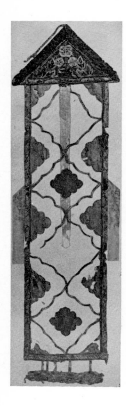

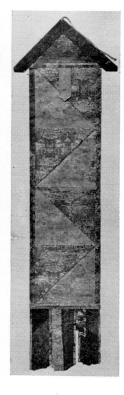

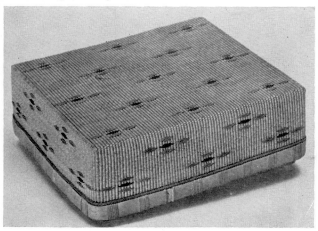

48 (far left). Silk banner. Silk gauze; length, 141 cm. Eighth century. Shoso-in.

49 (left). Brocade banner. Brocade; length, 168 cm. Eighth century. Shoso-in.

50. White vine box. Height, 8.2 cm.; length, 20.7 cm.; width, 18.6 cm. Eighth century. Shoso-in.

include gilt-bronze ornamental pieces representing clouds and flowers in openwork (Fig. 47); a thin, shallow wine cup of agate (Fig. 51); a wide-rimmed, white glass vessel with a high foot (Fig. 52); a silver lidded vessel known as *gosu;* Buddhist rosaries of amber; a coffer (Figs. 17, 87) decorated with *mitsuda-e* designs containing cloves and birthwort roots, kept for their medicinal properties; a box of white woven vine (Fig. 50) enclosing various *obi* and knives; and a small red lacquer chest of zelkova wood containing several eight-lobed oblong drinking cups and silver receptacles. Of particular interest are two knives (Fig. 53) fitted with rhinoceros-horn handles and silver sheaths with trailing vine motifs, offered by Shomu's mistress, Lady Tachibana. Precious treasures in their day, these items attest to the earnestness of those who vied in presenting them.

Interestingly enough, the Shoso-in holds in addition many accessories and costumes used for Bugaku, a masked dance set to traditional court music, which was introduced to Japan from China during the Nara period. Among these are long swords used in connection with the ancient Chinese musical performances *Po-chen Yueh* (Breaking Camp) and *Wu-wang* (King Wu). As many as 171 Gigaku masks (Figs. 85, 86, 108, 109, 111, 112), believed to have been worn in the eye-opening ceremony, have been preserved. There are well over one hundred items of apparel worn by dancers and musicians made of silk twill, brocade, chiffonlike gauze, and hemp cloth. These include a varied assortment of outer coats, long undergarments, sleeveless coats worn between these, underclothes, long, divided skirts, stockings, and *obi*. A number of musical instruments with no inscriptions, kept in the south

51. Leaf-shaped drinking cup. Agate; diameter, 17 cm. Eighth century. Shoso-in.

52. High-footed vessel of white glass. Alkaline lime glass; height, 10.7 cm. Eighth century. Shoso-in.

storeroom, may also have been used on this occasion.

RELICS USED IN STATE CEREMONIES

From the inscriptions found on certain implements used at services held at the Todai-ji, it seems that many of these services would be better described as formal state ceremonies. For instance, we possess a fragrant incense wood, *senko* (literally, shallow incense), said to have the quality of neither sinking nor floating entirely when placed in water, which was presented to the Todai-ji on the twenty-ninth day of March, 753, on the occasion of a Ninno-e, a protective reading of the *Benevolent Kings Sutra* (*Ninno-kyo*). Another item is the ivory tag attached to a copy of the *Heart Sutra* (*Hannya Haramitta Shin-gyo*) owned by the emperor Gensho (r. 715–24). Other ceremonial items are porcelain dishes and bamboo baskets holding symbolic paper flowers used in the memorial service performed on the nineteenth day of July, 755, to commemorate the first anniversary of the death of Shomu's mother, Fujiwara Miyako. Also preserved are decorative twine streamers attached to *keman,* pendant ornaments symbolizing a chaplet of flowers and hung inside Buddhist sanctuaries; cords from a censer with a lion-shaped pedestal used in the funerary rites for the emperor Shomu on the nineteenth of May, 756; a gilt-bronze "pacifying" bell (*chintaku*) used as a banner weight; and bamboo flower baskets, all of which were used in the memorial service held on the first anniversary of Shomu's death, the second day of May, 757. A great number of ritual banners of all sizes made of a variety of cloths have also been kept from this occasion.

53. Left: knife with mounted silver and iridescent insect wings, scabbard wrapped with birch bark. Right: jeweled knife with rhinoceros-horn handle, scabbard with trailing vine, and motifs in silver. Tag reads, "Donated by Lady Tachibana." Wood and silver; full length, right, 13.8 cm., left, 15 cm. Eighth century. Shoso-in.

Other ceremonial objects are two famous silver jars (Figs. 54, 55) with inscriptions dating from the fourth day of February, 767, the occasion of Empress Koken's visit to the Todai-ji; an offering cushion on which gifts were displayed during the imperial visit on the fourth of March in the same year; a low stand of boxwood and a similar stand (Figs. 56, 57) decorated with *sai-e* (literally, colored designs) applied here to a green ground. These are thought to have displayed gifts offered during an imperial visit to the temple on the third of April, 768, shortly after Koken had reascended the throne as the empress Shotoku following civil disturbances

in 764. Various other offering cushions and *obi* of silk also date from this visit.

Non-Buddhist rites were also conducted at the Todai-ji. The Shoso-in preserves the remains of a Chinese hand plow used in New Year's observances held on the First Day of the Rat during the reign of Koken. The symbolic plow was used to assure the productivity of the land and a rich harvest, and the rite was performed together with the silk ritual discussed earlier. On the plow handle is inscribed, "Todai-ji. Dedicated on the First Day of the Rat, New Year, 758." This important observance, then, was held outside the imperial palace at the Todai-ji, indicating that the monastery-temple was often used as the site for major ceremonies of state.

Besides the treasures having clearly inscribed dates or other positive proof of authenticity, the Shoso-in also houses a variety of implements and regalia without inscriptions and used in Buddhist services and court ceremonies. Several musical instruments found in the south section of the repository were probably presented to the temple as gifts and were no doubt played on occasion at Buddhist memorial services. These are a maple-wood *biwa* inlaid with mother-of-pearl and inscribed simply "Todai-ji"; the remains of a harp, or *kugo*, decorated with mother-of-pearl inlay; a cypress-wood *wagon*; a *shakuhachi* of black bamboo; a transverse flute of mottled bamboo; and a Chinese mouth organ of imitation mottled bamboo.

Other treasures of uncertain provenance are assorted boxes bearing the names of the different Todai-ji halls and pagodas. Among these are a coffret (Fig. 58) from the Senjudo (Hall of the Thousand-armed Kannon) decorated with *kingin-e*, a technique in which gold and silver particles were mixed in glue, here applied to a green ground; a box from the East Pagoda made of boxwood and decorated with *kingin-e* motifs; and the *kingin-e* foliate vessel with a lid (Fig. 59) carved from wood of the Chinese phoenix tree, and belonging to the Kaidando (Ordination Hall). Each box was used to store gifts presented to the temple and, together with thirty offering stands, was probably laid at the foot of the Great Buddha by members of the imperial family and court nobility in the course of

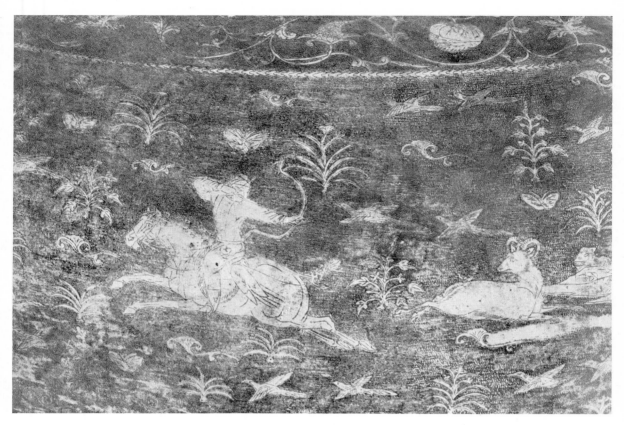

54, 55. Silver jar decorated with hunting scenes. Above: detail of hunter taking Parthian shot at fleeing ibex. Silver; height, 43 cm. 767. Shoso-in.

56, 57. *Offering table with colored motifs on green ground. Japanese cypress; height, 6.2 cm.; length, 50.5 cm.; width, 42.1 cm. 768. Shoso-in.*

the Buddhist services conducted at the Todai-ji. We do not know for sure what these gifts were, but eight of the wooden tags once attached to the original offerings remain, each signed by its donor, including one bearing the signature of Lady Tachibana herself.

Another wooden tag carries the inscription "Two ceremonial robes. One for the abdicated emperor. One for the empress dowager. Chest number three." The inscription on the reverse side reads "Chest number three. The ninth day of the fourth month in the year 752." Doubtless these garments are the ceremonial gowns worn by Shomu and Komyo on the day of the eye-opening ceremony. The actual robes have long since disappeared, and while we can only guess at the regal attire, the wooden tags indicate that they were indeed kept at the Todai-ji.

THE TODAI-JI REPOSITORY The north section of the Shoso-in, the Hoku-so, stores primarily those gift offerings that have been collectively catalogued as properties of the Imperial Household. In the south storeroom, the Nan-so, however, ceremonial regalia and other items associated with Buddhism and Buddhist rites predominate. Among these are Buddhist trappings used at the Todai-ji and particularly those that figured in the eye-opening ceremony of 752, religious implements belonging to the different halls and pagodas, and articles used by priests and monks.

There is nothing unusual in the large number of Buddhist implements and accessories housed in the Shoso-in when one considers that it served as the Todai-ji's chief repository. According to the early twelfth-century *Todai-ji Yoroku* (Record of Important Events at the Todai-ji), the great majority of

58. *Coffret with gold and silver motifs on green ground. Japanese cypress; height, 10.6 cm.; length, 27.9 cm.; width, 17.5 cm. Eighth century. Shoso-in.*

59. *Lid of oblong foliate vessel decorated in gold and silver. Chinese phoenix wood; height, 33.9 cm.; width, 14.2 cm. Eighth century. Shoso-in.*

stored treasures were kept in the long double storehouse (*narabi-kura*) of the Sangatsudo (or Kensaku-in), a hall so named because its rites were held annually in the third month (*sangatsu*). In the year 920, many objects were removed from two pavilions inside the temple domains, the Amidado (Amida Hall), dedicated to Amitabha, the Buddha of Infinite Light, and the Yakushido (Yakushi Hall), which venerated Bhaisajyaguru, the Buddha of Healing, and transferred to the Sangatsudo's twin storehouse. However, this building fell into ruin as tiles and wooden members deteriorated, and in June, 950, articles stored there were removed to the Nan-so in the Shoso-in.

A hand-copied version of the *Amida-in Homotsu Mokuroku* (Inventory of Treasures in the Amida-in), a property index compiled in 767 and believed to refer to the Amida Hall, lists several objects re-sembling items in the Shoso-in's Nan-so. Among the articles in the index corresponding to Nan-so treasures are two lotus pedestals for incense trays similar to the one in Figure 60, which is decorated with gold leaf embedded in lacquer and bears the inscription *koinza*, "incense pedestal"; a *shakujo*, or priest's crosier, made of "white bronze" (*hakudo*), a silvery alloy of copper and nickel, and surmounted by a head with six metal rings attached (Fig. 67); amber prayer beads; such musical instruments as a *wagon*, a *so no koto* (a *koto*-like instrument of Chinese origin), mouth organs, and transverse flutes; and banners, cushions, *obi*, and other dyed and woven fabrics. Another entry closely resembles the white bronze brazier (Fig. 61) kept in the Shoso-in's central storeroom. Although it is possible that several examples of each item may originally have existed, the similarity between entries in the

60. *Lotus-flower-shaped pedestal of incense burner. Lacquer and gold leaf on wood; diameter, 56 cm.; height, 17 cm. Eighth century. Shoso-in. (See also Figures 125, 128.)*

Amida-in property index and art objects stored in the Shoso-in should be noted.

The treasures kept in the south and central storerooms of the Shoso-in, then, were for the most part Buddhist implements and stores belonging to the Todai-ji. Religious paraphernalia consisted mainly of ritual ornaments used to solemnize temple halls and pagodas, accessories used in ritual offerings placed before the Buddha's image, and the ceremonial attire and accessories worn by high priests. These articles enable us to form some idea of the nature of Buddhist rites performed at the Todai-ji during the Tempyo period.

THE SOLEMNITY OF
THE BUDDHIST SERVICE

The Todai-ji is said to have comprised nearly one hundred separate structures, foremost of which was the Daibutsuden, completed in 751, and numerous Buddhist services, notably the ritual readings of the *Flower Wreath Sutra,* the *Benevolent Kings Sutra,* and the *Lotus Sutra* (*Hoke-kyo*), were frequently performed there. On these occasions, five-color curtains and hanging screens were draped inside and outside the halls. Ritual banners of all sizes, some of brocade or silk gauze stitched back to back, others handsomely embroidered with elegant flower and bird motifs (Fig. 26), fluttered in the breeze. Pennants or curtains decorated with images of bodhisattvas and celestial beings, or with auspicious motifs, such as the Twelve Branches and flying clouds, were also used on occasion. Ordination banners for Buddhist initiation rites (Fig. 62) and symbolic *keman* wreaths, all executed in gilt-bronze openwork, glittered brightly in the glow of votive candles, adding their sparkle to reflecting mirrors attached to the ceiling and pillars and bathing the image of Buddha in a symphony of light.

Today, only twenty-seven mirrors remain in the Todai-ji's Sangatsudo, but thirty-six are said to have been hung from the ceiling and eleven attached to the hall's pillars at one time. Rush mats

61. *Incense burner with animal-shaped legs. White bronze; diameter, 21 cm. Eighth century. Shoso-in.*

62. *Buddhist ordination banners. Gilt bronze; length, 170 cm. Late eighth century. Shoso-in.*

and felt rugs were spread on the floor inside the hall, and octagonal taborets and chairs were arranged to accommodate high priests and visiting nobles. Incense trays were set on lotus pedestals, and incense was burned as an offering to the Buddha. Also placed before the Buddha were flower baskets containing symbolic lotus petals for scattering, made of gold, silver, red, and green paper; a foliate gilt-bronze vessel (Figs. 64, 65); and a gilded silver floral tray (Figs. 4, 12) heaped with rice, *mochi* rice cakes, and other food. At certain Buddhist services, ritual meals were offered to the Buddha and partaken of by the monks present. At these times, different foods were served in a variety of gold, silver, copper, and ceramic bowls, plates, and self-contained sets of bowls (Fig. 185), accompanied by carafes, long-handled spoons, and chopsticks. Gold, silver, and copperware utensils were reserved for the Buddha, while priests and monks used ceramic items, but the same food appears to have been served to both.

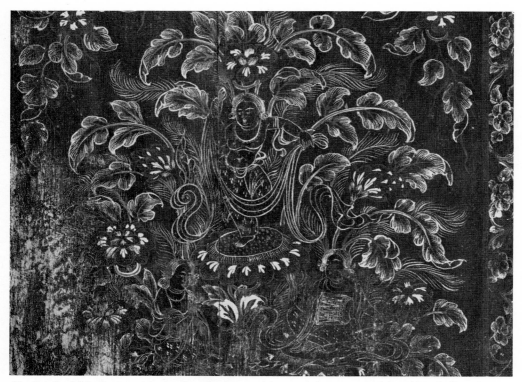

63. *Detail of lid of sapan-stained coffret showing musicians and dancer executed in gold and silver pigment. Wood; height, 30.3 cm.; width, 21.2 cm. Eighth century. Shoso-in.*

64, 65. *Foliate container with elaborate openwork. Gilt bronze; height, 17 cm.; length, 44.2 cm.; width, 30 cm. Eighth century.* ▷ *Shoso-in.*

Next, offering stands laden with coffrets, each filled with gifts presented by notables of the court, were arrayed before the image. A number of small chests designed in a wide range of shapes and employing different decorative schemes have survived to remind us of that distant time. One of these is a low octagonal table with the inscription, "East Small Pagoda," decorated with *kingin-e* motifs applied over white clay priming, to which are attached ornate flower-shaped legs painted in *gindei,* a mixture of pulverized silver and glue. Another is a coffret with attached legs (Fig. 63) depicting a drummer, musician, and dancer rendered in gold and silver against a sapan-stained ground and having the same inscription. All of these are thought to have belonged to the small east and west pagodas built in 767 by the well-known monk Jitchu, Roben's assistant.

Belt ornaments worn suspended from the *obi,* such as knives (Fig. 53), incense pouches, fish-shaped pendants (Fig. 40), and rock-crystal jewelry, are not lacking among donated items; but rare treasures of foreign origin, the wonder of their day, were also presented to the Buddha as votive offerings. These were glassware including a *ruri* bowl (Fig. 91), *ruri* ewer (Fig. 99), a deep blue *ruri* goblet

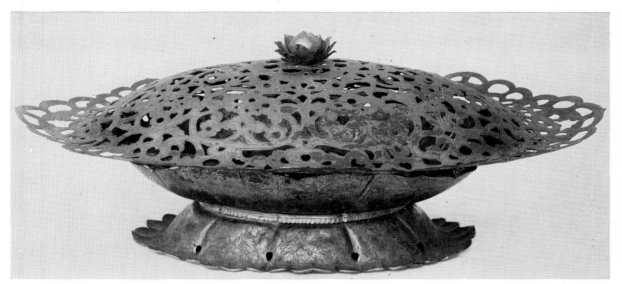

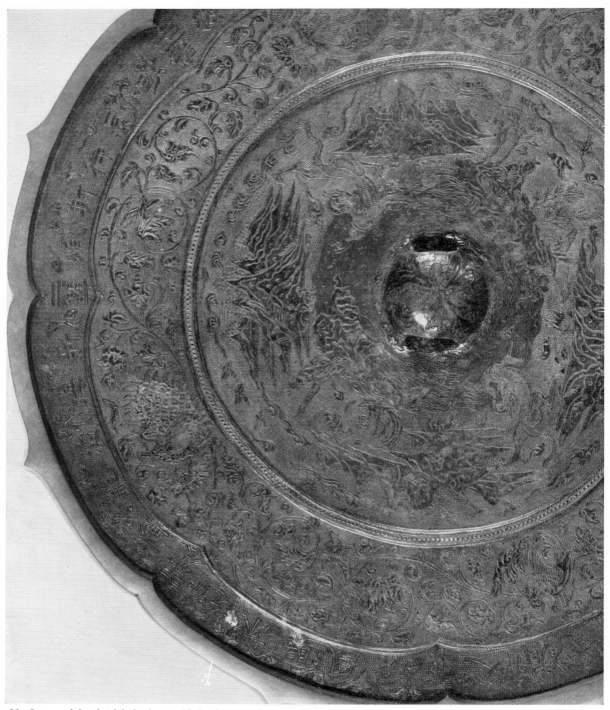

66. *Octagonal bracket-lobed mirror with landscape and the Eight Divinatory Trigrams. Silver-plated copper; diameter, 40.7 cm. Eighth century, T'ang. Shoso-in.*

67. *Priest's crosier surmounted by six metal rings. White bronze; diameter of rings, 13.6 cm. Eighth century. Shoso-in.*

68. *Three-pronged vajra used in esoteric Buddhist rites. White bronze; length, 31.3 cm. Eighth century. Shoso-in.*

69, 70. *Rhinoceros-horn priest's staff mounted with gold ornamentation and stone setting. Length, 50.3 cm. Shoso-in.*

(Fig. 16), a bowl of jade, and similar objects. Mirrors with back designs in cloisonné, like the exquisite example in Figure 126 with twelve petal-shaped lobes of *ruri* (glass) and solid gold, silver-backed mirrors, such as the eight-lobed example in Figure 66 featuring landscape scenes with Eight Divinatory Trigrams, and other decorated mirrors are believed to be imported items. Such treasures were probably gift donations rather than ritual accessories used to solemnize Buddhist sanctuaries.

INAUGURAL RITES
AT THE KAIDAN-IN

Rites celebrating the completion of the Kaidan-in (Ordination Pavilion), the building housing the ordination platform where priests were ordained, were held at the Todai-ji on the thirteenth of October, 755. The officiating priest was the famous Chinese monk Chien-chen,

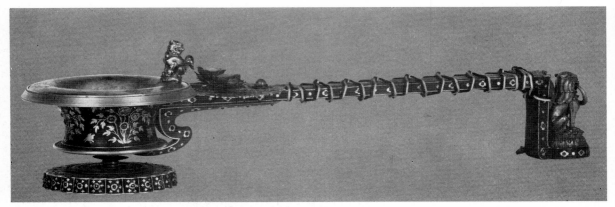

71. Gold-mounted censer with long handle. Red sandalwood, gilded copper, and crystal; length, 39.5 cm. Eighth century. Shoso-in.

known in Japan as Ganjin, who had recently arrived in Nara from the T'ang court, and the ritual invocation was recited by the abbot of Todai-ji himself, Roben. On that occasion, thirty-two priests softly intoned the sacred chants while another thirty-two struck their long *shakujo,* rings jangling, in rhythmical accompaniment. In all, about 120 monks were present at the inaugural service.

For such important Buddhist rituals, the officiating priest and high-ranking clergy under him donned ceremonial robes much like the priest's cope, or *kesa,* preserved in the Nan-so. With elaborately ornate regalia in hand, such as the rhinoceros-horn *nyoi,* or staff, encrusted with gold and precious stones (Figs. 69, 70), and the long-handled censer of red sandalwood mounted with gold (Fig. 71), the priests probably entered the Kaidan-in under a baldachin held aloft by attendants. Lower-ranking priests taking part in the ceremony carried either a whisk with a tortoise-shell or white-bronze handle or a *shakujo* (Fig. 67), depending on the function and status of the bearer. The ritual invocation recited on that day belonged to the liturgy of esoteric Buddhism, and the three-pronged *vajra,* a thunderbolt symbol (Fig. 68), and prayer beads carried by the priests are said to have figured in esoteric rites.

Some of the numerous musical instruments in the Nan-so were probably used in the eye-opening ceremony, but Buddhist services were often accompanied by music and dancing, performed as offerings, and, together with Gigaku masks and musicians' costumes, the instruments may have seen frequent use. However, the plectrum guard of the five-stringed red sandalwood and mother-of-pearl *biwa* in the Hoku-so is so well preserved that it was most likely set aside as a votive gift offering.

The prayer of the empress dowager Komyo recorded in the *Kokka Chimpo-cho* dedication and quoted earlier continues: "May these gifts, I humbly pray, help his spirit on the Wheels of Sacred Laws to speed on its way to the temple of the Lotus World. There may he always enjoy heavenly bliss, and may he finally be admitted to the sacred hall of the Buddha of Light. . . ." (J. Harada, trans.)

Through the virtuous works of commissioning the construction of the Great Buddha Hall at Todai-ji, an earthly manifestation of the Temple of the Lotus World, and making offerings to the Vairocana Buddha, the Japanese of Tempyo and first among them the emperor Shomu and Komyo, his imperial consort, hoped to ensure the national welfare and tranquillity and find deliverance from the burden of worldly suffering: "Thus may his benevolence extend to ten billion people and his virtue disseminate over a million worlds."

72. *Lacquered Persian-style ewer with bird-headed spout.* Rantai *lacquer with silver hei-*datsu *designs; height, 41.3 cm. Eighth century. Shoso-in.*

73. *Sassanian ewer. Gilded silver; height, 33.8 cm. Sixth century. (See also Figure 132.)*

74. *Ewer with three-color glaze. Three-color ceramic ware; height, 34.9 cm. Eighth century, T'ang. Haku-tsuru Art Museum, Hyogo Prefecture.*

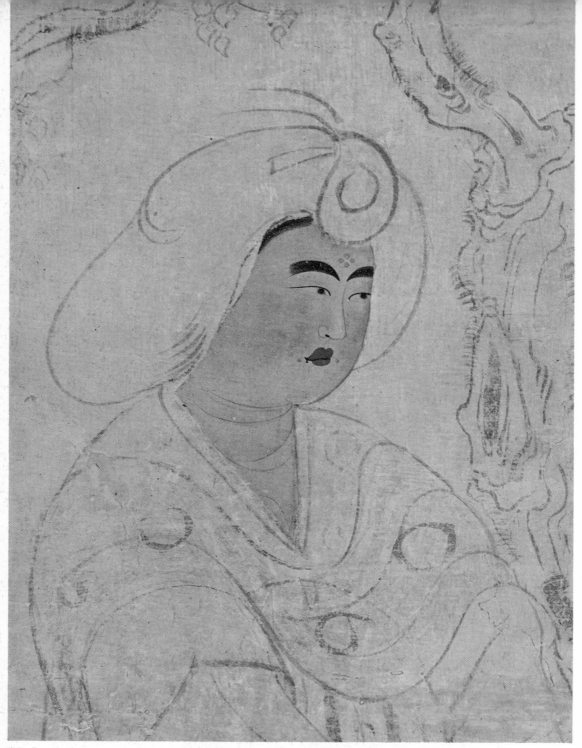

75. *Detail of screen panel picturing a Chinese lady under a tree. Originally decorated with bird feathers. Colors on paper; height, 136.2 cm.; width, 56.2 cm. 752–56. Shoso-in. (See also Figures 134, 135, 192.)*

76. *Detail of Sassanian ewer showing Anahita, the Persian goddess of fertility, executed in* repoussé. *Gilded silver; height,* ▷
34 cm. Sixth century.

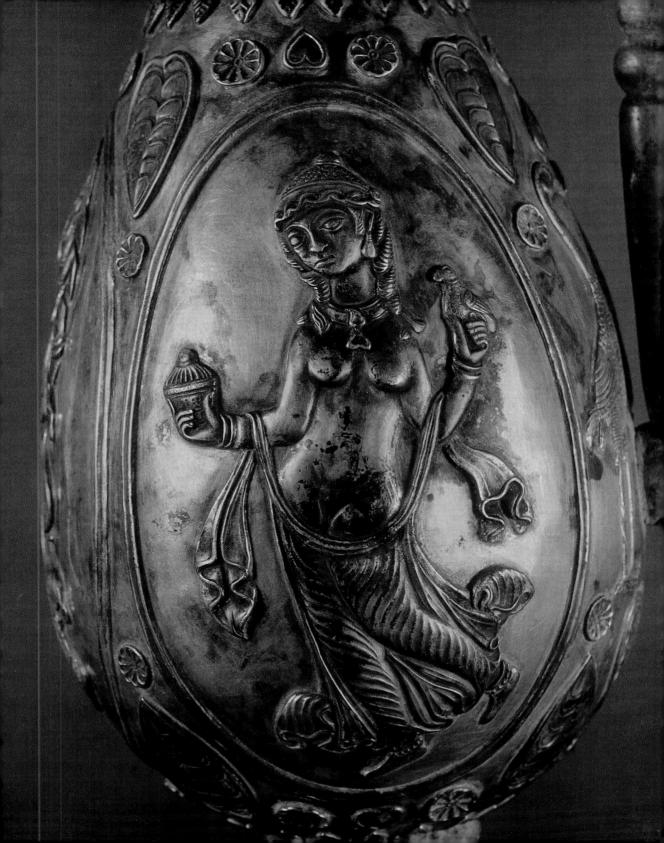

78. *Twelve-lobed oblong drinking cup of green glass. Lead glass; length, 22.5 cm. Shoso-in.*

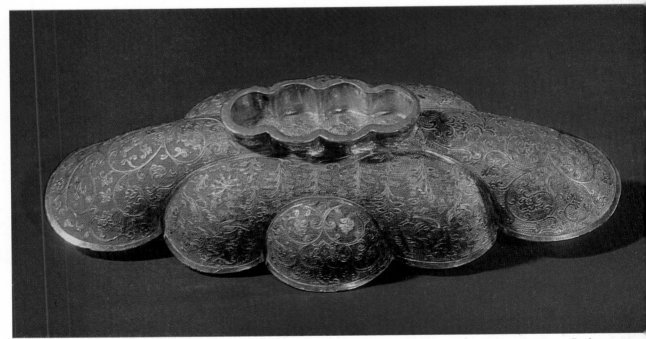

79. *Eight-lobed oblong cup. Gilded silver; length, 15.2 cm. Eighth century, T'ang. Hakutsuru Art Museum, Hyogo Prefecture.*

◁ 77. *Twelve-lobed oblong cup. Silver; length, 26 cm. Sixth or seventh century, Sassanian. Idemitsu Art Gallery, Tokyo.*

80. *Jar decorated with hunting motifs executed in ring matting* (nanako). *Gilded silver; height, 4.4 cm. Eighth century. Todai-ji, Nara.*

81. *Painting on plectrum guard of lute showing scenes of a hunt and feast. Red sandalwood and leather; full height of instrument,* ▷ *98.7 cm. Eighth century. Shoso-in.*

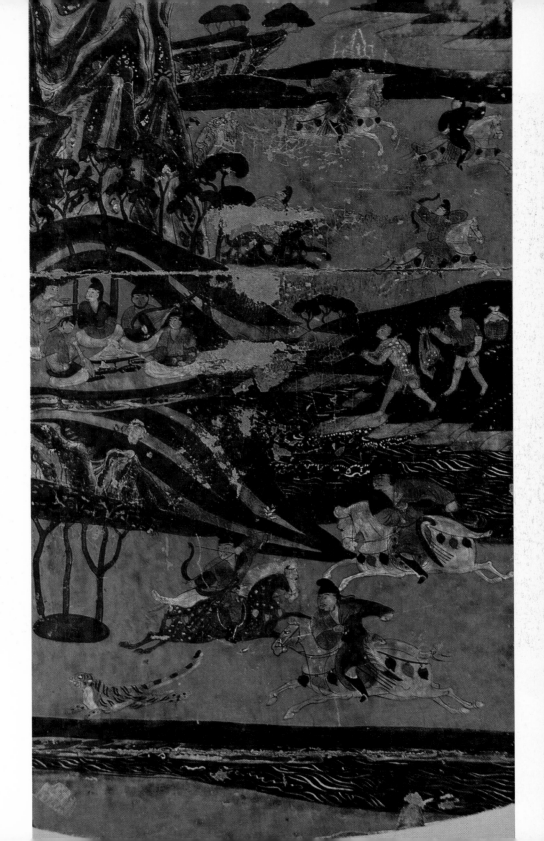

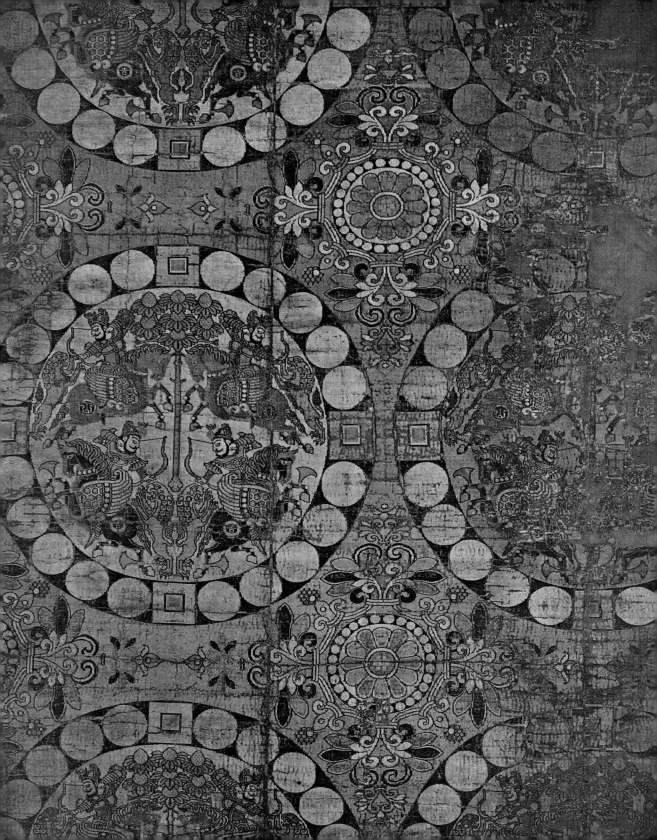

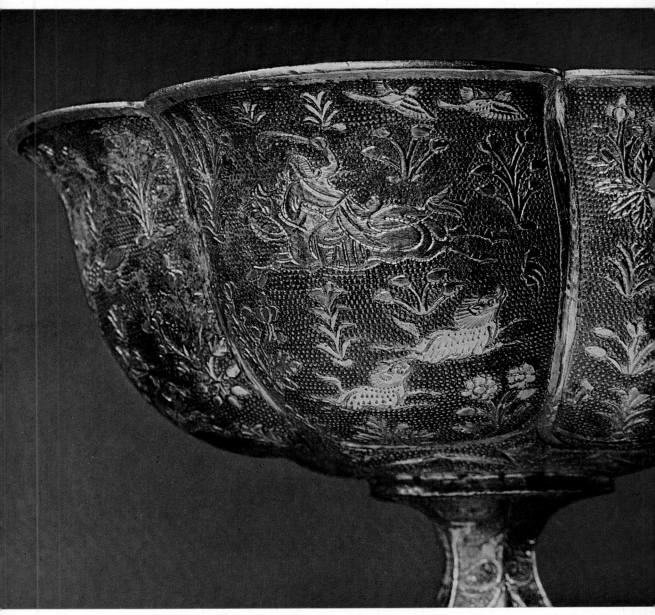

83. *Scenes of the hunt on a six-lobed stemmed cup. Partially gilded silver; height, 5.4 cm. Eighth century, T'ang. Hakutsuru Art Museum, Hyogo Prefecture.*

◁ 82. *Detail from brocade with lion-hunting motifs. Silk brocade. Late seventh century, T'ang. Horyu-ji, Nara.*

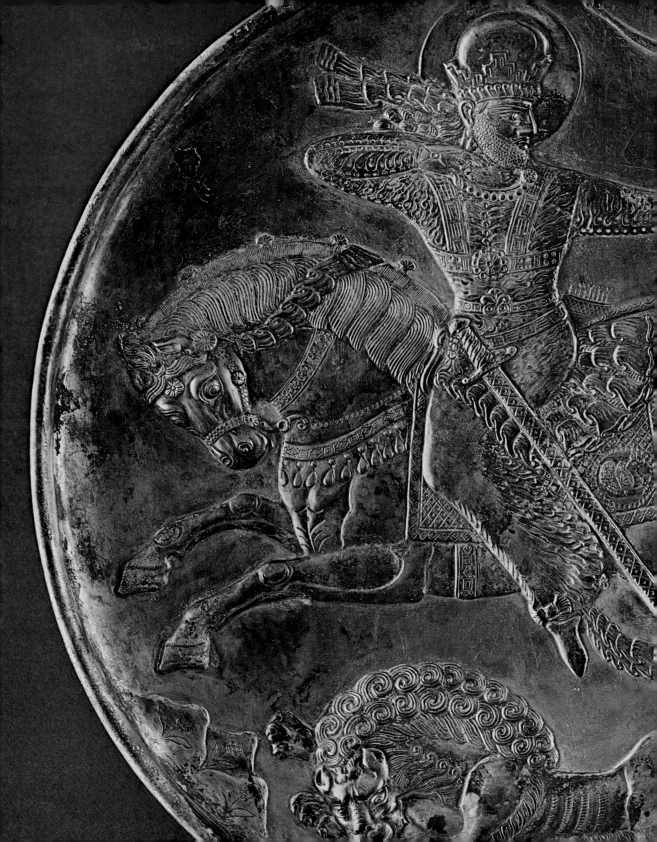

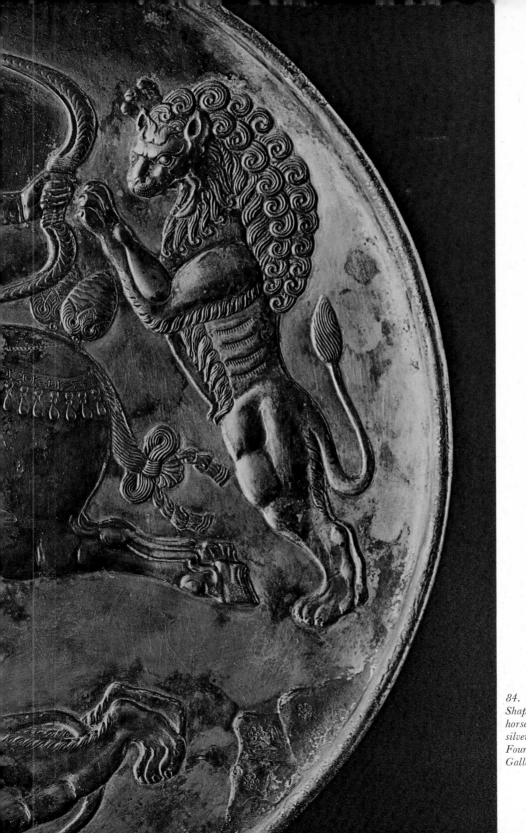

84. Sassanian plate depicting Shapur II hunting lions on horseback. Partially gilded silver; diameter, 26 cm. Fourth century. Idemitsu Art Gallery, Tokyo.

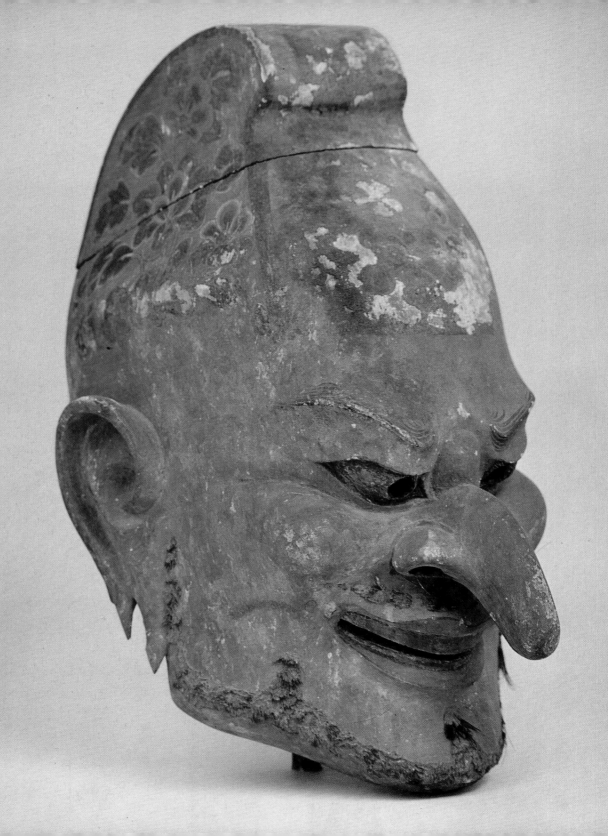

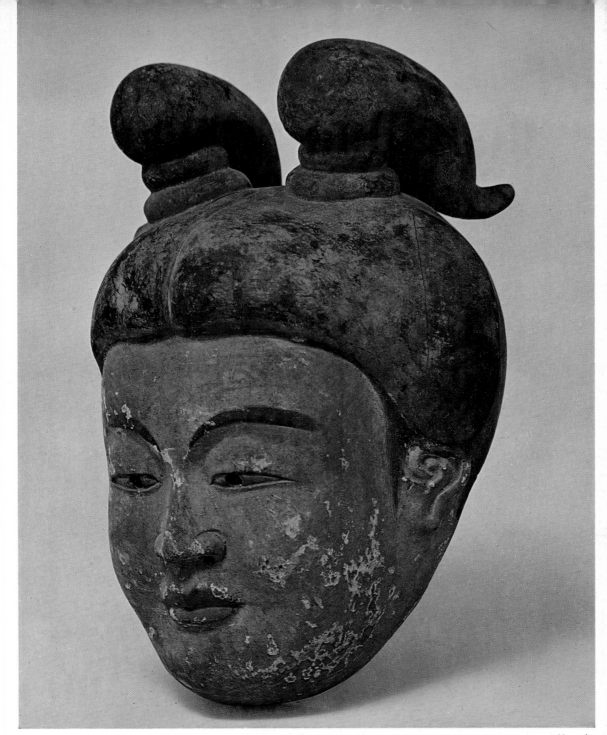

86. *Gigaku mask of the Woman of Wu (Gojo-men). Paulownia wood; height, 34.5 cm. Eighth century. Shoso-in.*

◁ 85. *Gigaku mask of the Drunken Persian King (Suiko-o-men). Paulownia wood; height, 37.7 cm. Eighth century. Shoso-in.*

87. *Lid of lacquered chest with floral and phoenix motifs in oil colors. Inscription reads, "Dedication—cloves and birthwort to Todai-ji at celebration of service." Lacquer on wood; height, 2.8 cm.; length, 45 cm.; width, 30 cm. Early eighth century. Shoso-in. (See also Figure 17.)*

CHAPTER FOUR

The Introduction of Continental Culture

IN THE YEAR 733, the emperor Shomu appointed Tajihi no Hironari to be ambassador plenipotentiary and dispatched an embassy of four ships to the T'ang court. Two of the ships drifted hopelessly off course and were lost in southern waters, and the envoy's ship, the first to return home, did not reach Japan again until November of the following year. The ship's safe arrival was a fortuitous event, for with the ambassador on his return were some Japanese students to China, among them Kibi no Makibi and Gembo, who would later contribute much to the development of Tempyo culture. Two years later, in August, 736, a second ship returned, bringing home the vice-ambassador, Nakatomi no Nashiro. Accompanying Nakatomi was a host of figures who would play prominent parts in the eye-opening ceremony of the Great Buddha at the Todai-ji. Worthy of mention among these were the T'ang priest Tao-hsuan; Bodhisena, the Indian high priest of Buddhism; and the priest Fo-che (in Japanese, Buttetsu) from the ancient Indochinese kingdom of Champa. Others included the T'ang musicians Huang-fu Tung-chao and Huang-fu Sheng-nu, who were accompanied by a lone Persian, Li Mi-i. The Persian's profession is unknown, but like his T'ang companions, he may have been a musician. Whatever the case, it was a significant moment in world history when a Persian from the distant West at last found his way to the isolated islands in the Eastern seas.

THE DIFFUSION OF PERSIAN CULTURE

By the eighth century A.D., Persia's Sassanian empire (224–651), which included most of what is today Iran, Afghanistan, and Pakistan, had succumbed to the Saracen Muslims. Shortly after the last Sassanian defeat in 651, however, the exiled Persian prince Peroz, identified in the *T'ang Shu* (A History of the T'ang Dynasty) as P'ai Lu-chi, established a fortified garrison state at Zereng in Central Asia, known to the Chinese as the Western Region, a vast area then under T'ang control, in an attempt to restore the fallen dynasty. One hundred years later, in 750, the Abbasid caliphate implanted itself and became known as the Neo-Sassanian Empire, winning the support of the Persian people and building its opulent capital, Baghdad, along the banks of the Tigris River. Thus the flower of Persian culture, which had blossomed under the Sassanian rulers, was not left to wither in its native soil. Indeed, despite the suddenness of the transformations wrought by Islam, Persian art prospered, for Arabian culture had no pre-elaborated artistic cannons with which to replace it, and Persian craftsmen were free to continue in their own cultural idiom.

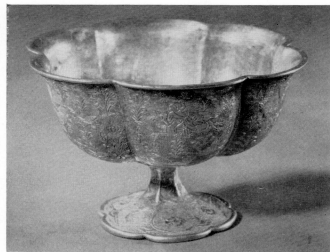

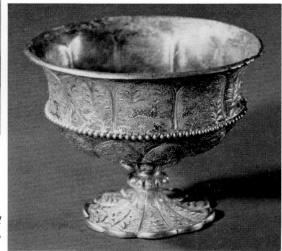

88. Six-lobed stemmed cup with hunting motifs. Partially gilded silver; height, 5.4 cm. Eighth century, T'ang. Hakutsuru Art Museum, Hyogo Prefecture.

89. Stemmed cup with flower, bird, and animal motifs. Partially gilded silver; height, 5.5 cm. Eighth century, T'ang. Hakutsuru Art Museum, Hyogo Prefecture.

Peoples of Persian descent, such as the merchant inhabitants of Sogdiana, an ancient Persian garrison state in Central Asia, were known to the Chinese as *hu-jen* (in Japanese, *kojin*), a term that also denoted foreigners in general. Contemplative "green" eyes flashing and "purple" beards flying in the wind, these hardy traders led innumerable caravans back and forth over the precipitous mountain passes of the Pamir range, the Roof of the World, and across the endless stretches of sand known as the Takla Makan Desert to exchange luxury goods from the West for Chinese silks. The reach and impact of Persian culture was visible everywhere in the oasis towns that flourished along the old Silk Road (Foldout 1).

This ancient route, which connected the center of East Asian civilization with the Roman Empire in the West, had its beginning at the old capital of Ch'ang-an (now Sian) in Shensi and, following the Kansu corridor northwest, ran as far as Tun-huang, where the roads diverged to avoid the Tarim Basin and Takla Makan Desert. They met again at the crossroads town of Kashgar, after which the route scaled the Pamirs and, reaching across the small states that once comprised the Persian empire, finally attained the Roman frontier and the coastal cities of the Mediterranean. Two oasis towns, renowned as the "twin jewels" of Central Asian culture, lay along the northern and southern routes of the Silk Road between Tun-huang and Kashgar. These were Kucha, a town on the northern route of the T'ien Shan South Road, which crossed the desert at the entrance to the Tarim Basin and followed the southern base of the T'ien Shan moun-

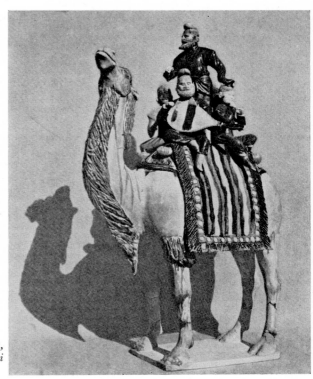

90. *Persian minstrels on camelback. Three-color ware; height, 58.4 cm. 723, T'ang. From tomb of Hsien-yu T'ing-hui near Sian, Shensi Province.*

tains, and Khotan, which lay along the southern route of the same road that skirted the northern foot of the K'un-lun Mountains. Art treasures thought to bear the imprimatur of Sassanian Persia have been found in both cities.

THE PERSIAN VOGUE AT CH'ANG-AN Then at the height of its glory, the T'ang capital, Ch'ang-an, boasted a population of one million and is said to have rivaled Baghdad in the West as the world's most cosmopolitan city. The endless stream of visitors created by arriving and departing emissaries, students, merchants, travelers, artists, and performers from the different countries of the world gave the capital a truly cosmopolitan air. Indians came from the south, and from the north arrived nomadic tribes-

men like the Kirghiz and Uighurs. Travelers from oasis towns in the garrison states of Central Asia were frequent visitors, and others from Japan and the Korean kingdom of Silla in the east also made their way there.

A large number of transient foreigners could be found around the city's western market, just southwest of the imperial palace, and several thousand Persians are said to have lived there shortly after the revolt of An Lu-shan in the mid-eighth century. In the vicinity of the foreign settlement, several churches and temples reportedly stood side by side, representing the foreign religions introduced to China after the seventh century. Among these were the Hsien-tz'u, a Sassanian Zoroastrian temple; the Ta-yun Kuang-ming Ssu, a Manichaean church; and the Ta-ch'in Ssu, a Nestorian church (*ta-ch'in*

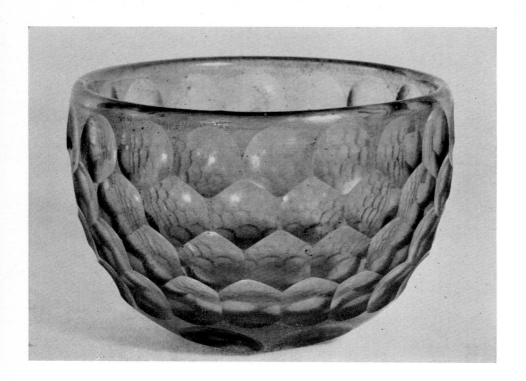

is the Chinese word for Roman Syria). The inscription on a Chinese stele erected in 781 by Ta-ch'in Nestorian Christians in China suggests that many Chinese were counted among the faithful in that day.

The *T'ang Shu* records that palace life during the flamboyant court of Ming Huang was heavily influenced by Persian elements: "Inside the palace, Iranian music is held in high esteem, the tables of persons of noble rank are always served with Persian food, and the women compete with one another in wearing Persian costumes." Persian styles, then, were in vogue at Ch'ang-an and Lo-yang, the capital of some earlier dynasties, and this influence reached even the common people. In Ch'ang-an, for example, round baked "Persian" cakes of wheat flour are said to have been made by Persian bakers and sold throughout the city as the preferred favorite of the commoners. We do not know what kinds of Persian delicacies were served

inside the imperial palace, but wine, like that mentioned in the tenth-century *Yang Tai-chen Wai-chuan* (An Unofficial Biography of Yang Kuei-fei), supposedly presented to Ming Huang's capricious mistress, Yang Kuei-fei, was most certainly prized. The story goes that the wine came from Liang-chou in western Kansu, a Chinese trade town on the Silk Road, and the beautiful courtesan drank the gift of wine in a glass cup that sparkled like seven jewels.

SHOSO-IN There are three glass cups in the
GLASSWARE Shoso-in collection. One of these, a
 modern-looking high-footed goblet
of deep blue *ruri* (Fig. 16), made of crude glass, is decorated with twenty-two cobalt-colored glass rings fused to the outside, and the stem and base are of silver. Several metal vessels like the silver stemmed cups (Figs. 88, 89) owned by the Hakutsuru Art Museum in Kobe, Hyogo Prefecture, have been discovered on the Chinese mainland, but no

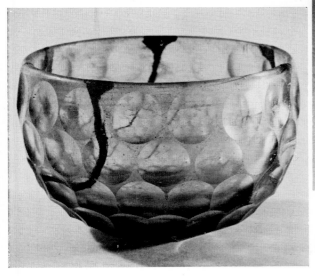

91. Glass bowl with cut facets. Alkaline lime glass; height, 8.5 cm. Eighth century. Shoso-in.

93. Sassanian cut-glass bowl. Alkaline lime glass. Sixth or seventh century. Tenri Museum, Nara Prefecture.

92. Repaired cut-glass bowl. Alkaline lime glass; height, 8.1 cm. Late sixth century. From tomb of Japanese Emperor Ankan. Tokyo National Museum.

glassware has been excavated there. The Shoso-in also owns a transparent amber-colored vessel of cut glass (Fig. 91) whose formal designation is "white *ruri* bowl." Similar objects have been unearthed in fragments near Kucha in Central Asia, but to date none have been found in China. Cutglass bowls such as this have appeared in large numbers in Iranian marketplaces recently, and several like that in Figure 93 have also reached Japan. A round, faceted platter-shaped receptacle held by a stone figurine, discovered in the ruins of the caravan town of Palmyra at the western end of the Silk Road, is apparently made of cut glass, offering evidence that the cut-glass bowls known as "Roman glass" were, as the name implies, used extensively throughout Roman Syria and Sassanian Persia.

In contrast to excavated articles, all of which have whitened or become silvery through exposure to the elements, glassware preserved in the Shoso-in

has retained the freshness and sparkling transparency that characterized it when new. Although damaged, a vessel (Fig. 92) unearthed at the tumulus of the Japanese emperor Ankan (r. 531–35) is a very rare and valuable object, as is the Shoso-in cut-glass bowl to which it is almost identical. These vessels were not, of course, made in Japan but imported from abroad and were probably transported from distant lands by caravans plying the old Silk Road. The wine cup celebrated in the verse of the classical T'ang poet Wang Han, "The exquisite grape wine, the night shining cup," if not of jade was almost certainly made of glass (*ruri*).

The Shoso-in owns another glass cup (Fig. 78) referred to in the records as a "twelve-lobed green *ruri* oblong cup." Yet another of similar shape, an eight-lobed gilt-bronze oblong cup (Fig. 94), is also included in the collection. Such cups are found scattered across the Eurasian continent. The silver

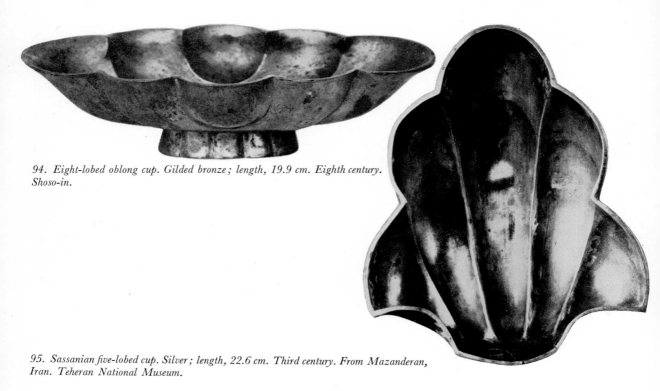

94. *Eight-lobed oblong cup. Gilded bronze; length, 19.9 cm. Eighth century. Shoso-in.*

95. *Sassanian five-lobed cup. Silver; length, 22.6 cm. Third century. From Mazanderan, Iran. Teheran National Museum.*

cup in Figure 79, which belongs to the Hakutsuru Art Museum, was made in T'ang China, but many others of Sassanian origin have been discovered in places as far away as west Poland, south Russia, and more recently, Iran itself. In Japan these cups are owned by the Idemitsu Art Gallery and the Tenri Museum (Figs. 77, 96). These vessels' unusual shape is said to have evolved from the traditional Chinese "eared cup," an oval drinking vessel with an ear-shaped handle at each end. Recently, however, a silver cup was reportedly excavated in Mazanderan, an area in northern Iran on the south shore of the Caspian Sea for a long time under Sassanian rule. The receptacle recovered was in the near half-shape of an eight-lobed oblong cup (Fig. 95), and when two of these are fitted end to end, a fully formed cup is obtained, leading us to believe that the design was probably created by Sassanian artisans. But, comparing the silver cup owned by the Hakutsuru Art Museum with that produced in

Sassanian Persia, one senses in the refinement of technique and the fluid floral arabesques and bird and flower motifs of the former, a munificent yet polished elegance that could only be T'ang in inspiration.

PERSIAN EWERS The Shoso-in owns one glass water pitcher (Fig. 99), referred to as "white *ruri* carafe." Another ewer of similar shape, known as a lacquer *kohei* (literally, Persian vase, Fig. 72), consists of a bamboo basketwork frame (*rantai*) over which cloth has been stretched and several coats of lacquer have been applied. The *Kokka Chimpo-cho* describes the bulbous pitcher, known as *rantai* lacquerware, as follows: "Decorated with bird and flower motifs in silver *heidatsu* inlay. Small silver chain attached to lid which is shaped like bird's head. Holds 3.5 *sho* [about 2.7 liters]." Each of these vessels is distinguished by its slender neck and full, globular body,

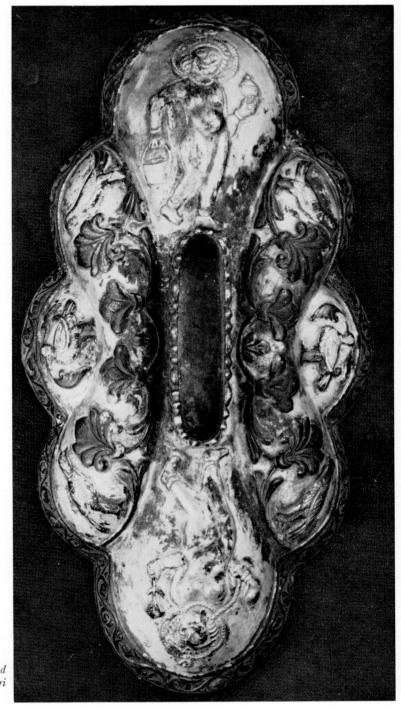

96. *Sassanian eight-lobed oblong cup. Gilded silver; length, 28.2 cm. Sixth century. Tenri Museum, Nara Prefecture.*

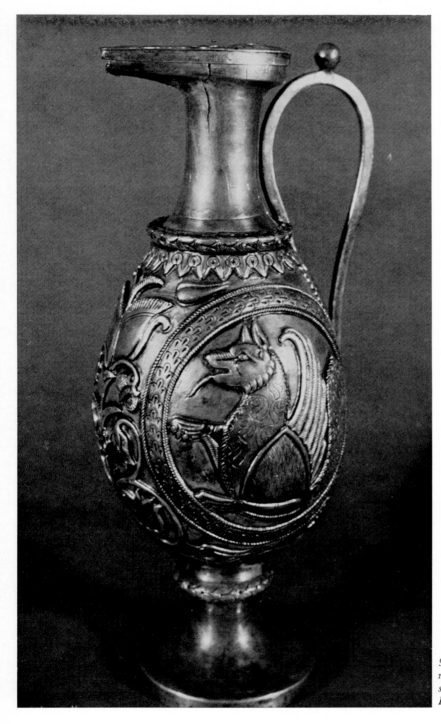

97. Sassanian ewer depicting the mythical Simurgh. Partially gilded silver; height, 33 cm. Sixth century. Hermitage Museum, Leningrad.

98 (left). Sassanian ca-
rafe. Alkaline lime glass.
Sixth or seventh century.
From Gilan, northwest
Iran.

99 (right). White glass
carafe. Height, 27.2 cm.
Eighth century. Shoso-in.

and among those of Sassanian origin are ewers of
glass and metals such as silver and bronze (Figs.
73, 97, 98). Carafes of similar shape are still used
today in Iranian households. Some ewers have
stemmed bases, others do not, but the Tempyo
Japanese made no distinctions and referred to all
as *kohei*, suggesting some awareness of the vessels'
Persian origins.

The archaeological expedition led to Central Asia
by the Kyoto priest Kozui Otani (1876–1948) at
the turn of the century recovered an unglazed Per-
sian ewer (Fig. 100) from the ruins of Kara Khojo
near Turfan. Numerous other examples of ceramic
ware made in this shape (Fig. 101) attest to the wide
popularity of such vessels during the T'ang. Here
we might cite a silver ewer (Fig. 102) with a dragon-
headed spout in the Gallery of Horyu-ji Treas-
ures and a three-color ceramic ewer (Fig. 74) with

a phoenix-headed spout in the Hakutsuru Art
Museum. While the Sassanian vessels are fitted
with relatively simple spouts, those on T'ang ewers
are fashioned to resemble the heads of mythical
phoenixes and dragons. The surface ornamentation
is also transformed into distinctively T'ang motifs.

THE HOUSEHOLD BELONG-
INGS OF AN LU-SHAN

An Lu-shan, the
commoner known
to be of Tur-
kish origin who rose to become a full general
and the imperial favorite of Ming Huang's court,
where Persian fashion reigned, received in the
year 750 a new villa replete with household furnish-
ings as a gift from the fawning emperor and his
courtesan, Yang Kuei-fei. According to the ninth-
century *An Lu-shan Shih-chi* (A Biography of An
Lu-shan), among the gifts were a screen partition

100 (left). Ceramic ewer. Height, 28.5 cm. Seventh or eighth century. From Kara Khojo, Sinkiang Province.

101 (right). Ewer with bird-headed spout and hunting motif. Three-color ware. Eighth century, T'ang. Tenri Museum, Nara Prefecture.

decorated with silver *heidatsu* inlay complete with gilt-bronze fittings; stencil-dyed (*kyokechi*) silk gauze; blinds made of *tsuzure-nishiki*, a weft-patterned brocade; a low bedstead with white sandalwood slats and screen panels decorated with birds, flowers, court ladies, horses, and similar motifs; mattress cushions of red brocade, trimmed with auspicious embroideries, and two-colored silk twill; and mirrors and wooden pillows inlaid with mother-of-pearl. The long list of gift items presented to An Lu-shan on his birthday, celebrated on the first day of the New Year, 751, reads almost line for line like the entries in the Shoso-in's *Todai-ji Kemmotsu-cho*. These include an *obi* decorated with jade plaques and fish-shaped belt ornaments of gold; a tortoise-shell earpick; toilet articles, such as a rhinoceros-horn brush and comb; and a silver washbasin. Other gifts were table utensils, including jade and gilded silver vessels; a platter decorated with flower motifs rendered in gold and a large agate salver; a silver bowl with gilded motifs; a gold *heidatsu* tureen with ladle and large cup; and assorted ceramic cups. An Lu-shan was also presented with many clothes and a generous selection of carpets. One of the presents recorded was an ewer described in the catalogue as a "large silver Persian vase with inlaid gold flowers [*chin-chi-hua*]." *Chin-chi-hua* is thought to refer to a T'ang flower motif inlaid with gold, a technique known in Japan as *kin-zogan*. Whatever the case, the ewer, fitted with a phoenix- or dragon-head spout, must have been a magnificent example of T'ang-style ornamentation.

The fetching smiles of voluptuous blue-eyed Persian beauties, their hair in curls, were not an unusual sight in the taverns of Ch'ang-an during

102. Persian-style ewer with dragon-headed spout and motif of celestial winged horses. Partially gilded silver; height, 49.8 cm. Eighth century, T'ang. Gallery of Horyu-ji Treasures, Tokyo National Museum.

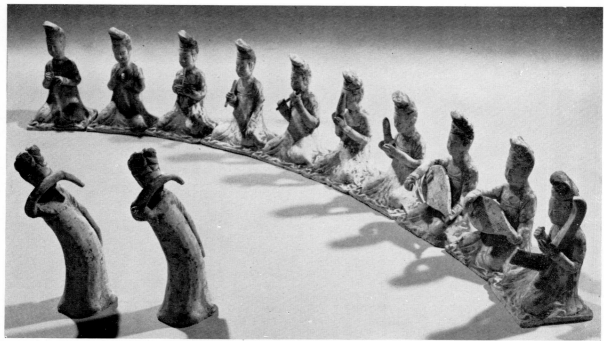

103. Tomb figurines of dancers and orchestra. Ceramic. Eighth century, T'ang.

this period, as this verse, written by the immortal T'ang poet Li Po (701–62), suggests: "Where shall we say adieu? / Why not the Ching-i Gate of Ch'ang-an / Where Persian waitresses beckon with white hands, / Enticing customers to drink their fill of fine wine?"

PERSIAN MUSIC IN VOGUE A passage in the *Yang T'ai-chen Wai-chuan* records the popularity of string and wood-wind concerts at the court of Ming Huang: "The music continued from morning to noon. Ning Wang played the jade flute, the emperor the deerskin drum, Yang Kuei-fei the lute, Ma Hsien-ch'i the chimes, Li Kuei-nien the flageolet, Chang Yeh-hu the harp, and Ho Huai-chih the wooden clappers." The ensemble was composed of woodwinds—the "jade," or marble, flute (*yu-ti*) and the *pi-li*, a strident flageoletlike instrument; strings—the *p'i-p'a* (*biwa*), or lute, and the *k'ung-hou* (*kugo*), or harp; and percussion instruments—the *chieh-ku*, a horizontal drum; the *fang-hsiang*, a glockenspiellike set of chimes; and the *p'o-pan*, or wooden clappers. Together these must have produced some very lively airs indeed.

The emperor Ming Huang was fond of singing, dancing, and music making, and his own musical skills are reputed to have rivaled those of the professionals. Inside the court was a special institute for the dramatic and musical arts, the *Li Yuan*, or Pear Garden, where the emperor himself is said to have taught, and even today, *li yuan* and its Japanese equivalent, *rien*, denote the world of the theater. Court banquets of the period were enlivened with popular music of ancient origin commonly performed with *hu-yueh*, "Iranian mu-

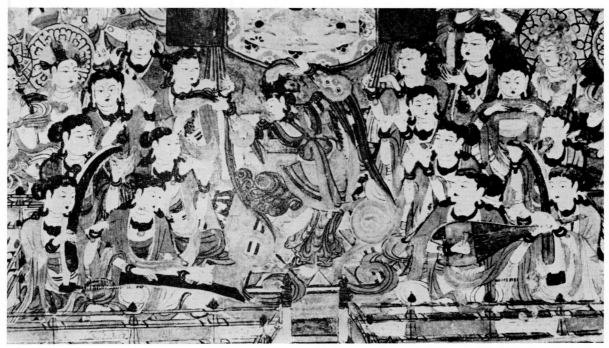

104. *Wall painting of orchestra and dancers. Mid-tenth century (Five Dynasties period). Cave 98, Tun-huang, Kansu Province.*

sic," from Central Asia. This music was composed primarily of Iranian elements, and in particular of Sogdian and Kuchan forms, but it also incorporated influences from India and Champa. This music achieved such wide acclaim in T'ang times that the ninth-century poet Wang Chien wrote, "The families of Lo-yang learn Iranian music."

Among the oasis towns dotting the T'ien Shan South Road, the northernmost trade route crossing the Tarim Basin, Kucha was renowned as a center of music. The prominent position enjoyed by Kuchan forms in the Persian music of the T'ang is suggested by an anecdote of the period. Ming Huang, watching the sweat pour off Ning Wang, his elder brother, as he practiced the drum to a Kuchan score in the heat of a summer's day, is said to have remarked lightly, "The emperor's elder brother has gone quite mad over music."

Descriptions of court orchestras were recorded in musical notices of the period like those in the *T'ang Shu*, but the tomb figurines dancing and playing instruments in Figure 103 and the musicians depicted in a paradise scene (Fig. 104) from a wall fresco in one of the Tun-huang cave temples give us a firsthand idea of the composition of such orchestras. The lifelike statuettes bring the imperial household music of the Pear Garden into our very presence, and we can almost hear the rhythmical chime of the *fang-hsiang* lending its clear, metallic, glockenspiel ring to the melody carried by the string and wind instruments. Not one of the original instruments used to perform this music has survived in China, but the Shoso-in collection fortunately preserves several that date from the Tempyo period, and these constitute a priceless historical record of East Asia's musical heritage.

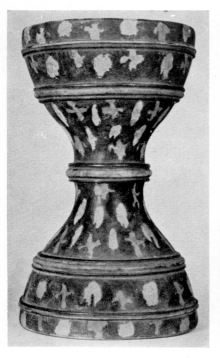

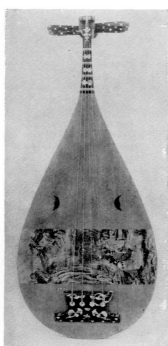

105 (far left). Ceramic drum. Three-color ware; length, 38.1 cm. Eighth century. Shoso-in.

106 (left). Lute with plectrum-guard painting of musicians on elephantback. Maplewood and hide; length, 97 cm. Eighth century. Shoso-in. (See also Figure 121.)

107. Detail of reliquary depicting a troupe ▷ of musicians. Seventh century. From Kucha, Sinkiang Province. Cultural Properties Protection Commission, Tokyo.

SHOSO-IN INSTRUMENTS AND T'ANG COURT MUSIC

The most representative stringed instruments used in Iranian music are the *biwa* lute and the *kugo,* a vertical harp. Two types of *biwa* are known, one with four strings and one with five. The five-stringed *biwa* with ornamental mother-of-pearl inlay in Figures 44 and 45 is the world's only surviving example of an ancient Indian lute. The neck is straight and the body slender. The back of the instrument is decorated with bird and flower motifs, rendered in mother-of-pearl and tortoise shell, and on the plectrum guard (Fig. 28) the figure of a Persian on camelback is seen strumming a four-stringed *biwa* beneath a tropical tree.

The Shoso-in owns five four-stringed lutes, one of which, a mother-of-pearl and maplewood *biwa,* is shown in Figure 106. All five are Persian pear-shaped lutes with curved necks and large, full bodies. The Chinese *p'i-p'a,* from which the Japanese *biwa* derives, is itself the phonetic transcription of the old Persian word *barbat,* which originally denoted a four-stringed lute. The figure of a musician playing such a lute is found on a Sassanian silver platter, and a winged child playing the same instrument is painted on the lid of a reliquary brought back from Kucha by the Otani expedition. However, the famous musician of the day, Po Ming-ta, a native of Kucha and well known for his rendition of the classical melody "The Spring Nightingale Sings," is reputed to have played the five-stringed lute with consummate skill.

The Shoso-in preserves only the partial remains of a *kugo,* but its restoration gives a reasonably accurate idea of the original shape and construction (Foldout 1). The large, vertical *kugo* used at the T'ang court is immediately recognized as a variety of harp. The origin of the harp is of great antiquity.

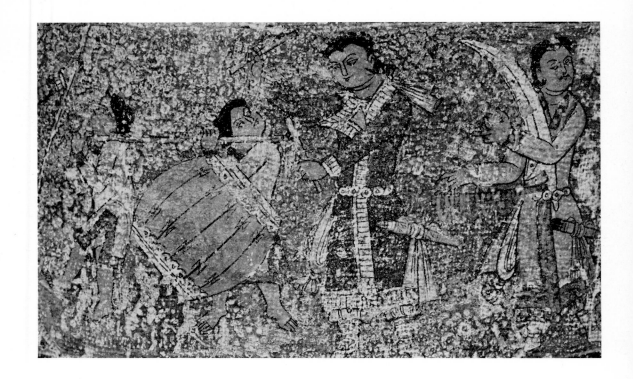

In West Asia, terra-cotta relief carvings belonging to the Isin-Larsa period and dating from the second millennium B.C. show musicians playing this instrument. Later examples of harp players are found in the relief sculptures in the palace ruins of Nineveh, the ancient Assyrian capital, which date from the seventh century B.C.; in floor mosaics in the Sassanian palace of Bishapur in southwestern Iran; and in the famous relief scenes of the King's hunt on cut-rock Sassanian monuments at Taq-i-Bustan in northwestern Iran. These early works of art attest to the great age of this musical instrument. In Central Asia, harp-carrying musicians are seen on a Kuchan reliquary (Fig. 107), and similar themes are found in China after the Northern Wei (386–535), as evidenced by the wall frescoes in cave temples at Tun-huang and the sculptured images in cave chapels carved from Yun-kang's sandstone cliffs in north Shansi.

One of the musicians frequenting the Pear Garden at Ming Huang's court was the brilliant harpist Li P'ing. Under the spell of Li's playing, the famous court poet Li Ho (791–819) was moved to write: "Li P'ing strums his harp / In the Middle Kingdom. / As jade crumbles on Mount K'un-lun / And the phoenixes cry, / As the lotus weeps dew / And fragrant orchids smile, / Even the cold glare of light / Before Ch'ang-an's twelve gates / Is softened, / And the sound of twenty-three strings / Moves the heart of His Celestial Majesty."

Li P'ing, who had been bestowed the T'ang imperial surname of Li, appears to have been a Persian, but his actual origins are uncertain. The twenty-three-stringed harp was probably tuned to the full chromatic scale, making Li P'ing's virtuoso performance a most memorable one.

The Shoso-in owns several other wind instruments including *sho* mouth organs (in Chinese,

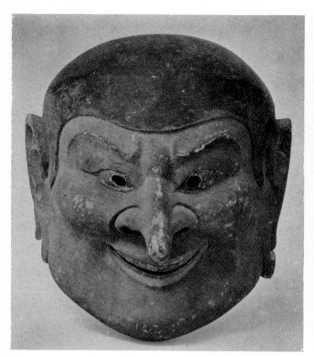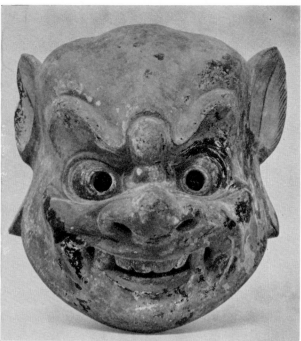

sheng), *shakuhachi,* and transverse flutes (Fig. 46); percussion instruments, such as *hokyo* chimes and horizontal hip drums; and a number of traditional Chinese stringed instruments including *ch'in* citterns (in Japanese, *kin*) and banjo-shaped *genkan* (Fig. 25). Yuan Hsien (in Japanese, Genkan) was one of the Seven Sages of the Bamboo Grove honored in Chinese folklore, and the circular, flat-bodied, four-stringed instrument with the long neck is thought to have been named after him sometime during the T'ang. Used in Japan during the Nara period (646–794), these instruments reflect in a general way the type of music heard in the T'ang court. The Champa priest Buttetsu, who oversaw the Bugaku performance at the eye-opening celebrations, is said to have lived at Nara's Daian-ji temple, where he trained novice musicians. Buttetsu may have been an expert in T'ang court music,

and the elegant, aristocratic Gagaku performed at the Heian court (794–1185) and still heard in Japan today may very well derive from the T'ang court music taught by the foreign priest.

GIGAKU MASKS Masks were used in certain Bugaku dance performances, such as *The King of Lan-ling,* which was also known as *Dai-men* (The Great Mask). The Shoso-in, as we noted earlier, preserves as many as 171 masks used in Gigaku. Gigaku, also known as *kure-uta* (literally, Wu singing), was introduced to Japan in 612 during the Asuka period (552–646) by Mimashi, a Korean from the kingdom of Paekche, and is said to have originated in the ancient Chinese state of Wu and the provinces to the south of the Yangtze (present-day Anhwei, Kiangsu, and Chekiang). Numbered among the collection of Gigaku masks are the

108 (opposite page, left). Gigaku mask of the Gentleman of Wu (Goko-men). Paulownia wood; height, 27.3 cm. 778. Shoso-in.

109 (opposite page, right). Gigaku mask of K'un-lun (Konron-men). Paulownia wood; height, 32 cm. Eighth century. Shoso-in.

110. Cloth mask. Hemp; length, 36 cm.; width, 37 cm. Eighth century. Shoso-in.

effigies of men and women who appear to be Chinese, such as Wu-kung (in Japanese, Goko, Fig. 108), or the Gentleman of Wu, and Wu-nu (in Japanese, Gojo, Fig. 86), or the Woman of Wu. But several masks with their long noses and weird looks have distinctly foreign faces, and Chinese masked dances alone do not appear to explain their existence.

On the day of the eye-opening ceremony at the Todai-ji, dancers wearing Gigaku masks, together with entertainers performing Gagaku, Bugaku, and Sangaku, paraded in front of the Great Buddha. Masked dances, however, do not appear to have been included in the performances, and the Gigaku troupe may simply have followed along as part of the retinue. Gigaku employed only certain instruments, such as flutes, hip drums, and small cymbals (*dobatsu*), and it is possible that the masked drama

originally evolved from a variety of masked drum-and-fife band. This is suggested, for example, by a ritual procession, the *hsing-hsiang* (in Japanese, *gyozo*), held in China during the Northern Wei to celebrate the birthday of the Buddha. A lion mask was always at the head of the parade, and also present was a red-faced mask with pointed nose known in Chinese as *chih-tao*, or the guide, which is believed to be the prototype of the *tengu*, Japan's long-nosed goblin. Since Gigaku was associated with this type of Buddhist observance, it is not surprising that it should have adopted elements of foreign dress or that its masks should have assumed outlandish features as the dance traveled northward from India through the Western Region of China and eventually to Japan.

Although relatively little is known about Gigaku as it was actually performed during the Tempyo,

property registers belonging to the Horyu-ji and other monasteries tell us that Todai-ji was not the only temple to own such masks. Judging from surviving masks, early records, and a notice concerning Gigaku in the *Kyokun-sho,* a thirteenth-century, ten-volume compilation on music, the parade appears to have been followed by various dances and performances. The first was the lion dance (*shishi-mai,* Fig. 112) followed in succession by the courtly Wu-kung (in Japanese, *goko-mai*) with its Chinese airs; a quick ring-dance featuring the fabulous fire-breathing bird Garuda (*karura-mai*); a *vajra,* or thunderbolt, dance (*kongo-mai*); and others, depending on the ritual occasion at the temple. With the Brahmin dance (*baramon-mai*) that came afterward, the performance gradually took on the comical dimensions of a farce. The "Brahmin" mimicked an Indian high priest and, when he danced, waved long, flowing pieces of cloth about. But the elaborately ritualized gestures of the punctilious priest appear to have resembled nothing so much as an old man washing diapers, transforming the mime into a comic burlesque.

In the K'un-lun dance (*konron-mai*) that followed, the bestial K'un-lun (Fig. 109) falls in love with the T'ang beauty Wu-nu and is reproved by the half-naked guardian Li-shih, the popular hero of the Li-shih dance (*rikishi-mai*). K'un-lun was the Chinese word originally designating the lands to the south of China. Dark-skinned slaves with curly hair, taken from this southeast Asian region and known to the Chinese as *k'un-lun nu,* were used at the T'ang court, and the fierce-looking demons on which are seen standing the statues of the Four Celestial Guardians are said to be the same. The K'un-lun farce, then, is the story of a lowly male slave who succumbs to the charms of a Chinese noblewoman, provoking laughter by his outrageous situation. K'un-lun was followed by the T'ai-ku performance (*taiko-mai*), which featured an old man, T'ai-ku-fu, with pointed Persian cap, who, aided by a young boy, T'ai-ku-erh, offers prayers to the Buddha. The Chinese character for *ku* (in Japanese, *ko*), meaning orphan, may once have signified "Persian."

The last comic drama was that of the drunken

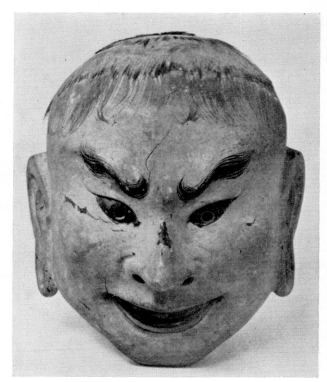

111. Gigaku mask of a retainer. Height, 26.1 cm. Eighth century. Shoso-in.

Persians, performed by eight actors and starring the Drunken Persian King, Tsui-ku-wang (Suiko-o, Fig. 85), and his attendant, Tsui-ku-ts'ung. In this act, the bearded king with hook nose and sunken eyes, wearing a splendid hat and crown, indulged in a rollicking, drunken free-for-all with a supporting cast of retainers (Fig. 111). As the languid dance, punctuated with slow leaps, picked up tempo, the actors shed their inhibitions and behaved in a thoroughly uproarious manner, probably drawing enthusiastic cheers from the delighted spectators.

It is not known whether the masked Gigaku dances are in any way related to the Greek dramas dedicated to the deity Dionysius, but they were

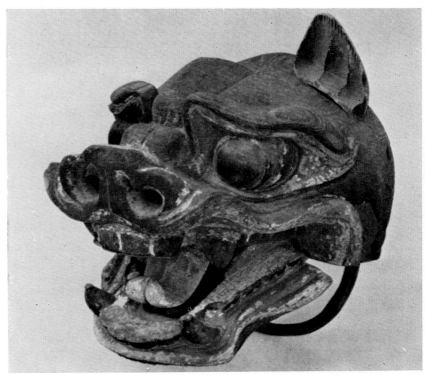

112. Gigaku mask of lion (Shishi-men). Paulownia wood; height, 38 cm. Eighth century. Shoso-in.

immensely popular in the Central Asian city of Kucha. On the reliquary brought back from Kucha, the figures of men wearing masks of animals and crown-bearing, bearded Persian kings are depicted holding hands and dancing to the music of horn flutes, large folk drums, and harps. Gigaku was brought to the T'ang court from Central Asia as a syncretic mixture of popular musical forms, and the celebrated T'ang poet Po Chu-i (772–846) immortalized in verse a Gigaku troupe from the city of Liang-chou on the ancient frontier of west China: "Skilled dancers from Hsi-liang, / Persian masks and lion masks. / The heads are carved of wood, / The tails are woven with thread. / Pupils are flecked with gold / And teeth capped with silver. / They wave fur costumes / And flap their ears / As if from across the drifting sands / Ten thousand miles away."

The eye-opening ceremony inaugurating the Todai-ji's Great Buddha stands as the central event of the Tempyo period, the flower of early Japanese culture. Sixty Gigaku performers and drummers are said to have made their appearance on that day, but the guests of honor were the masks worn by performers who trouped proudly before the image of the Great Buddha to the spirited accompaniment of drums and fifes. Having scaled the high Pamir plateau and crossed the Takla Makan Desert, these foreign envoys had reached their final destination, Nara, the last stop on the Silk Road.

CHAPTER FIVE

Shoso-in
Motifs and Designs

A MULTIPLICITY OF DESIGNS The infinite variety of motifs that decorate Shoso-in treasures belong, of course, to the mainstream of early Japanese art during the Asuka, Hakuho (646–710), and Tempyo periods, and for this reason might also be designated Tempyo or T'ang motifs. Those used in Shoso-in designs, when classified, present nothing out of the ordinary, consisting primarily of geometric patterns, representations of natural phenomena, and plant and animal forms, but there is such a diversity of types that it would be a difficult task even to name them all. This is particularly true of plant and animal motifs, which include not only genuine species but imaginary ones as well. The Shoso-in motifs can be divided into four distinct types:

1. Geometric forms. These include lozenge-shaped patterns (*hishi-gata*), checkered plaids (*ichimatsu*), cross-hatching (*igeta*), serrated patterns (*kyoshi-mon*), beaded roundels (*renju-mon*), floral patterns, angular patterns (*ryo-gata*), tortoise-shell designs (*kikko*), and patterns derived from fletching (*yabane*) (Figs. 32, 113, 156).

2. Representations of natural phenomena, such as mountains, rivers and oceans, clouds, sun, moon, and star motifs (Figs. 66, 122).

3. Animal forms. These include both real and imaginary species. Real species are birds, such as peacocks, parrots, mandarin ducks, cranes, wild ducks, wild geese, hawks, golden pheasants, and other small birds (Figs. 26, 36, 37, 115, 119, 167); such animals as lions, tigers, camels, mouflon, antelope, elephants, rhinoceroses, deer, monkeys, horses, hares, foxes, dogs, wild boars, rats, and others (Figs. 27, 114, 120, 130, 171); insects, including dragonflies and butterflies; and aquatic creatures, such as fish and turtles (Fig. 40). Imaginary bird species include phoenixes, birds holding a spray of flowers or a jeweled streamer in their beaks, and human-headed Kalavinka (Figs. 116–18); imaginary animal species are dragons, celestial winged horses, *ch'i-lin* (a griffinlike creature), fabulous lionlike beasts, flower-horned deer, and the twelve animals of the zodiac (Figs. 6, 12, 169, 170).

4. Plant forms. These also are represented by real and imaginary species. Real species include the pine, bamboo, plum, wisteria, ivy, Chinese miscanthus, lily, violet, tree peony, field peony, lotus, hemp palm, date palm, and grape (Figs. 26–28). Imaginary species include T'ang arabesques (*karakusa*) composed of palmette, grape, and pomegranate motifs; highly stylized forms of lotus blossoms, *hosoge* (an imaginary flower based on peony), and peonies; and sacred trees, such as various flowering trees and the Bodhi tree (Figs. 14, 31, 44, 45, 123, 125, 129).

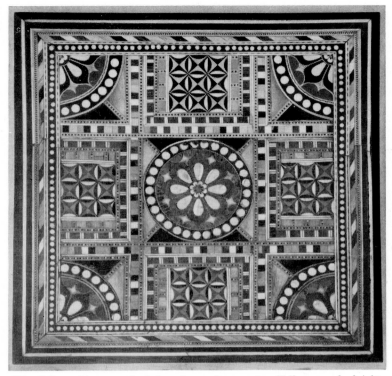

113. Coffret with geometric designs in wood marquetry. Zelkova wood; height, 17.5 cm.; length, 23.5 cm.; width, 23.5 cm. Seventh century, T'ang. Imperial Household Collection. (See also Figure 205.)

THE COMPOSITION OF SHOSO-IN MOTIFS When we consider the arrangement of these numerous motifs, we discover such an extensive range of variations, from simple compositions to complex composites, that the actual makeup of each design is not easily discerned. However, a general analysis distinguishes designs with pure patterned compositions and those closer to pictorial representations. The following are the primary arrangements found.

HERALDIC SYMMETRY. In this group are motifs featuring a pair of birds, animals, or mounted hunters set in opposition around a centrally positioned sacred tree. Similar symmetrically placed plants and animals are found in other examples but in simpler arrangements lacking a central motif (Figs. 27, 119, 130, 170).

ALIGNED COMPOSITION. These designs make use of one basic motif, which is repeated in rows, such as the flower patterns inlaid with mother-of-pearl on the five-stringed *biwa* (Figs. 44, 45). Other examples are the ivory footrules (Figs. 36, 37) in which various flower, plant, animal, and bird motifs are juxtaposed in alternating intervals. Others, such as the white marble slab in Figure 172, combine two different motifs, which are intertwined to form one design. This particular design is believed to derive from the art of the nomadic tribes of western and northern Asia, where it was widely employed.

CIRCULAR COMPOSITION. Included here are de-

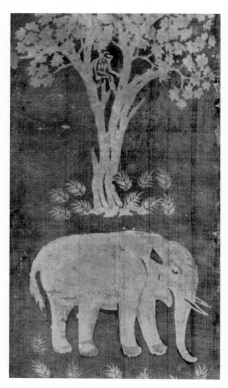

114. Detail from wax-dyed screen with elephant and tree motifs. Plain-weave silk; length, 163 cm.; width, 57 cm. Eighth century. Shoso-in.

signs enclosed by pearl-studded roundels and arabesques, such as that on the blue Shoso-in brocade with lion-hunting scenes (Fig. 13), that are seen frequently on textiles (Fig. 82). Other motifs in this category include pairs of birds chasing each other in flight, such as the playful parrots inlaid with mother-of-pearl on the red sandalwood *genkan* in Figure 25.

PICTORIAL COMPOSITION. Among these are scenes from the Land of the Immortals like that on the eight-lobed mirror in Figure 66, decorated with the Eight Divinatory Trigrams and landscape; idyllic scenes of paradise, as found on the lacquered ewer in Figure 72; and hunting scenes, such as those on the silver jar in Figures 54 and 55. In each of these examples, different motifs are scattered across the design surface in profusion, and the effect achieved is more pictorial than decorative.

Here we should note that several of these arrangements are actually composites, as for example the dispersed but picturelike composition on the gold and silver *hyomon kin* (Figs. 7, 10), which graphically blends human figures sitting opposite one another under trees, with plant life, birds, insects, clouds, and other motifs to produce one synthesized design.

A TREASURY OF T'ANG ARABESQUES It would be quite impossible to catalogue the profuse and heterogeneous assemblage of Shoso-in motifs, and it might be more profitable to limit our attention to the rich abundance of imaginary plant designs found in the collection. The Shoso-in is a veritable treas-

115. Red lacquer Chinese chest with peacock motifs. Lacquer on wood; height, 48.4 cm. Eighth century. Shoso-in.

ure-trove of exotic rinceau forms, known in Japanese as *karakasa,* or T'ang arabesques. Although *kara* literally means "T'ang," this term is used to denote anything foreign to Japan, and hence *karakusa* includes plant patterns from more distant lands as well. The billowing *karakusa* painted on the small *mistuda sai-e* chest with oil-color designs in Figures 17 and 87, their slender fanlike fronds parting left and right to a gentle cadence, are superb examples of this work. A Chinese touch is apparent here, but traces of palmette arabesques, which evolved out of the Egyptian and, later, the Greco-Roman traditions, have been faithfully if somewhat unexpectedly preserved. This type of arabesque is generally known in Japan as *nindo,* or honeysuckle, but it does not in fact represent any specific variety of vine, being an entirely imaginary plant form. In keeping with international usage, we are best advised to retain the more common name, palmette. Western palmette arabesques and lotus motifs from India were brought to China during the period of the Northern and Southern dynasties (c. 317–589), where, undergoing a variety of changes, they eventually produced a unique and distinctive floral culture.

Grape and pomegranate arabesques, portrayed with representations of real leaves, were in wide use from the late Northern and Southern dynasties period through the Sui (581–618) and T'ang periods. In Japan, Tempyo artisans, taking foreign-made mirrors, such as those depicting bird, animal, and grapevine scroll motifs (Figs. 9, 143), and grape-patterned *nishiki* brocades as their models, added decorative grape arabesques to the pedestal

116. *Ornamental piece with phoenix pattern. Gilt bronze; height, 78.5 cm. Eighth century. Shoso-in.*

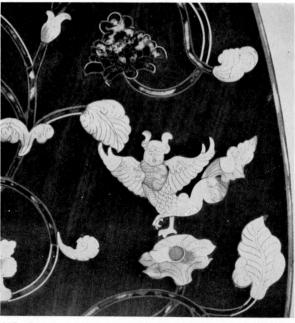

117. *Detail of back of lute showing Kalavinka, a mythical human-headed bird of Indian origin, and arabesques. Red sandalwood, chestnut, and algae; full length, 99.6 cm. Eighth century. Shoso-in.*

118. *Brocade with phoenix and arabesque motifs on wine-colored ground. Detail from armrest. Silk brocade; length, 78.2 cm. Eighth century. Shoso-in.* ▷

(Fig. 129) of the main image at the Yakushi-ji temple in Nara and many other works with their own hands. Mirrors with animal and grapevine designs employ a composite of grape arabesques, birds, and animals that shows the influence of Sassanian silver plates. The Shoso-in's wine-colored *nishiki* with phoenix design covering an imperial armrest (Fig. 118) also displays grape arabesques, here encircling a flying-phoenix motif, and this design, which features birds or animals enclosed inside large roundels, may also be considered a legacy of Sassanian art (Foldout 2).

Karahana, the highly stylized Chinese flower designs, the most notable of which are the imaginary *hosoge,* or flowers of precious appearance, must

not be omitted from our discussion of T'ang plant motifs. One remarkable example is the eight-lobed *heidatsu* mirror box in Figure 127. Here floral arabesques enclose a series of fragile phoenixes in wreathlike roundels arranged around the outer edges of the box, while in the center, an elegant *karahana* unfolds its lotus-shaped blossoms. Should we venture to pluck one of these delicate flowers from its garden bed, however, we would be surprised to find its petals transformed from fanlike palmette leaves.

T'ang flower motifs, in addition to grape, pomegranate, and lotus-blossom rinceau designs, also assimilated real flowers, particularly the common tree peony, which produced a refined, almost

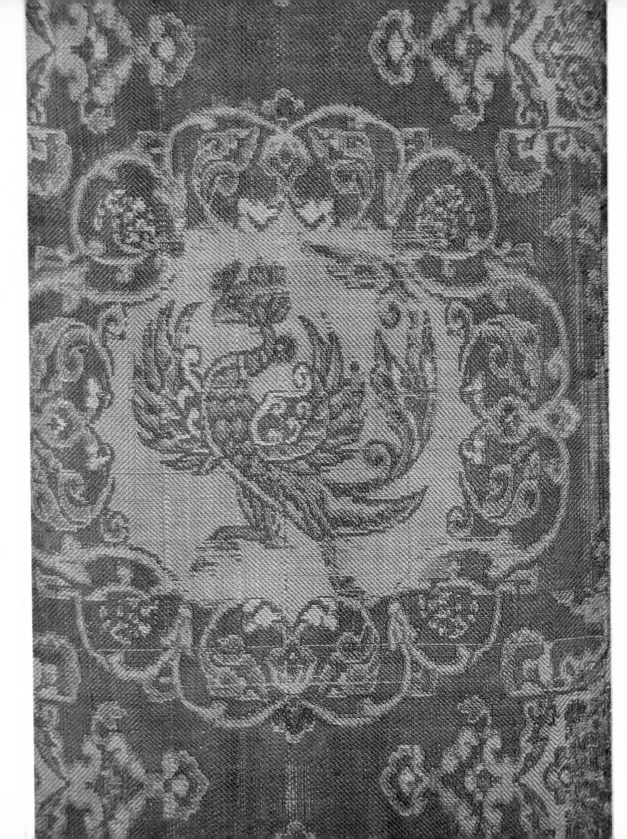

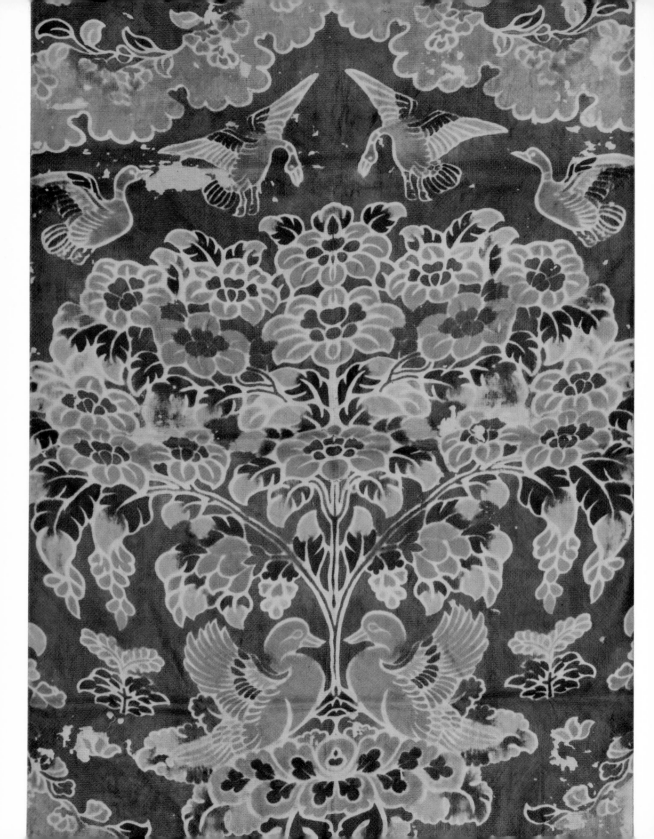

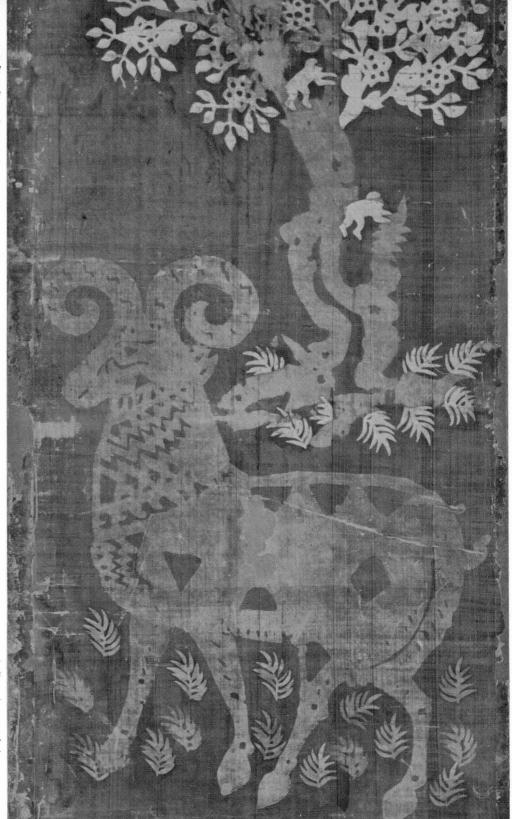

119. Detail of offering cushion of plain silk with stencil-dyed (kyokechi) *motifs of flowering tree and birds on dark blue ground. Plain-weave silk; height, 104 cm.; width, 53.5 cm. Eighth century. Shoso-in.*

120. Detail of folding-screen panel with wax-dyed (rokechi) mouflon and tree motifs. Plain-weave silk; height, 163.5 cm.; width, 56.5 cm. Eighth century. Shoso-in.

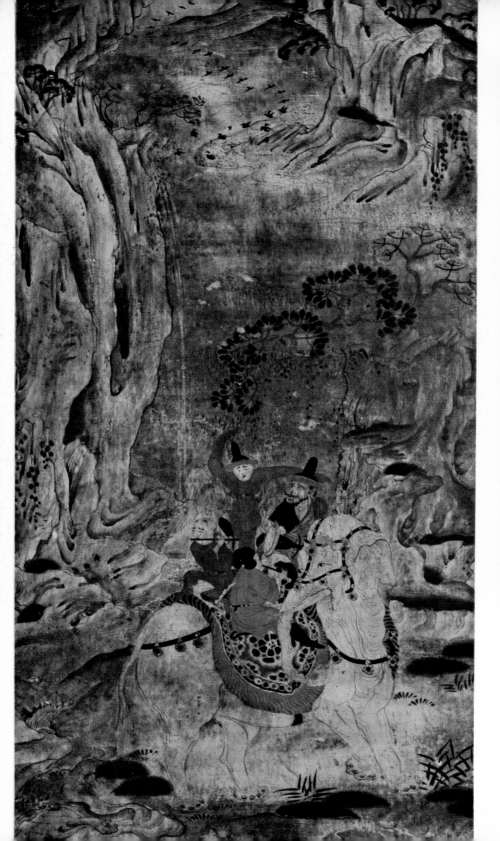

122. *Detail of sapan-stained coffret with gold and silver* kingin-e *landscape. Black persimmonwood; length, 38.8 cm. Eighth century. Shoso-in.*

◁ 121. *Detail of plectrum guard on sapan-stained maplewood lute with painting of musicians on an elephant. Hide and maplewood; height, 40.5 cm.; width, 16.5 cm.; length of instrument, 97 cm. Eighth century. Shoso-in. (See also Figure 106.)*

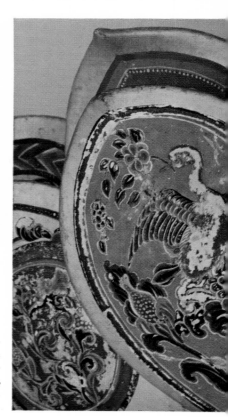

123 (left). Lacquer scabbard for Chinese sword mounted with ornamental arabesques in silver openwork. Silver, lacquer on wood; length, 98 cm. Eighth century. Shoso-in. (See also Figure 189.)

124 (right). Lid of box decorated with gold motifs, wood marquetry, and rectangular plaques with paintings of flowers and animals using transparency techniques. Aloewood, red sandalwood, rock crystal, and ivory; length, 33 cm. Eighth century. Shoso-in. (See also Figure 166.)

125 (right). Detail of lotus-flower-shaped pedestal of incense burner. Lacquer, wood, and bronze; diameter, c. 56 cm.; length of petals, c. 18 cm. Eighth century. Shoso-in. (See also Figures 60, 128.)

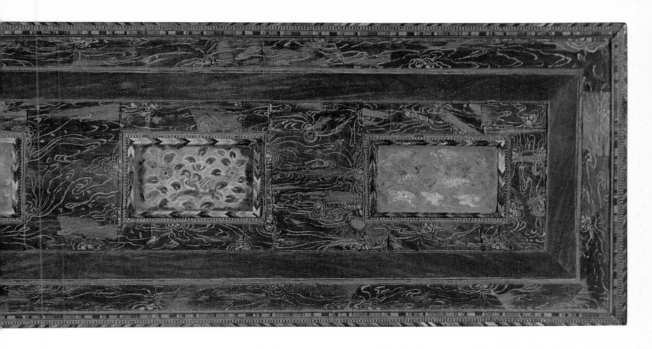

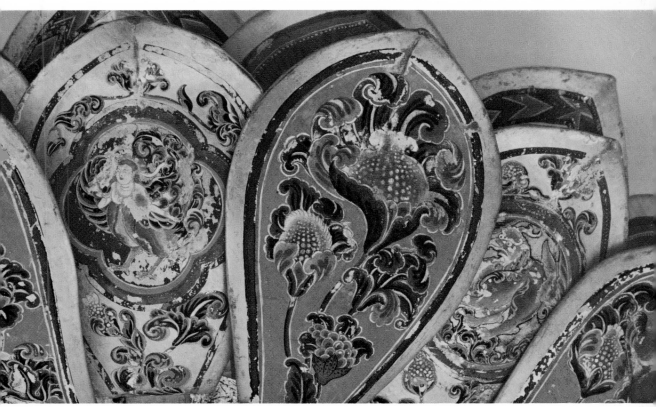

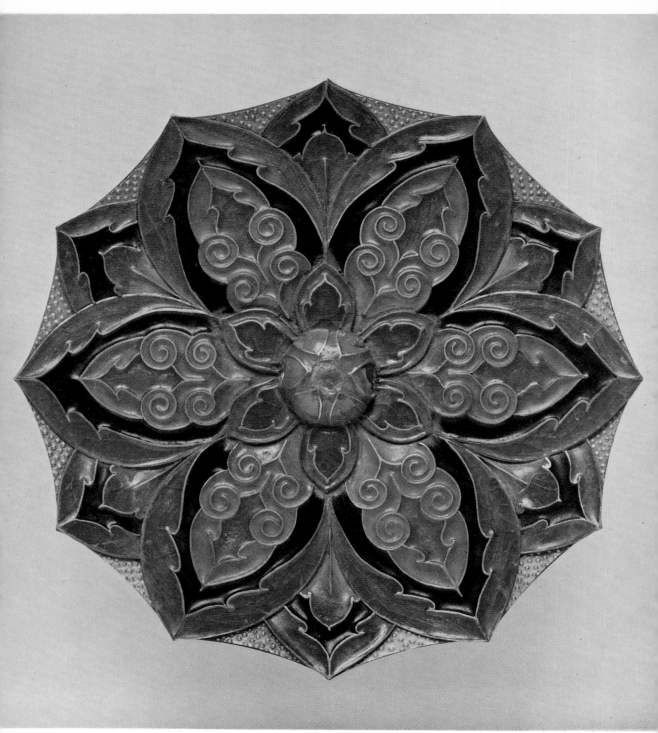

126. Twelve-cusped-arc gold- and glass-backed cloisonné mirror. Silver; diameter, 18.5 cm. Eighth century, T'ang. Shoso-in.

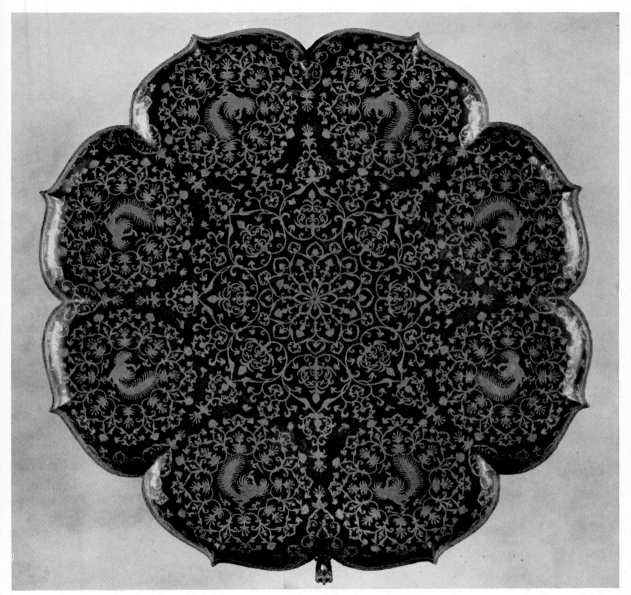

127. *Octagonal bracket-edged box with* heidatsu *ornamentation of phoenixes and arabesques. Lacquer on wood; diameter, 36.5 cm. Eighth century. Shoso-in.*

128. Hosoge *motif on lotus-flower-shaped pedestal. Lacquer, wood, and bronze; full height, 17 cm.; length of petals, 18 cm. Eighth century. Shoso-in. (See also Figures 60, 125.)*

129. *Section from the pedestal of the Yakushi image showing* ▷ *grapevine and rinceau motifs. Bronze; height of pedestal, 150.7 cm. Seventh or eighth century. Yakushi-ji, Nara.*

sensuous hybrid, the *hosoge*. These imaginary flowers figure prominently on the lotus-flower-shaped pedestal used to offer burning incense to the Buddha (Figs. 60, 125, 128). Each of the thirty-two petals radiating from the base is covered in gold leaf on which lions, phoenixes, and *hosoge* have been painted in brilliant colors. While the *hosoge* are quite clearly a variety of tree peony, the fruit in the center of each cluster of petals is treated in a manner that strongly suggests a pomegranate or grape cluster.

Floral decorative art blossomed during the T'ang dynasty, attaining a splendid perfection. A multitude of flower shapes were used for mirrors, utensils, furniture, and the art used to decorate them, and the endless array of designs offered by the Shoso-in treasures reflects the florescent beauty of T'ang-dynasty art, arousing our enduring interest.

THE STYLE OF THE DUKE OF LING-YANG

During the reign of the Chinese emperor T'ai-tsung (627–49), a government official named Tou Shih-lun was made the Duke of Ling-yang in acknowledgment of his remarkable success in designing costumes and ornamental accessories for the court. A T'ang-period document records that "motifs of *tui-chih* [brace of pheasants], *tou-yang* [fighting ibexes], *hsiang-feng* [phoenix on the wing], and *yu-lin* [strolling *ch'i-lin*] for auspicious brocades in the repository were first used by Shih-lun," and that the people of Shu (present-day Szechwan), a center of the dyeing and weaving industry, referred to the brocaded silk motifs as being in the Duke of Ling-yang style.

The *tui-chih* motif probably depicted a brace of pheasants; *tou-yang*, or fighting rams, may have

shown two ibexes confronting each other, about to lock horns; the *hsiang-feng*, or phoenix on the wing, motif must have represented a mythical phoenix in flight; and the *yu-lin* design no doubt portrayed a *ch'i-lin*, an imaginary griffinlike creature, sauntering about. Fortunately, an abundant array of dyed, woven fabrics featuring similar designs is preserved in the Shoso-in and other museums, giving us a rather accurate idea of the original motifs.

SACRED-TREE-AND-ANIMAL MOTIFS "One hundred folding screens," the first entry in the *Kokka Chimpo-cho*, is indicative of the very large number of folding screens presented as gifts to the Todai-ji. Of these, seventy-five screens were decorated by stencil dyeing (*kyokechi*) and batik, or wax-resist, dyeing (*rokechi*) techniques. Each screen was composed of four or six panels, two screens constituting one set, but today, the leaves are in disarray and only sixty-five panels survive. One of these, a stencil-dyed screen decorated with bird and grass designs, depicts two symmetrically arranged long-tailed birds resembling pheasants, each poised with butterfly in beak against a grass and flower décor in what may be considered a fair approximation of the *tui-chih* pattern. Only one panel of a stencil-dyed screen originally portraying *ch'i-lin* and deer against a backdrop of grass and trees has survived. At the top center of the panel (Fig. 130) is a tree beneath which two deer stand facing each other amid wisps of grass and flowering plants. Another example, a wax-dyed panel (Fig. 120), captures the lordly posturing of a wild mouflon depicted walking under a tree. One mouflon, by itself, does not constitute a *tou-yang* motif, but had another been

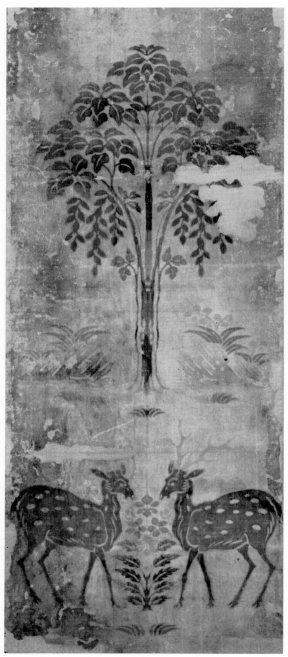

130. Stencil-dyed folding-screen panel with symmetrical arrangement of deer, grass, and tree motifs. Plain-weave silk; height, 149.5 cm.; width, 57 cm. Eighth century. Shoso-in.

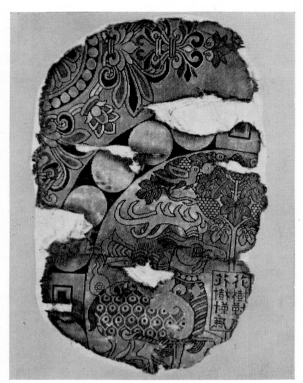

131. Flowering tree and deer. Silk brocade. Seventh century, T'ang. From Murtuk, Sinkiang Province. Tokyo National Museum.

added beside it, we would have a variation on the fighting-ibex theme. Or, imagining a *ch'i-lin* in its place, one obtains the *yu-lin,* or strolling *ch'i-lin,* motif.

All of the animals on Shoso-in screens are either depicted facing each other with trees or grassy floral settings in the center, or they are shown beneath these. Many of these motifs are found on dyed, woven fabrics (Figs. 26, 119), but several are also seen on such objects as a red lacquer chest decorated with pictures of clouds and rabbits. Needless to say, these motifs achieved wide popularity both in Tempyo Japan and T'ang China. One of the T'ang silk brocades (Fig. 131) discovered by the Otani expedition at Murtuk near the ancient

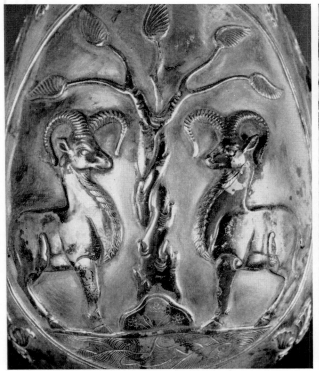

132. *Detail of Sassanian ewer showing mouflons arranged symmetrically around a tree. Partially gilded silver; full height, 33.8 cm. Sixth century. (See also Figure 73.)*

133. *Brocade with strutting mouflon motif. Sixth or seventh century, Sassanian. From Antinoe, Egypt. Musée Guimet, Paris.*

city of Turfan in Central Asia has woven into it in Chinese characters the legend, "flowering tree and facing deer." A Shoso-in brocade recovered in recent years shows a lion and two-horned rhinoceros facing each other in a symmetrical arrangement around a flowering tree situated in the center of the roundel; although fragmentary, it is plainly a T'ang brocade.

Motifs employing both tree and animal elements in their design were used in West Asia from very early times but found their widest application in Sassanian silverware (Fig. 132), woven fabrics, and the stucco ornamentation typical of Persian architecture. These decorative Sassanian themes are thought to have represented the sacred trees and

animals associated with the early Iranian sky cult. The crescent-shaped horns of the mouflon symbolized the moon, and tree motifs drew upon the symbolism of the sacred tree growing in the ocean of heaven, which gives sustenance with its life waters. A brocade with mouflon motif (Fig. 133), found in the ancient Egyptian city of Antinoe, shows the raised figure of a mouflon strutting about, wearing a beaded neck ornament with ribbons flying in the wind. Its ears are flattened back, and the massive horns curl powerfully to the right and left. Projecting an aura of dignity, the stately pose struck by the animal is nearly identical to that of the mouflon on a Shoso-in screen. The Shoso-in mouflon appears to have no ribbon, however. Although the dyeing is

134. *Detail of screen panel depicting Chinese lady under a tree. Colors on paper; height, 136 cm.; width, 56 cm. 752–56. Shoso-in. (See also Figures 75, 135, 192.)*

135. *Detail of screen panel depicting Chinese lady under a tree.* ▷ *Colors on paper; height, 136 cm.; width, 56 cm. 752–56. Shoso-in. (See also Figures 75, 134, 192.)*

imperfect and the design did not emerge clearly, the faint outline of a pearl-ringed necklace is just visible, providing sufficient evidence of a Sassanian influence in the design. Taking the probable origin of these motifs into account, we might assume that the style associated with the Duke of Ling-yang assimilated these motifs, and while they were doubtless Sinicized, we should qualify the assertion that Tou Shih-lun created them by adding the proviso "in T'ang China."

BEAUTY-UNDER-A-TREE MOTIF The Shoso-in's screen panels depicting palace ladies standing beside trees, colored with feathers applied to the surface of the design (see Figs. 75, 134, 135, 192), are the most outstanding examples of the classical beauty-under-a-tree genre (*juka-bijin*) favored by T'ang court painters. We

know from detailed inscriptions discovered on panel backings, which date from 752, that these rare screens were completed in the two or three years that followed, and dedicated in 756. Special techniques were used on each panel to achieve a unique craft effect. The ladies' faces, necks, hands, and other body parts were colored with green and vermilion pigments, but hair and costumes were generally sketched in rough outline in India ink and later filled in with pheasant feathers. Here, the vivacious beauty and leading courtesan of Ming Huang's brilliant court, Yang Kuei-fei, comes to mind. The perfect embodiment of the T'ang ideal, which prized a full-bodied, wholesome feminine beauty, she was acclaimed for her plump, round cheeks, almond eyes, and ample breasts. Another court lady, the Princess An-lo, is said to have commissioned a long skirt decorated with one hundred

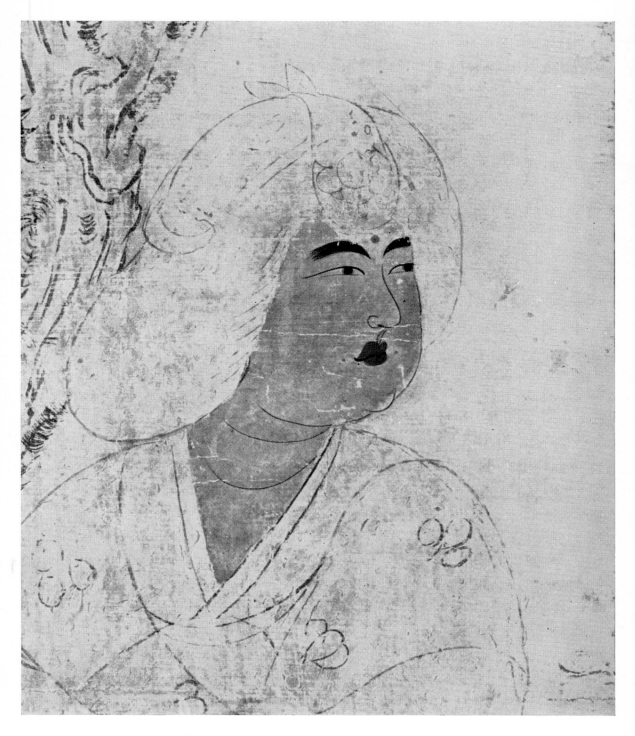

137. *Wall painting of court ladies (facsimile). 706,* ▷
T'ang. From tomb of imperial prince Chang Huai at
Ch'ien-hsien near Sian, Shensi Province.

136. *Painting depicting beauty under a tree. Silk.*
Eighth century. From Astana near Turfan, Sinkiang
Province. National Museum, New Delhi.

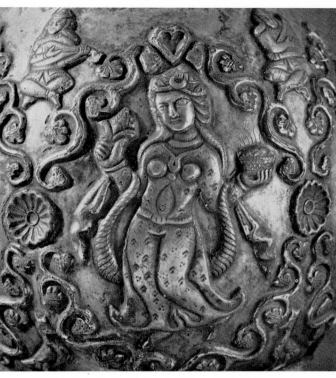

138 (right). Detail of the Persian goddess Anahita on Sassanian ewer. Partially gilded silver; height, 36.5 cm. Sixth or seventh century.

feathers, and the palace ladies in their feathered finery offer a glimpse of the high fashion of that day. The ships that carried the Japanese embassy to the T'ang court must have returned laden with exotic Chinese goods, and it may be that this fashion, much to the delight of Tempyo ladies, was imported to Japan at that time.

A number of treasures attest to the great popularity enjoyed by the *juka-bijin* motif during the T'ang. One of these, a polychrome painting (Fig. 136) found in Astana near Turfan, depicts women of noble birth standing beside a palm tree. In the recent excavations of the tomb of Prince Chang-huai in Shensi Province, wall paintings depicting scenes of bird watching and cicada catching were found. The murals also include a group of court ladies under a tree (Fig. 137). This painting is reminiscent of the famous works of the seventh-century painter Chou Ku-yen, known for his depictions of beauties against a landscape background.

The theory has been advanced that the beauty-under-a-tree motif is of Indian origin. A certain parentage can be seen in the Indian nature spirits, *yakshi,* said to guard the Buddha and seen entwined around trees carved on the stone reliefs of Sanchi, an important Indian Buddhist center in the first century B.C. Icons of Maya, mother of the Buddha, commonly found in the Greco-Indian art of Gandhara, also continue this traditional form. A similar theme encountered in art of the Sassanian period is that of a beauty believed to be Anahita, the Persian goddess of fertility (Figs. 76, 138). Sometimes she is seen standing under a grape-bearing vine and at other times under a rinceau arch of trailing grape arabesques. Occasionally she is found playing a musical instrument. The Sassanian nymphs strike

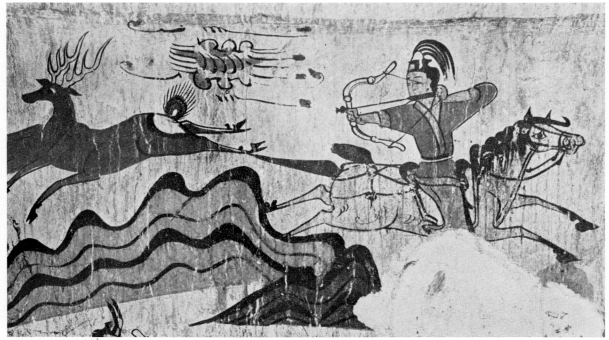

139. *Hunting scene depicted on section of mural painting. Fifth or sixth century, Koguryo. Wu-yung tomb, T'ung-kou, Kirin Province.*

different poses from the Indian goddesses and are not seen embracing trees, but the theme of women playing instruments on a carved *shakuhachi* in the Shoso-in and in the Astana polychrome painting was not unfamiliar to Sassanian artists. Here we might recall the gold and silver *hyomon kin* (Figs. 7, 10), which depicts several gentlemen sitting opposite one another playing instruments in a festive mood. The literati and immortals engaged in the leisurely pursuit of art are thought to embody a Chinese utopian ideal, yet even here, in this most thoroughly Chinese of scenes, the sacred tree of West Asia has left its indelible trace.

HUNTING MOTIFS A Shoso-in brocade (Fig. 13) with hunting scenes woven on a dark blue ground also features a central

tree with deer and mouflon motifs. Persian archers hunting lions on horseback are placed symmetrically around the tree. Another lion-hunting brocade (Fig. 82) is that with a particularly clear, tightly woven design owned by the Horyu-ji and known as the Four Celestial Guardians Brocade (*shitenno-mon nishiki*). The name of the brocade is fanciful, however, having been bestowed by overzealous Buddhist monks during the Kamakura period, and owes nothing to fact. Designs of mounted archers with reversed torsos shooting arrows at attacking lions are also found on several silver plates of Sassanian make. Two of these (Figs. 84, 140), representing the Sassanian ruler Shapur II (309–79), are embossed with motifs almost identical to those on the Horyu-ji brocade. These examples alone are sufficient to convince us that

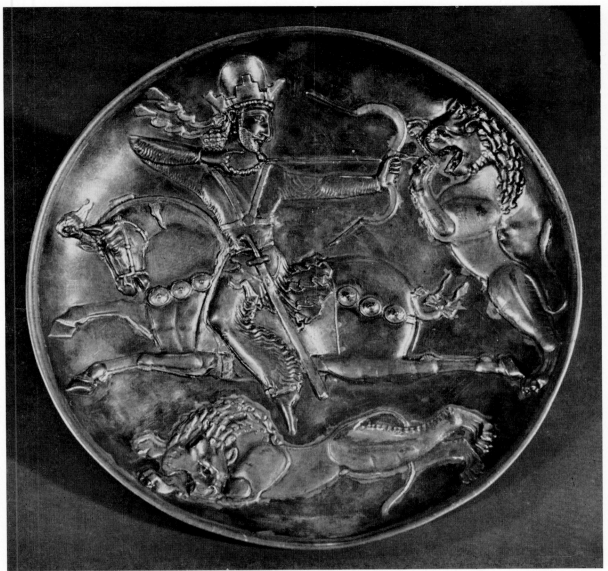

140. *Sassanian plate with embossed figure of Shapur II hunting lions. Partially gilded silver; diameter, 22.9 cm. Fourth century. Hermitage Museum, Leningrad.*

141. Tse-niao motif from mural painting, Sixth or seventh century. Kizil, Sinkiang Province.

the design is the work of a Sassanian craftsman.

In the *Wei-kung Ku-wu Chi* (The Story of the Duke of Wei), written during the T'ang period, is the following description of a costume design: "At the top are trees, below a man on horseback shooting arrows." The significance of the design on the costume is not clear, but horses on a brocade preserved in the Horyu-ji have embroidered on their flanks the Chinese characters for "good fortune" and "mountain," suggesting that such designs may have been considered auspicious motifs.

Hunting motifs bring to mind the more pictorial work on a silver jar (Figs. 54, 55) in the Shoso-in collection and a small silver jar (Fig. 80) belonging to the Todai-ji. From among the scattered crags and mountains, flowers, grasses, birds, butterflies, and clouds engraved on the metal surface, which is stippled with *nanako* (literally, fish roe), a variety of ring matting, emerge the line-engraved contours of a man on horseback, rendered in the T'ang manner, chasing wild boars, stags, rams, and hares. Similar scenes of the hunt are found on a silver stemmed cup in the Hakutsuru Art Museum (Fig. 83), on several examples of T'ang silverware, and even on the handle of a knife recovered

from Astana and brought back to Japan by the Otani expedition. The figures of mounted Persian archers occasionally appear in such designs, adding a strong foreign flavor (Foldout 2).

Hunting designs were known in China from the Warring States era, but it was during the Han period (206 B.C.–A.D. 220) that a special hunting preserve, the Shang Lin Yuan, was set aside for use by the imperial family, and hunting became a favorite pastime of the leisured class. A similar park existed in ancient Persia, known in Old Persian as *pairidaeza,* meaning enclosure or park (from *pairi,* "around," and *diz,* "to form"). This is the word paradise in its archaic form, and the stands of stately trees and verdant plant growth, grazing animals, and the figure of the king engrossed in the hunt became major decorative themes in Persian art. Among these motifs were the flying gallop, which portrayed a horse running full tilt, its four legs extended, and the Parthian shot, where an archer turns back in his saddle to loose an arrow (Fig. 139). Both forms, clearly of Western derivation, are found in China as early as the Han, but Chinese paintings depicting scenes of paradise endowed with luxuriant profusions of foliage and plant life probably appeared for the first time during the T'ang with the direct borrowing of Persian themes.

TSE-NIAO MOTIFS On the back of the Shoso-in's red sandalwood and mother-of-pearl *genkan* (Fig. 25) are two parrots chasing one another in flight, each carrying in its beak a jeweled sash indicating rank. Such designs belong to a decorative genre known in Chinese as *tse-niao* (in Japanese, *sakucho*), or gnawing bird, motifs and include the bird biting a vine stem on the petal of the incense tray in Figure 125 and the fowl with flowering branch in beak, rendered in *mitsuda-e,* on the wooden tray in Figure 19. A wall painting (Fig. 141) in the cave temple at Kizil, near Kucha, and a Sassanian brocade with *tse-niao* motif in the Vatican Museum confirm that this theme was borrowed from Sassanian art. A chapter in the *T'ang Hui-yao* (Important Documents of the T'ang, 961) discussing a long outer garment bearing foreign designs notes that during the reign of Wen-tsung

...ered pilgrim's bottle

JAPAN

KOREA

Heijo (Nara)

Yun-kang

Lo-yang Yang-chou

...an

T'ANG CHINA

Gigaku mask of
the Woman of Wu

CHAMPA

silver censer

genkan

rhinoceros-horn bowl

Foldout 2: Transmission of Persian Motifs

	Palmette Arabesques	Grapevine Arabesques
Sassanian Empire	Cup rim. Hermitage Museum. Wall decoration. Iran. Berlin Nat'l. Museum.	Silver plate. Hermitage Museum.
Central Asia	Reliquary. Kucha, Sinkiang. Wall painting. Kara Khojo, Sinkiang.	Brocade. Turfan, Sinkiang. Musée Guimet.
T'ang China	Mandorla. Shensi. Mirror. Ehime.	Mirror. Hakutsuru Art Museum.
Japan	*Mitsuda-e* coffret. Shoso-in. Hair ornament on Yakushi-ji Kannon, Nara.	Figured silk twill. Shoso-in.

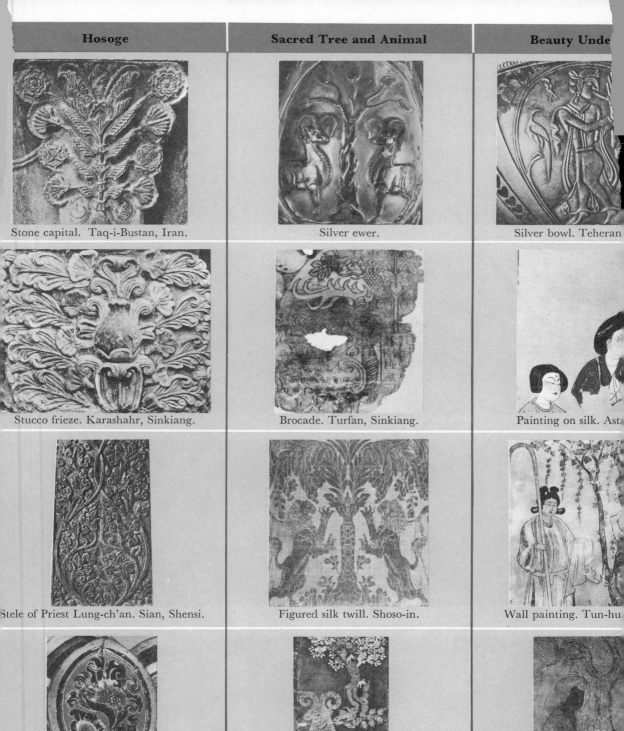

Hosoge	Sacred Tree and Animal	Beauty Unde
Stone capital. Taq-i-Bustan, Iran.	Silver ewer.	Silver bowl. Teheran
Stucco frieze. Karashahr, Sinkiang.	Brocade. Turfan, Sinkiang.	Painting on silk. Asta
Stele of Priest Lung-ch'an. Sian, Shensi.	Figured silk twill. Shoso-in.	Wall painting. Tun-hu
Petal from censer pedestal. Shoso-in.	Screen panel. Shoso-in.	Screen panel. Sh

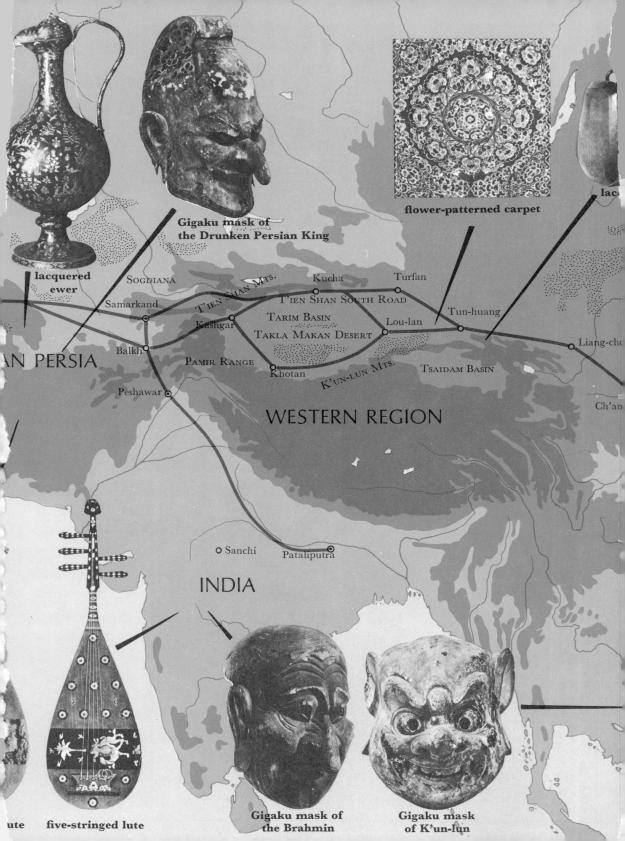

lacquered
ewer

**Gigaku mask of
the Drunken Persian King**

flower-patterned carpet

lac

SOGDIANA

T'IEN SHAN MTS.

Kucha

Turfan

Samarkand

T'IEN SHAN SOUTH ROAD

Tun-huang

Kashgar

TARIM BASIN

Lou-lan

N PERSIA

Balkh

TAKLA MAKAN DESERT

Liang-cho

PAMIR RANGE

Khotan

K'UN-LUN MTS.

TSAIDAM BASIN

Peshawar

WESTERN REGION

Ch'an

Sanchi

Pataliputra

INDIA

ute **five-stringed lute**

**Gigaku mask of
the Brahmin**

**Gigaku mask
of K'un-lun**

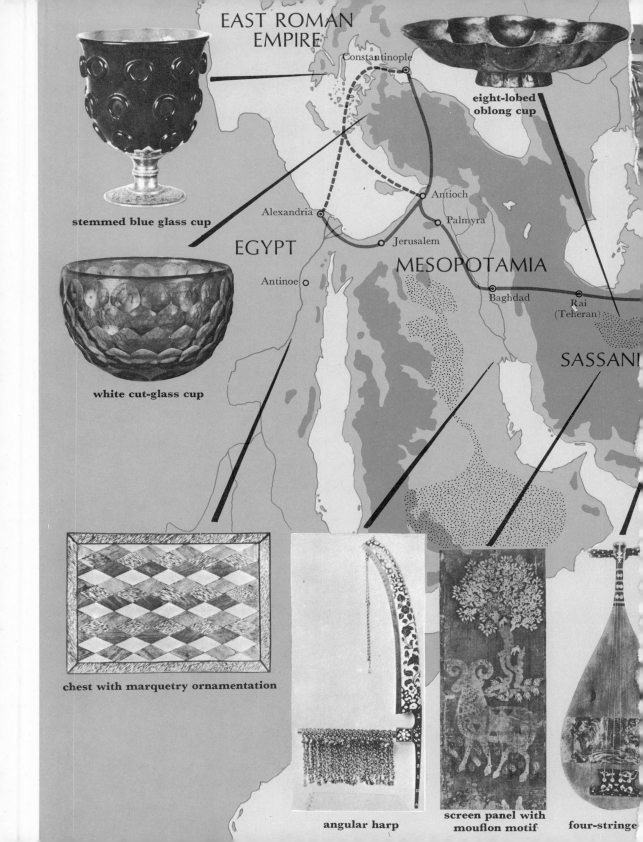

EAST ROMAN
EMPIRE

Constantinople

eight-lobed
oblong cup

stemmed blue glass cup

Antioch

Alexandria

Palmyra

EGYPT

Jerusalem

Antinoe

MESOPOTAMIA

Baghdad

Rai
(Teheran)

white cut-glass cup

SASSANI

chest with marquetry ornamentation

angular harp

screen panel with
mouflon motif

four-stringe

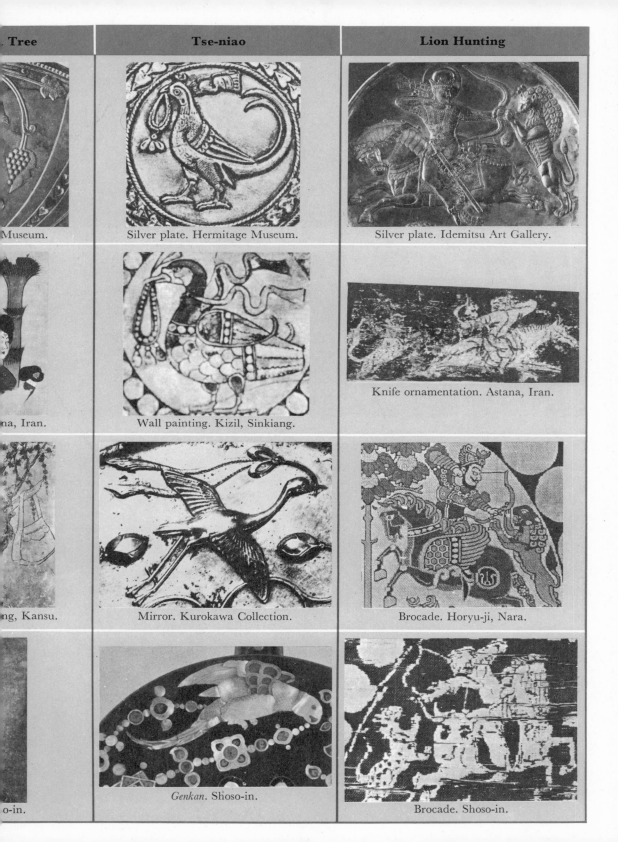

Tree	Tse-niao	Lion Hunting
Museum.	Silver plate. Hermitage Museum.	Silver plate. Idemitsu Art Gallery.
na, Iran.	Wall painting. Kizil, Sinkiang.	Knife ornamentation. Astana, Iran.
ng, Kansu.	Mirror. Kurokawa Collection.	Brocade. Horyu-ji, Nara.
o-in.	*Genkan*. Shoso-in.	Brocade. Shoso-in.

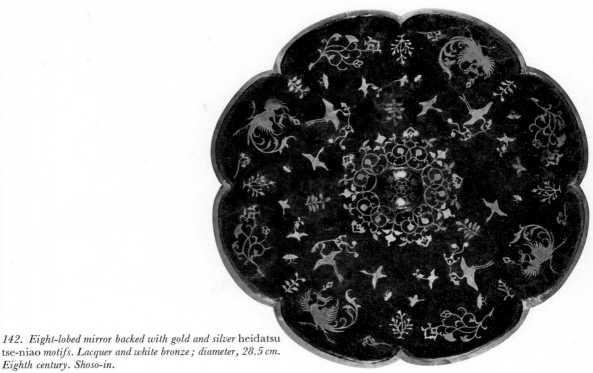

142. *Eight-lobed mirror backed with gold and silver* heidatsu tse-niao *motifs. Lacquer and white bronze; diameter, 28.5 cm. Eighth century. Shoso-in.*

(r. 827–40), only high-ranking court officials were permitted to wear costumes decorated with the *yen hsien shou-tai* (wild goose carrying sash in beak) and *ku hsien shui-t'sao* (falcon carrying auspicious sprig in beak) motifs.

Designs on woven fabrics like the Shoso-in *tse-niao* wild goose with sash in beak, a Sinicized version of the original Sassanian motif, and others featuring birds of prey carrying stylized sprigs or branches were immensely popular, and abusive wearing appears to have led to restrictions on their use. Designs in the Sino-Persian style, passed on to Japan by the T'ang artists, quickly caught the fancy of the Nara court. Eagerly applying these themes to a wide variety of handcrafted objects, Japanese artisans gradually worked them into the popular *matsukui-zuru,* or crane with pine bough, motif (Fig. 176), which flourished during the Heian period.

ALL SHAPES AND SIZES OF MIRRORS The *Kokka Chimpo-cho* records a total of twenty mirrors presented to the Shoso-in as gift offerings and notes that these were of two varieties: round mirrors (*enkyo*) and octagonal mirrors (*hakkaku-kyo*). The term *hakkaku-kyo,* or eight-angled mirror, is not to be taken literally; it denotes, depending on the treasure, eight-lobed foliate mirrors formed by scalloped arcs, such as the octagonal gold and silver *heidatsu* example in Figure 142, or octagonal mirrors formed by eight bracket-shaped edges, like that decorated with the Eight Divinatory Trigrams and landscapes in Figure 66. Each of these is a T'ang mirror design, and mirrors reaching Japan from T'ang China, together with those found in recent years on the Chinese mainland, may be classified generally into square and round shapes. Occasionally square mir-

143. Square mirror backed with bird, animal, and grapevine motifs. White bronze; height, 17.1 cm.; width, 17.1 cm. Eighth century, T'ang. Shoso-in.

144. Bottom of a lacquered foliate dish with colored motifs. Lacquer on wood; length, 37 cm.; width, 39 cm. Eighth century. Shoso-in.

rors have rounded corners. The round mirrors come in a variety of shapes: six-, eight-, or even twelve-lobed shapes, with the lobes ranging from simple, compound, and bracket-shaped, to cusped arcs.

There are no six-lobed flower-shaped mirrors in the Shoso-in, but some excavated examples do exist, notably one, owned by the Hakutsuru Art Museum, that depicts a pair of birds inlaid with mother-of-pearl. Mirrors with six compound lobes also existed, as did octagonal forms, which included foliate mirrors with eight lobes, mirrors with eight bracket lobes, and mirrors preserved in the Sumitomo and other collections decorated with *hosoge*, or imaginary flower, motifs, and cast with compound bracket-lobed designs.

The Holmes collection in New York owns a mirror with animals and grapevine motifs shaped in eight concave arcs, each overlaid with an embossed silver design. The Shoso-in solid gold- and

glass-backed cloisonné mirror (Fig. 126) composed of what are described as twelve bracket-shaped lobes is identical to the eight-cusped Holmes mirror and should therefore be classed as a twelve-cusped-arc variety. Not only is this cloisonné mirror the only one of its kind in existence, but it is also a valuable source of information for the study of T'ang mirror designs. Square forms include a truly exceptional Shoso-in square mirror (Fig. 143) cast in white bronze with bird, animal, and grapevine motifs. The gold and silver *heidatsu* square mirror with phoenix motifs and rounded corners in the Holmes collection is a rare art object equally worthy of mention.

A PROFUSION OF RECEPTACLE SHAPES

This progression of shapes is also observed among various household items and table utensils. These include square recepta-

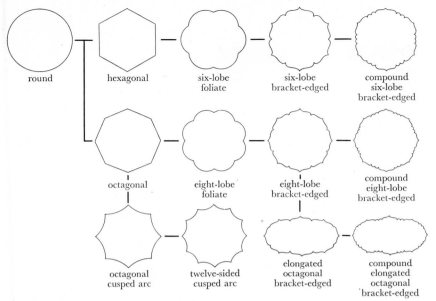

round hexagonal six-lobe foliate six-lobe bracket-edged compound six-lobe bracket-edged

octagonal eight-lobe foliate eight-lobe bracket-edged compound eight-lobe bracket-edged

octagonal cusped arc twelve-sided cusped arc elongated octagonal bracket-edged compound elongated octagonal bracket-edged

long foliate stand with gold and silver motifs

square foliate stand with gold and silver motifs

145. Receptacle and mirror shapes. *146. Table shapes.*

cles, like the cedar box (Fig. 199) decorated with *sai-e* designs applied over a green primer coat, and rectangular table forms, such as the *mitsuda-e* chest in Figures 17 and 87 and a rectangular table with *sai-e* over white clay ground. Hexagonal objects include a *kingin-e* lacquered-hide mirror box and the blue mottled inkstone in Figure 177 made of peridotite. There is one oblong hexagonal object, a small red sandalwood stand, and octagonal forms are represented by the eight-sided box with a tortoise-shell lamina in Figure 165.

The variety of round items, notably the lacquer-on-hide mirror boxes, is too numerous to cite individually, but some of the basic shapes can be mentioned. These are six-lobed foliate containers, such as the gilded silver flower-shaped tray (Fig. 4); foliate items with six notched lobes, such as a hexagonal sapan-stained table; shapes with six bracket lobes, including a hexagonal table with

legs in imitation tortoise shell; and compound bracket-lobed hexagonal shapes, including a gilt-bronze flower salver owned by the Hakutsuru Art Museum. Octagonal foliate vessels include a silver tureen with a lid, also in the Hakutsuru collection. Octagonal bracket-edged objects in the Shoso-in are the silver *heidatsu* mirror box in Figure 127 and the octagonal stand in Figure 160 decorated with *sai-e*. An elongated octagonal bracket-edged table painted with *kingin-e* applied over *gofun* and the eight compound bracket-shaped edges of an octagonal *sai-e* table display variations that evolved out of this shape. Oval forms, like the elongated jade drinking cups and rectangular *sai-e* stand with four compound bracket edges, might also be added to the range of shapes outlined above.

Additional forms are those with two concave hollows scooped out of each side, such as the long flower-shaped table (Fig. 146) with six legs decor-

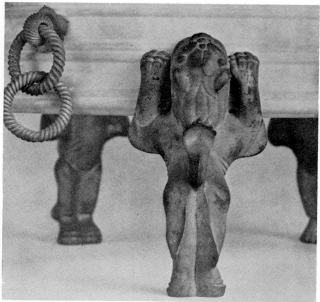

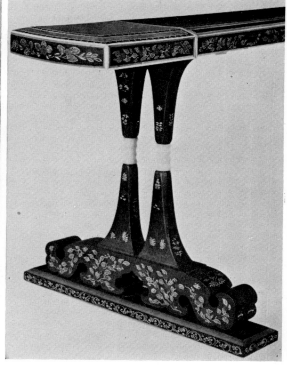

147. *Detail of incense burner with animal legs. Marble and gilt bronze; full height, 22.6 cm. Eighth century. Shoso-in.*

148. *Detail of sandalwood armrest with wood marquetry ornamentation. Red sandalwood; height, 33.5 cm. Eighth century. Shoso-in. (See also Figure 180.)*

ated in *kingin-e*, or even more complex variations; square items with four scalloped arcs on each side, such as the sapanned *kingin-e* foliate table in Figure 146; fully formed flower shapes, each with eight petals, like the oblong foliate tureen with a lid carved from the wood of the Chinese phoenix tree; and flower-shaped containers, like the lacquered serving dish in Figure 144 composed of four trefoil lobes to which smaller three-leaf sections have been added on four sides.

Thus far, receptacles have been grouped only according to external shape, but many of these combine to form composite shapes. Some items, like the silver *heidatsu* mirror box in the Shoso-in, present a round exterior enclosing a sculptured octagonal bracket-lobed figure. The contours of others, such as the silver tureen in the Hakutsuru

Art Museum, describe eight-lobed floral patterns inside of which octagonal bracket-lobed foliate figures have been embossed. These comprise a family of designs ranging from flat surface outlines to three-dimensional flowers with petals, and the great diversity of shapes assumed by these vessels is astonishing (Figs. 145, 146).

BRIGHT AND VARIED LEG DESIGNS

The seemingly endless variety of leg supports attached to boxes and tables is of particular interest. Support pieces ranging from the square bed legs of the imperial couch (Fig. 35) to the thirty slender square posts, aligned fifteen to a side, bracing the imperial table used in the First Day of the Hare observances, a ritual celebrated in the first month of the New Year

to obtain health and long life, are typical examples in use since early times. But some of the legs and supports found on coffrets or tables display various and elaborately sculptured curves. Among these are examples in which a design is created by the sinuous ornamental space between the legs, known as a *gozama,* and others in which the leg itself carries the design. Supports with flared ornamental fins fashioned into half-palmette motifs, as found on *kobako* (basket boxes set on low stands), and supports displaying carved *karakusa* arabesques, as on the small red sandalwood stands, must clearly be assigned to this latter class.

Here, examining the leg shapes that compose *gozama* designs, we find those whose lower sections describe U-shaped curves with sides sloping at steep or shallow angles. In others, the lower boundary is broken in the middle, as in the case of the green *sai-e* coffret in Figure 199, and in yet others, such as the red lacquer cabinet in Figure 38, this line describes a convex curve. Finally, some examples, such as the bamboo cabinet presented to Horyu-ji, have flared legs that extend outward from the base. Turning next to the upper portion, simple S-shaped curves are traced in the decorative aprons of certain *gozama* designs (Fig. 43), whereas others feature one, two (Fig. 160), or three (Fig. 17) cusped concave arcs. Some, like the red sandalwood *go* board in Figure 23, display a serrated run of such arcs. Viewed in this context, the half-palmette motifs carved in the ornamental leg fins of the *kobako* boxes mentioned above may be thought of as combining a series of sculptured concave and convex arcs. Examples like the green table in Figures 56 and 57 with its wooden runners at each end, which accentuate the *gozama,* might also be cited. *Gozama* artistry has found wide application among craft and architectural designs in East Asian art, and these treasures represent an indispensable addition to our knowledge of its development.

Leg supports fashioned into animal forms have been found among the ancient craft arts of Egypt and Western Asia, and in China these motifs were also used from an early date. The white-bronze brazier shown in Figure 61 and the marble brazier in Figure 147, both supported by rearing lions, their whole aspect revealed in high relief, are cast in this tradition, and throughout the T'ang period, animal legs, such as those on T'ang three-color jars, had great appeal. Many of the small tables and trays in the Shoso-in collection, however, are fitted with *kesoku,* or flower legs, fanciful carved representations of flowering plants. *Kesoku* are rarely found outside of the Shoso-in examples, and although many of these have since been repaired or restored, they nonetheless constitute a priceless collection of art treasures. *Kesoku* may be classified according to shape as follows.

1. Leafy petal forms, where each petal is shaped from a thin wooden strip. These include simple petal-shaped legs, such as seen on the *kingin-e* flower-shaped tureen carved from the wood of the Chinese phoenix tree, and compound petal legs, as found on a square foliate stand with white-clay decor (Fig. 149), and an oblong stand decorated in like fashion (Fig. 153).

2. Petal forms with central petal extended. These include simple petal legs, such as those on a gilded silver flower salver, which are shaped from a thin strip of metal (Fig. 4), and compound petal legs, as found on an octagonal *kingin-e* stand, which are carved in the round (Fig. 152).

3. Petal forms emerging from a calyx. Included in this category are petal shapes without stamen, such as those on a *kin-e* foliate stand, sculptured in the round (Fig. 150); petal shapes with stamen, such as the legs on a *gin-e* (silver-painted) foliate stand, sculptured in the round (Fig. 154); and circinate petal shapes, as seen on the legs of a foliate stand decorated with *sai-e* motifs painted over a *gofun* primer coat (Fig. 151). These, too, are carved in the round.

4. Bracken sprout (*warabide*) or cloud forms. Included here are legs shaped like double *warabide,* such as those found on a foliate tray decorated with *urushi-e,* or colored lacquer designs, with legs carved from a wood strip; legs shaped to resemble sculptured cloud forms, as on a *sai-e* table, carved from a single wood strip; legs in the shape of petals, such as those on a rectangular table, carved from a wood strip and decorated with *mokume-e* (literally, wood-grain designs), a lacquer motif that imitates

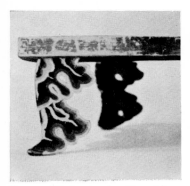

Square foliate stand with white-clay decor. Japanese cypress; height, 9.45 cm.

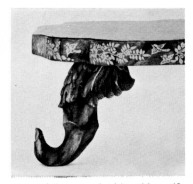

Long foliate stand with gold motifs on sapan-stained wood. Black persimmonwood; height, 9.8 cm.

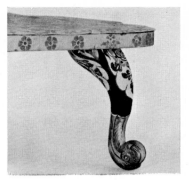

Foliate stand with colored motifs on white clay. Japanese cypress; height, 12.7 cm.

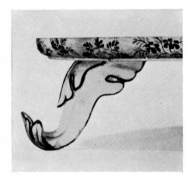

Octagonal stand with gold and silver motifs on white clay. Japanese cypress; height, 9.6 cm.

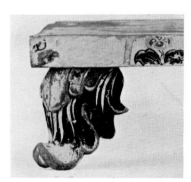

Oblong stand with colored motifs on white clay. Japanese cypress; height, 7.7 cm.

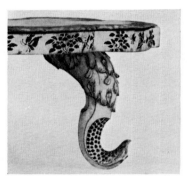

Foliate stand with silver motifs on white clay. Cherrywood; height, 10.3 cm.

149–54. Flower legs attached to offering stands. Eighth century. Shoso-in.

the natural grain of wood; and those on a red sandalwood armrest (Fig. 148), also sculptured from a block of wood.

Leg pieces on the *kingin-e* tureen and the gilded silver flower salver are molded from thin metal strips cut and bent to resemble leaves, but in each of the other examples, the *kesoku* have been carved from wood and lavishly decorated from the rich palette of *kingin-e* or *ungen* colors. Some *kesoku* in particular, such as those on the *gin-e* foliate table, have received special treatment inside the petal,

where small dots have been cut to represent stamens, adding a realistic touch to the design.

In addition to these, interesting developments may be observed in the table utensils and musical instruments found among the receptacle shapes employed by the craft arts of that period, including those of Western origin discussed previously. The continual synthesis of old forms gave rise to an endless profusion of new ones, and receptacle shapes, by adding a wealth of ornamental motifs, came to display a highly ornate beauty.

In Search of Ornamental Beauty

FROM SIMPLE COLOR TO POLYCHROME Most Shoso-in treasures are generously endowed with a wealth of color, but not all display polychrome decoration. For example, such objects as flower baskets, each woven from separate split-bamboo strips, were left a natural monochrome, but as green, gold, and silver flowers for ritual scattering were piled into the baskets, these must have assumed some very colorful hues. Another variety of flower basket was woven with silver wire on which were strung yellow, green, blue, and red glass beads, producing a sparkling polychromatic effect. However, with the exception of ordinary utensils, monochromatic articles generally derived their strength from design alone. One such example, the silver censer in Figure 33, is decorated with the figures of a dancing phoenix and a playful lion rendered in openwork amid arabesque whorls. Although the censer is a silver monochrome, the design itself and the see-through effect of the openwork create a showy allure.

Both a *mokuga* chest inlaid with lozenge-shaped pieces of resinous wood, the soft parts of which have decayed, and the betelwood *mokuga* coffret in Figure 156 of similar design skillfully exploit differences in the natural hue and grain of their wooden components and, for the period, have a modern aesthetic appeal. Objects of a similar nature are the spotted bamboo writing brushes (Fig. 155) and transverse flutes, which make clever use of this natural feature. The large number of treasures displaying brush-applied spots, such as chests of imitation spotted bamboo and hexagonal tables of imitation tortoise shell designed to resemble the genuine material, attest to the fascination these mottled motifs held for Tempyo artisans.

Other techniques, to which the term monochromatic (*tansai*) is perhaps more applicable than unicolored (*tanshoku*), attempted to create gradations by utilizing the tints and shades of a color. The box of white woven vine in Figure 50, for example, employs small black and brown lozenge patterns to accentuate the basic white ground. The figured silk twill (Fig. 27) showing a symmetrical arrangement of lion tamers and lions under a flowering tree achieves a very stylish though simple color combination by contrasting the darker shades of brown in the motif with the light straw-brown background tone.

Gold and silver were widely used and should be mentioned together with varieties of monochromatic coloring. Although *kingin-e* motifs sometimes use only silver or gold, often the glittering metallic gold and silver colors were arranged to produce a harmony of contrast. Some of these, like the *kingin-e*

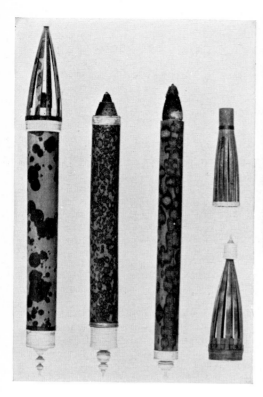

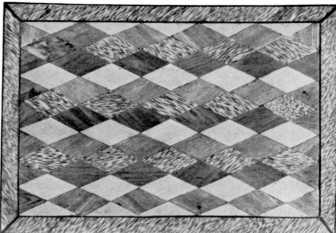

156. *Lid of box with wood marquetry ornamentation. Betelwood, boxwood, and mulberry; height, 11.1 cm.; length, 33 cm.; width, 23.5 cm. Eighth century. Shoso-in.*

157 *(opposite page, left). Striped* ungen *brocade with clustered diamond and seven luminaries motifs. Eighth century. Shoso-in.*

155. *Spotted bamboo brushes and caps. Length, extreme left, 19.6 cm. Eighth century. Shoso-in.*

box with green base coat in Figure 58, highlight the gold and silver *dei-e* motifs against a light blue-green field, while others, such as the striking persimmonwood chest in Figure 122, stained with sapan juice and decorated with rugged *kingin-e* landscapes, and the sapan-red coffret in Figure 63, with drummers and dancer rendered in gold and silver, make use of a dark sapanned background to bring out the motif. The *kingin-e* technique is closely allied to simple line sketches (*hakubyoga*) and water and ink drawings (*suibokuga*), and in this sense, the serene composed beauty characteristic of monochromatic art is rather to be sought in these latter examples.

The refined sense of color observed in these monochromatic compositions continued to deepen and develop alongside Tempyo's fondness for polychromatic ornamentation. Any number of different coloring schemes may be described as polychromatic. Polychromatic ornamentation is found on the jeweled flower baskets and other items that attempt to achieve a vivid effect by the combining of many different colors. Some articles employ an *ungen* gradation of halolike light and dark tones, while others adopt schemes that seek to contrast the colors selected. The striped brocade in Figure 157, which is decorated with four-diamond clusters (*yotsu-bishi*) and representations of the seven luminaries (*shichi-yo*, the sun, moon, and five planets), separated by *ungen* gradations, and the legs on the octagonal stand in Figure 160 decorated with *sai-e* motifs applied to a green ground are

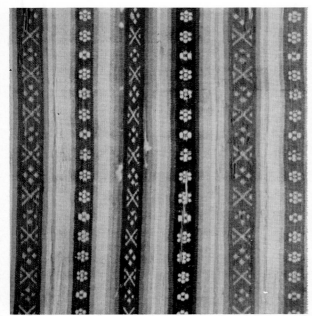

158 (right). Warp brocade with mountain and flower motifs on light red ground. Eighth century. Shoso-in.

159 (far right). Weft brocade with mountain and flower motifs. Eighth century. Shoso-in.

excellent examples of *ungen* coloration. Also included here are the freely rendered *e-gami* (paper with pictorial designs) scrolls whose outer edges, when rolled up, display a broad color spectrum of purple, red, yellow, white, light brown, green, and dark blue tones.

Ungen effects were originally obtained by juxtaposing lighter and darker tones of the same color to produce a three-dimensional gradation of hues of varying intensity. Influenced by the West, this technique gained great popularity under the T'ang and in Japan after the Tempyo period became the most highly favored of polychromatic ornamental styles. But, at the same time, a movement away from traditional *ungen* arrangements with their simple color tones began to manifest itself, later degenerat-

ing into a preoccupation with color change for its own sake.

CONTRASTIVE
COLOR SCHEMES
During the Tempyo period, artists were already experimenting with elementary color contrasts, and a conscious attempt appears to have been made to harmonize cold blue tones with warmer reds. One such example is the handle of the rhinoceros-horn *nyoi* (Figs. 69, 70) mounted with gold and decorated with a series of ivory sections carved in *bachiru*, most of which have been repaired. The front panels are colored, from top to bottom, green, red, and blue, and the back sections red, blue, and red respectively. In the center of each red and blue segment is set a stone of clear

160. *Octagonal stand with colored motifs and* ungen *designs. Japanese cypress; height, 9.3 cm. Eighth century. Shoso-in.*

crystal through which contrasting blue or red colors, applied to the stone's base, may be seen. Another example is the dark blue stencil-dyed offering cushion (Fig. 119) on which flowering tree and bird and animal designs are depicted in brown-red colors (originally bright red) to which yellow and green have been added against a background of clouds dyed various shades of indigo.

The color composition of the often cited lotus-flower-shaped incense-burner pedestal (Figs. 60, 125) is highly complex. The lotus petals are built up into four slightly overlapping rows, and their outer surfaces portray peony-inspired *hosoge*, Chinese lions, cherublike Kalavinka, birds carrying flowers, large wild geese, mandarin ducks, and other creatures rendered in vermilion (*shu*), its somewhat darker shade of red lead (*tan*), brownish red, ultramarine, Prussian blue, bluish green, white,

and *sumi* black. The outer row of petals is decorated on vermilion ground, the second on gold leaf, the third on ultramarine, and the fourth, innermost row on gold leaf. Besides the combination of these cold and warm colors, both the inside and outside of the petals are treated with *ungen* motifs in green, blue, red, and purple. This tray is remarkable not only for its variety of motifs, but also for its display of the full range of coloring techniques known to that period, from sophisticated color contrasts to *ungen* gradations. Polychromatic art attains its most extravagant expression here.

THE ART OF MARQUETRY Inlay or marquetry work found great favor with the people of Tempyo Japan. Of great antiquity, marquetry techniques are found in western Asia as early as 3000 B.C. and were also known to

161. Detail of flower-patterned rug. Felted sheeps's wool; length, 276 cm.; width, 139.5 cm. Eighth century. Shoso-in.

the ancient Egyptians. In East Asia, these techniques were already in use during the Shang (1523–1027 B.C.) and Chou (1027–256 B.C.) dynasties. Originally employed to achieve a highly colored ornamental effect, inlay work evolved into a predominantly lapidary art. These techniques range from classical inlay methods, in which sparkling jewels and precious stones of every color were encrusted in settings carved in wood or metal surfaces, to more advanced *shippo* (*émail*) techniques that developed later, in which colored glass was poured into cloisonné molds. A superb cloisonné work, and the only perfect example of its kind from that period, is the Shoso-in twelve-sided mirror with cusped arcs (Fig. 126) inlaid with solid gold and glass. Marquetry work consists of a base material inlaid with pieces of the same or a different material for ornamental purposes. But here, en-

larging on this interpretation, marquetry ornamentation can include any aesthetic contrastive or mosaiclike effect achieved through the juxtaposition of two or more materials, where each is clearly outlined, regardless of the technique employed.

The most prominent examples of inlay ornamentation are *mokuga*, mother-of-pearl, and *heidatsu*. *Mokuga* marquetry is a *yosegi* (joined woodblock) technique that utilizes bits of wood that are fitted together to form mosaiclike designs. The Shoso-in possesses several outstanding examples of *mokuga* craftsmanship, and a very unusual *mokuga* chest (Fig. 205), which graphically depicts what appears to be a Chinese boy chasing a lion, is included among the treasures dedicated by the Horyu-ji to the imperial household. As the mother-of-pearl on red sandalwood *genkan* (Fig. 25) reveals, mother-of-pearl inlay, or *raden*, relies on the iridescent

162. *Eight-lobed foliate mirror with mandarin duck and auspicious flower motifs in inlaid mother-of-pearl. White bronze; diameter, 24.5 cm. C. 700, T'ang. Hakutsuru Art Museum, Hyogo Prefecture.*

163. *Lid of hide box decorated with gold and silver* ▷ heidatsu. *Lacquer on hide; height, 6.3 cm.; length, 33 cm.; width, 27 cm. Eighth century. Shoso-in.*

pearly inner mantle of the nautilus and other shells, set in wood or lacquer, to produce a dazzling effect. Other substances, including tortoise shell, agate, and amber, were often used with mother-of-pearl as well. *Heidatsu,* or *hyomon* as it is sometimes known, made use of gold or silver leaf embedded in a lacquered surface, and may be thought of as similar to *raden* work except that in this instance thin strips of metal foil replace the pieces of shell. Employing a black-lacquer background, both *heidatsu* and *raden* display a distinctive high luster, are characterized by their cold quality, and differ in their decorative effects from the rather soft, warm touch of wood marquetry.

Technically speaking, even dyed or woven textiles like the felt rugs (Figs. 14, 161), which feature elaborate motifs of wooldyed light and dark tones of green, red, and indigo, may be thought of as a variety of decorative inlay. In similar fashion, raised designs that appear only in certain parts of a fabric, such as weft-woven tapestry brocades and embroidered motifs inserted between ground wefts and warps with colored thread, might also be included in this category. The three methods of textile dyeing, wax-resist, stencil, and tie-dyeing, too, are not unrelated to inlaid work. In each case, a variety of colors is applied inside motif boundaries highlighted by white outlines, or the colors are added to patterns that have been left white. Technical considerations aside, the effects produced by these methods closely resemble *bachiru* decoration. A notice in the *T'ang Shu* records that

in 757 the wearing of "precious jewels, inlaid work of valuable substances, inlaid lacquerwork, and embroidery" was forbidden, suggesting that inlay ornamentation had become so popular by this time in China that it was deemed necessary to prohibit its indiscriminate use. Many craft and textile arts of the Tempyo period make use of pictorial techniques for decorative purposes, but inlay and related methods were more admired, and the special interest these elicited in Japan is owing to the prestige they enjoyed in T'ang China.

A FASCINATION WITH LIGHT AND ITS EFFECTS

The Shoso-in treasures employ extensively precious materials of sparkling brilliance, such as gold, silver, gems, amber, crystal, natural pearls, nautilus shells, and tortoise shell. While ancient peoples the world over never lost their attachment to precious metals and stones, the T'ang Chinese and the Japanese of Tempyo appear to have been particularly taken with the alluring glitter of these substances, and this fascination with the play of light and its harmonies and contrasts exerted a telling influence on the development of their art.

Two types of light effect were used. Substances like gold, silver, and pearls shine by reflecting light from their surface, whereas glass, quartz, tortoise shell, and similar substances allow the light to pass through them, producing a diaphanous sheen. The white *ruri* bowl (Fig. 91) is one example that achieves nearly perfect transparency. The bowl's

164. *Lid of inlaid mother-of-pearl box. Lacquer on wood; diameter, 25.6 cm. Eighth century. Shoso-in.*

exterior is ringed with four rows of eighteen twinkling cut-glass facets, which form a diaper of hexagonal patterns, and the intricate play of light creates a luminous transparency of great beauty. It must be in admiration of such radiant elegance that the poet wrote of the "night glittering cup."

The Shoso-in collection contains a rather large number of treasures studded with small half-ball settings of glass and crystal through which flower and other motifs, painted in reds and greens on the bottom, may be seen. Examples of this work are the *raden* box lids in Figures 164 and 165, where half-balls are set in the center of each blossom to embellish the flower motifs executed in mother-of-pearl. This technique was already known to the Chinese of the Han dynasty, and its trace is found

on a quatrefoil bronze fitting from Honan in which a glass half-ball has been set. The figure of an immortal has been painted on the base of the glass piece and appears to have once had a gold leaf overlay. In another example, a square coffer unearthed at Lo-lang in Korea, immortals are depicted in black lacquer on the undersurface of a tortoise-shell lamina, evidence that tortoise-shell painting is also of great antiquity.

Tortoise shell is a yellowish, transparent material, as may be seen from the octagonal tortoise-shell box inlaid with mother-of-pearl in Figure 165, and was widely used because, superposed on a gold leaf ground, it reveals the glitter of the gold underneath. The black-dappled tortoise shell, it should be noted, also transforms the splendid golden sheen

165. *Lid of octagonal box with tortoise-shell and inlaid mother-of-pearl ornamentation.* Muku *wood and tortoise shell; diameter,* 39.2 cm. *Eighth century. Shoso-in.*

166. Side view of box decorated with gold motifs, wood marquetry, and plaques with flower painting using transparency techniques. Aloewood, red sandalwood, rock crystal, and ivory; height, 8.85 cm.; length, 33 cm.; width, 13 cm. Eighth century. Shoso-in. (See also Figure 124.)

into a more sober elegance. For tortoise-shell painting, only the clear, unmottled portions of the shell were used, and the dark glow of many tortoise-shell objects is due to this see-through quality. Two such examples are the gold and silver tortoise-shell box (Fig. 32) and a cypress *wagon*. The former is decorated with gold and silver flower motifs impressed in alternating sequences onto a green ground with hexagonal patterns and covered with tortoise shell. On each side of the *wagon*, birds and flowers are depicted against a green ground and landscapes, birds, and animals against a red one in a series of miniature scenes painted in narrow, alternately arranged panels.

The *mokuga* box of aloewood (Figs. 124, 166), decorated with *kin-e*, employs the same technique, but sheets of crystal are used to cover the paneled motifs, which resemble framed paintings. Through the transparent crystal of the rectangular windows in the lid and sides of the box can be seen flowers, birds, and animals rendered in lively colors against blue, minium red, green, and purple backgrounds. These objects recall the many Shoso-in paintings treated with a uniform surface coat of oil and known as *yushoku*, which include the plectrum guard of the famous maplewood and mother-of-pearl *biwa* (Fig. 121) with its scene of musicians and a dancer on an elephant. *Yushoku* treatment was primarily intended to prevent colors from fading but may also have been applied for the limpid quality it imparted to finished paintings. We should also refer in passing to items employing special devices to achieve a transparent effect, such as the *kobako* basket boxes, which are covered with thin finely woven silk gauzes, placed as if to reveal their contents.

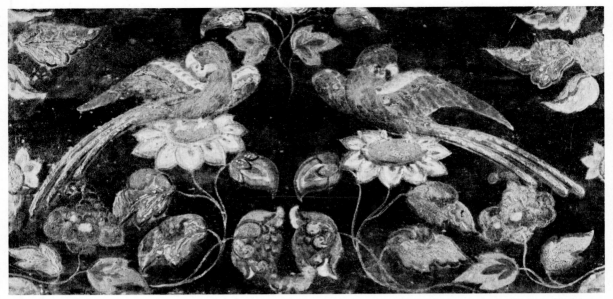

167. *Detail of box with flower and bird motifs covered with a protective oil coat. Lacquer on wood; full height, 27.2 cm. Eighth century. Todai-ji, Nara.*

BEYOND NATURAL REPRESENTATION

The T'ang concern with naturalism was carried to Japan, where it exerted a considerable influence on Tempyo art, permeating every artistic medium from sculpture and painting to the craft arts. Shoso-in examples of pure sculpture or painting are not numerous, but treasures like Gigaku masks and the ink-on-hemp drawing of a bodhisattva (Fig. 168) all display a three-dimensional plasticity and realism of expression that are readily apparent. Approaching more closely, however, one realizes that these works extend beyond mere naturalistic representation. This observation is borne out by the fierce red lacquer mask of the guardian Li-shih, which bears the inscription, "Todai-ji. Front One. Made by Shori no Uonari on the ninth day of the fourth month in the year 752"; the long-nosed Brahmin mask resem-

bling an old man, which carries the inscription, "Made by Kieishi"; and the Woman of Wu mask (Fig. 86), all thought to have been used in the eye-opening ceremony. Looking closely at these masks, one notices that not only are the facial expressions cleverly rendered, but there is a search for an ideal classical type, and the cast of the masks' features even succeeds in suggesting a symbolic spiritual quality.

The ink-on-hemp drawing of a bodhisattva (Fig. 168) also attests to the artist's exceptionally competent handling of the spatial dimension. Executed in freehand brushstrokes, the bodhisattva is portrayed floating on a cloud fragment, his heavenly scarf billowing out in loose folds around him. An impression of downward movement is masterfully created, as if the bodhisattva were descending from heaven located at the top left of the sketch toward

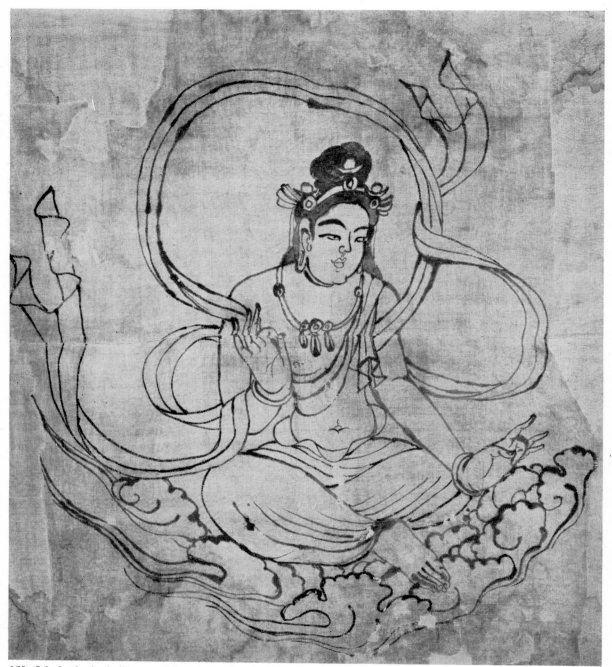

168. Ink sketch of a bodhisattva. Ink on hemp; length, 138.5 cm.; width, 133 cm. Eighth century. Shoso-in.

169. *Detail of cittern showing dragon motifs. Lacquer on paulownia and red sandalwood; length of dragon, 12.5 cm. 735, T'ang. Shoso-in.*

170. *Eight-lobed mirror backed with motif of ascending dragons. White bronze; diameter, 31.7 cm. Eighth century. Shoso-in.*

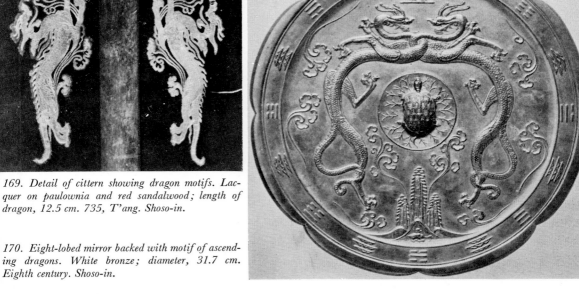

earth below at the bottom right. While ample care has been shown in the placement of the feet and hands, the central portion of the trunk appears abnormally contracted in comparison, but the *déformé* effect is in fact intentional here, being the typical T'ang mode of representing a bodhisattva.

Craft designs possess similar qualities. For example, one finds the same powerful expression of natural proportion and form in the treatment of single-deer motifs. The "flower deer" on the gilded silver platter in Figures 4 and 12 is delicately embossed and modeled from the tips of its antlers to its hoofs, and the lines of the eyes, mouth, and coat of fur are chased with sketchlike precision, creating a full-bodied, lifelike representation. Indeed, the consummate skill of T'ang craftsmen never fails to impress. Although Tempyo artists may have observed real deer, as the stencil-dyed screen panel

showing two deer under a tree (Fig. 130) would indicate, technical limitations precluded the rendering of fine detail. Yet the body contours, the eyes, noses, and spotted coats are skillfully suggested by brushstrokes applied ever so lightly, reflecting the naturalistic style of T'ang motifs.

The Shoso-in plant and animal motifs have been considered earlier, but it is worth noting again that these include not just realistically portrayed living species but imaginary ones as well, conceived with such lifelike feeling of movement that one might mistake them for real. The dragons on the gold and silver *hyomon kin* (Fig. 169) and the pair depicted on the eight-lobed foliate mirror in Figure 170 are such examples, as are the phoenix on the purple brocade in Figure 118 and the elegant *hosoge* motifs on the lotus-flower-shaped incense tray in Figure 125. This crystallization of the imagination, with a

171. *Detail of sleeveless coat of bleached cloth showing lion with flowering branch. Cotton; length, 57 cm. Eighth century. Shoso-in.*

172. *White marble slab with relief of a tiger en-* *twined around a hare. Length, 21.4 cm.; width, 33 cm. Eighth century. Shoso-in.*

naturalistic bent attempted to bring even chimerical forms to life, was sought after by artists with an almost obsessive zeal, and it is this working of imaginary detail that I prefer to call the naturalistic illusion. However animated the representation, these plant and animal forms lead an illusory existence but also open a new world of perception where realism and abstract decorative art are able to merge freely.

Here we might cite the interesting example of a short, vestlike garment of bleached cloth decorated with *sai-e* designs. The front side of the sleeveless musician's costume features line drawings of flowers and birds limned in vermilion and *sumi* ink. On the back, a mandarin duck shown amid *hosoge* motifs and a *karashishi,* or Chinese lion (Fig. 171),

carrying in its teeth a flowering sprig, are handsomely depicted in the same colors. *Kin-dei* has been applied in areas, but the design is almost a line sketch, and the garment is a refreshing work of art. The *karashishi* is a supernatural creature that evolved from representations of ordinary lions. These are depicted springing up on their hind legs, torsos reversed, holding in their teeth and paws a flowering branch. The primary interest here lies in the *karakusa* that adorn the lions' shoulders and thighs, and a similar style is observed in certain Shoso-in animal motifs, such as those on the white marble reliefs (Fig. 172) depicting the four directional divinities and the Twelve Branches of the zodiac. There is a total of eight slabs showing the animals in pairs. This motif has its origins in the

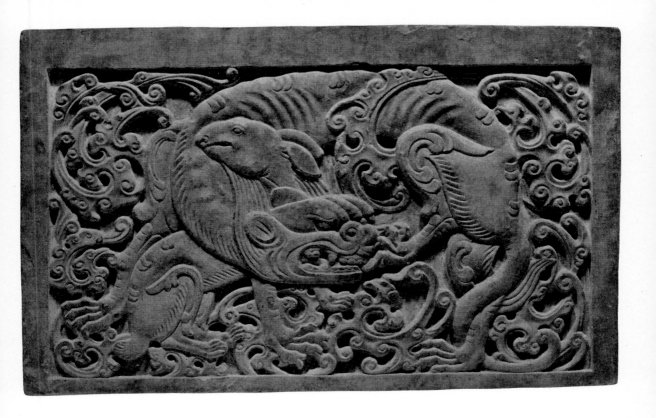

floral ornamentation appearing in animal designs on Sassanian and Byzantine textiles, and it reached Japan from across the world through intermediaries like the T'ang brocade (Fig. 131) depicting deer under a blossoming tree.

Another point of interest is the flowering bough held by the lions. Attached to the branch is a flower enfolding a cluster of eleven fruits that seem to spill out of a trefoil leaf amid curling petals, and I have shown elsewhere that such T'ang floral motifs are prototypes of the curious arabesques with "grape clusters wrapped in leaves" appearing on the pedestal of Yakushi-ji's main image (Fig. 129). The engaging design on this musician's vest alone tells us how taken were the T'ang and Tempyo artists with the naturalistic imagination and its lifelike

illusions and how it inspired an unending quest for ornamental beauty.

TRANSITION IN
T'ANG CRAFT ARTS

"The cliff face is sharp, / Trailing threads of vine. / Ponderously, a boulder sits / And spreads its mat of moss. / The spring at the summit / Brushes past the rock, / Murmuring not a sound / As it falls into the valley." Composed by the emperor Saga (r. 809–23), these lines are taken from the *Keikoku-shu* (Collection of State), an anthology of the best classical verse of the Konin era (810–24) compiled in 827. The poem was inspired by a landscape painting inside the Seiryo-den, the emperor's residential palace, and such renowned court literati as Sugawara no Kiyokimi,

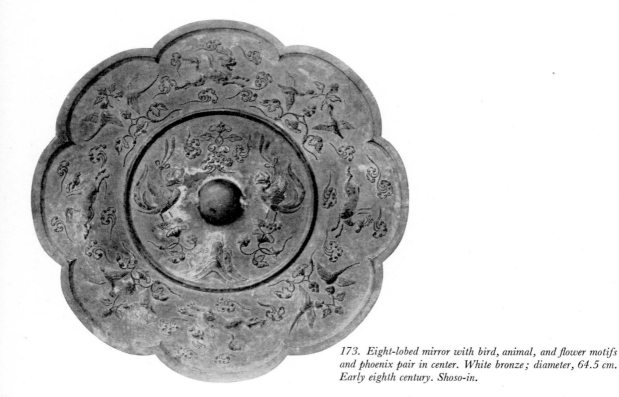

173. *Eight-lobed mirror with bird, animal, and flower motifs and phoenix pair in center. White bronze; diameter, 64.5 cm. Early eighth century. Shoso-in.*

head of the Bureau of Education, Miyako no Haraka, Doctor of Literature, and Shigeno no Sadanushi, Teacher of Classics to the Crown Prince, took writing brush in hand to complement the emperor's stanza.

One of the verses reads, "In one inch one can paint ten million miles," suggesting that perspective was skillfully used to represent distances in the landscape. The image created by Saga's poem recalls the scene of musicians on elephantback depicted on the plectrum guard of the *raden* and maplewood *biwa* in the Shoso-in (Fig. 121). The trailing vines hanging from the sheer rock face of the cliff and the clear ribbon of water cascading into the valley from the heights closely resemble the scenic panorama evoked in the emperor's poem.

The treatment of middle and far distance creates a spatial progression of great visual depth and suggests the perspective landscape style of painting, transmitted by Lu Leng-chia, a disciple of the eighth-century T'ang master Wu Tao-tzu. At the very least, these examples tell us that the landscape paintings of the Early Heian period (794–897) were executed in a style closely approximating those in the T'ang manner found among the Shoso-in treasures.

The Shoso-in *Shutsu-nyu-cho* (Register of Articles Withdrawn and Entered) shows that in the year 814, twenty-six painted screens including a landscape depicting the Land of the Immortals and ten stencil-dyed screens were withdrawn, and that a silver *hyomon kin*, taken out at the same time, was

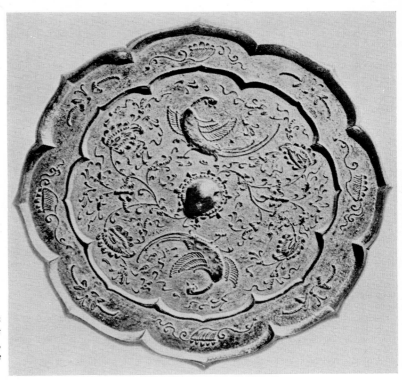

174. Octagonal bracket-edged mirror with design of pair of phoenixes amid auspicious flower motifs. White bronze; diameter, 31.2 cm. Tenth century. Kongosho-ji, Mie Prefecture.

replaced three years later by the gold and silver *hyomon* instrument now held in the repository. Again, in 823, musical instruments, such as the five-stringed red sandalwood and mother-of-pearl *biwa,* and other treasures, including a silver censer, were removed, only to be returned after two months. These events would seem to indicate, then, that Early Heian life was not greatly different from life during the preceding period, and that Tempyo musical instruments, daily accessories, and other articles were not out of place in an Early Heian setting. After the Fujiwara, or Late Heian, period (897–1185), however, this was no longer true. In the year 1019, the imperial regent Fujiwara Michinaga (967–1068) held for the first time a special viewing of the Shoso-in treasures, an indication

that by this period, these had come to be esteemed as objects of contemplation and were thought to have lost much of their functional value.

THE EMERGENCE OF A JAPANESE STYLE

Following the dominant stylistic currents in Japanese art, the Early Heian, which includes most of the ninth century, may be considered an extension of the Tempyo and belongs to the ancient period. A sharp line may be drawn between this early formative age and the Late Heian of the tenth century, which signaled the beginning of the medieval period and the emergence of a distinctly Japanese tradition in the arts. The main movement of painting follows this transition, from the thoroughly Chinese *kara-e,* or "T'ang

painting," to the Japanese genre, or *yamato-e*, paintings with their own indigenous themes. The landscape screens in the To-ji in Kyoto, and the door paintings (Fig. 175) in the Byodo-in's Phoenix Hall at Uji near Kyoto are masterpieces of eleventh-century art completed when Fujiwara power was at its height, but although both display background features peculiar to T'ang landscapes, comparing the brushwork with that in the Shoso-in and other T'ang-period *chefs-d'oeuvre,* we must acknowledge a great difference between the two periods.

A similar evolution is observed among craft designs, and we should turn now to mirror motifs, which best reflect this transition. Japanese mirrors cast during the Fujiwara period employ some T'ang mirror-back motifs borrowed directly, such as phoenix pairs and celestial winged horses. However, *hosoge* and phoenix motifs underwent a variety of subtle changes during the ninth century, and distinctive and elegant Japanese designs began to appear at this time (Fig. 174). This development may be seen in the octagonal bracket-lobed mirror portraying a pair of phoenixes amid curling "auspicious flowers," owned by the Kongosho-ji, and in a similar example dating from 988. These mirrors retained the symmetrical aspects of T'ang composition in the layout of motifs for some time, but even these eventually broke away from the T'ang mold, and pine trees, autumnal flowers, birds, and butterflies disposed in free arrangements on circular mirrors became fashionable, completing the evolu-

◁ *175. Detail of landscape painted on door of Phoenix Hall, Byodo-in. 1053. Uji, Kyoto Prefecture.*

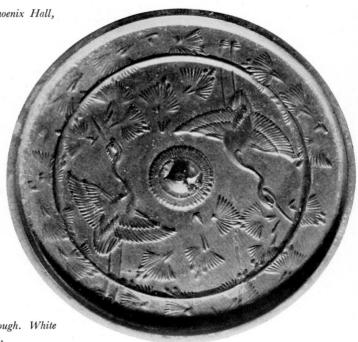

176. Mirror back showing crane with pine bough. White bronze. Twelfth century. Tokyo National Museum.

tion of the Japanese mirror. As mentioned earlier, the transformation of the Western-inspired bird-with-flowering-branch motif into the Japanese *matsukui-zuru*, or crane with pine bough, motif (Fig. 176) also dates from this period. For some reason, the grape arabesque, the great favorite among T'ang ornamental designs, simply disappeared without a trace from the repertoire of Japanese motifs.

The practice of sending official envoys to the T'ang court was discontinued in 894, bringing all formal contact between China and Japan to an end. This event is said to have been the turning point that hastened the evolution of a uniquely Japanese art, yet one might wonder whether the fall of the T'ang dynasty in 907 did not prove even more

significant. The *hosoge* and peony arabesques found in Fujiwara craftwork are, if anything, closer to those of the Sung period (960–1279). Moreover, motifs of Western origin, like the grape arabesque so fashionable during the T'ang period, were scarcely used by the Sung. This would suggest that the roots of T'ang art were shallow, and that this period's fondness for ornate and elaborate designs and things foreign was actually shared only by a small segment of the high nobility, never reaching to the common people. The craft designs of the Shoso-in treasures, with few exceptions, seem surprisingly never to have evolved beyond a certain stage in later periods, for they, too, suffered the fate of T'ang craft arts and were abandoned by the Chinese of Sung.

EMERGENCE OF A JAPANESE STYLE · *153*

A Survey of Shoso-in Treasures

THE CRAFTWORK PRESERVED in the Shoso-in is exceptional for its rich variety. Craft items are so diverse, in fact, that even when grouped according to function, construction material, and manufacturing technique, they defy simple classification. However, the profusion of craft materials gives us a firsthand idea of the everyday accessories used in that time and of the high quality of workmanship these exhibited. Were it not for the Shoso-in antiques, many receptacles would continue to survive only in written descriptions, and their special techniques of manufacture would remain forever lost to us. Moreover, as some of these techniques can no longer be imitated today, the Shoso-in treasures constitute a particularly precious heritage whose importance cannot be exaggerated.

One problem that continually arises in connection with the Shoso-in legacy is the number of articles owned by the collection, for there seems to be no easy way of counting these. For example, while certain treasures, such as the five-stringed *biwa* and the cloisonné mirror, are the only ones of their kind from this period in existence, others are found in such quantities that enumeration is quite impossible. Still others vary in number according to the method used to count them. The *Shoso-in Tana-betsu Mokuroku* (Inventory of the Shoso-in by Shelf Location, 1951) catalogues 794 art objects, but the 60 knives in the collection are counted as a single item, and other categories are treated in similar fashion. The Shoso-in also contains some 40-odd folding screen panels, more than 50 mirrors, over 60 knives, about 170 Gigaku masks, 565 bamboo flower baskets, several hundred metal plates and trays, and several thousand arrows. There is an unusually large quantity of glass beads, including 62 strings of between two and three hundred green glass beads each, 1,115 ornamental bead-endings known as "dewdrops," and enough broken beads to fill a twenty-liter container.

By far the most numerous items are scraps of old cloth, of which 120,000 pieces have already been sorted and inventoried, but at least as many fragments have yet to be counted, and a full itemization will probably not be completed for several decades. The 800 volumes comprising the *Shoso-in Monjo* and the more than ten thousand ancient manuscripts and documents owned by the treasury, to which must be added the 109 volumes constituting the Todai-ji's *Tonan-in Monjo*, should also be mentioned here. The task of enumerating each item in the Shoso-in collection is thus an almost hopeless one.

AN INVENTORY OF TREASURES The Shoso-in's holdings may be grouped in the following categories. The classifications have been made according to the function and use

177. Blue speckled inkstone. Peridotite set in red sandalwood; height, 8 cm.; length, 14.8 cm. Eighth century. Shoso-in.

of objects, and represent only a brief inventory of the vast repository.

MANUSCRIPTS AND DOCUMENTS. Manuscripts include several important works valued for their exceptional calligraphy as well as their content, such as the *Zasshu* (Miscellaneous Verse), the *Lo I Lun* (in Japanese, *Gakki-ron*, Treatise on Lo I), the *Tu-chia Li-ch'eng* (in Japanese, *Toka Rissei*, the Tu Guide to Successful Letter Writing), and the *Shih-hsu* (in Japanese, *Shijo*), a scroll containing the prefaces to forty-one poems by the early T'ang poet Wang Po (648–76). Among the documents are the *Kemmotsu-cho* and a great number of historical materials, the oldest of which is a Nara-period family register dating from 702.

WRITING MATERIALS. The Shoso-in owns eighteen writing brushes (known as *jakuto-hitsu*) with short, thick "sparrow-headed" tips, one of which bearing the inscription *Tempyo-hitsu* (Tempyo brush), was used at the eye-opening ceremony of the Great Buddha of the Todai-ji. There are fifteen sticks of black *sumi* ink, including a T'ang variety (*toboku*) with the inscription "K'ai-yuan Fourth Year" (716) and a Korean variety from Silla (*shiragiboku*). The only surviving inkstone is that with a crockery inkwell set in blue speckled peridotite (Fig. 177). Many sheets of writing paper made of hemp, mulberry, and other plants are owned. Colored paper dyed with cream yellow from the *Phellodendron*, blue from the indigo plant, and red from the sapan tree was widely used. The Shoso-in possesses thirteen sutra covers, including some exquisite examples of woven split bamboo, such as the cover for *Konkomyo Saisho-o-kyo* (*Sutra of the Golden Light*), which bears the date 747 (Fig. 178).

HOUSEHOLD FURNISHINGS. Shoso-in household goods are of every variety and include folding screens, cabinets (*zushi*), chests, tables, coffers (Fig.

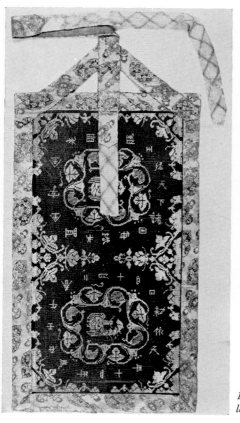

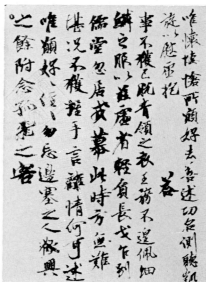

178. Cover for the Sutra of the Golden Light. Bamboo and brocade; length, 51.5 cm.; width, 29.5 cm. 742. Shoso-in.

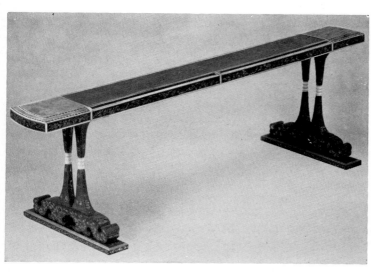

180. Sandalwood armrest with wood marquetry ornamentation. Red sandalwood; length, 111.5 cm.; height, 33.5 cm. Eighth century. Shoso-in. (See also Figure 148.)

181, 182. Revolving censer with metal brazier ▷ set on gimbals inside ornamental sphere. Copper and iron; diameter, 24 cm. Eighth century. Shoso-in.

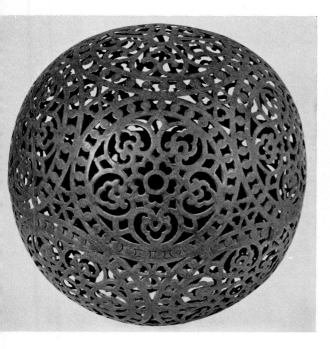

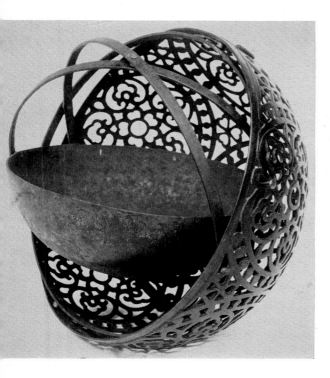

17), footrules, mirrors, rugs and carpets (Fig. 14), bedsteads (Fig. 35), armrests, aromatic censers, and incense braziers (Fig. 61). Screens were originally composed of six or eight panels fastened with cord to form one unit, but the screen leaves were detached and became scattered with time, and although since reassembled, they no longer preserve their original appearance. *Zushi* (Fig. 38) were of two types, cabinet *zushi* (*hako-zushi*), which resemble bookcases, and tiered *zushi* with shelves (*tana-zushi*). The footrules measure 29.67 centimeters in length and are close to the carpenter's rule, which is slightly longer than 30 centimeters. The red and green *bachiru* footrules (Figs. 36, 37) are thought to have been reserved for ceremonial use. Although some of the Shoso-in mirrors were doubtless used as everyday items, many more, such as the jewel-ornamented mirrors, were set aside for ceremonial purposes. Other mirrors, stored in the south treasury, are believed to have embellished temple surroundings (Figs. 8, 11, 66, 126, 142, 143, 170). Shoso-in carpeting includes, in addition to felt rugs, twill and brocade cushions and coarse rush mats that resemble tatami covers. Armrests, placed in front of a person for support, were of two kinds, those made of red sandalwood, like the beautifully executed rest in Figure 180, and those like the brocade rest in Figure 118 covered with woven fabric and decorated with a phoenix motif. The censers of silver and copper (Figs. 33, 181, 182), which were used to aromatize clothing with fragrant incense, are truly unusual articles. Fitted with a metal brazier, which rotates freely on gimbals set inside an ornamental sphere, these clever devices challenge the imagination.

PERSONAL ATTIRE. A wide assortment of costumes and items of apparel is preserved in the Shoso-in, including several outer coats, long undergarments, underclothing, long divided skirts, formal pleated skirts, *obi*, bootlike socks, footwear, and monks' robes. Costumes were made of two grades of material. High-quality dress wear was of twill, brocade, and two grades of gauze weave, and everyday wear of hemp cloth. High-quality apparel consists mainly of dancers' and musicians' costumes, one of which is a dazzling garment, a woman's waist-length

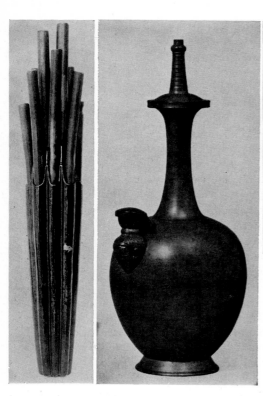

185. *Self-contained set of bowls. Copper alloy; diameter, 17 cm. Eighth century. Shoso-in.*

183 *(far left). Knives in clustered sheath. Wood; length, 31 cm. Eighth century. Shoso-in.*

184 *(left). Water pitcher. Alloy of copper, tin, and lead; height, 31 cm. Eighth century. Shoso-in.*

sleeveless gown with the ink inscription, "Todai-ji. Woman of Wu. Sixth year," made of brocade with a red ground weave. Protective clothing made of hemp cloth, such as apronlike skirts and sleeve covers, was worn by scribes who copied sutras.

In addition to crowns, combs, and scepters, personal accessories in the Shoso-in include many pieces hung from *obi*, such as knives, short rules, incense pouches, fish-shaped pendants, and gems. The custom of hanging small personal accessories from the belt entered China via the nomadic horsemen of the northern steppes and grew fashionable under the T'ang. Some knives are found together with files and augers in clustered sheaths (Fig. 183). The glass fish pendants in Figure 40 are forerunners of belt ornaments shaped like fish that appeared at a later date and are said to have originally been a type of name plate.

TABLE UTENSILS. The Shoso-in holds a large collection of eating and drinking implements once used at the Todai-ji. Among these are carafes, small drinking cups, high-footed bowls, self-contained bowl sets, bowls, plates, chopsticks, and long-handled spoons. Ewers (Figs. 72, 99, 184) are of two varieties, Persian pitchers and water bowls of Buddhist mendicants. There is a broad range of cups in the Shoso-in (Figs. 16, 51, 52, 78, 94), among which are various kinds of Western origin, rhyton-shaped cups for use on horseback, and oval drinking cups of jade. High-footed cups were probably used to hold sweets. The forty-five sets of self-contained bowls (Fig. 185) consist of a series of progressively smaller bowls that fit compactly one inside another.

MUSICAL INSTRUMENTS AND ACCESSORIES. The Shoso-in preserves more than seventy musical in-

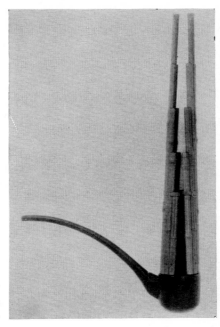

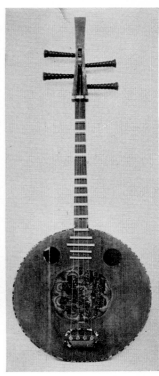

186. U, a variety of mouth organ. Eighth century. Bamboo; length, 53 cm. Shoso-in.

187. Genkan. Mulberry. Eighth century. Shoso-in.

struments representing a total of eighteen different types. Among the stringed instruments are the Japanese *koto*, or *wagon;* the shorter Chinese *ch'in* (*kin*); the *cheng*, another type of cittern (*so*); a similar instrument, the *se* (*shitsu*); the Silla *koto* (*shiragi-goto*); the *jun*, a seven-stringed zither; the four-stringed *yuan-hsien* (*genkan*, Figs. 25, 187); the *p'i-p'a* (*biwa*, Figs. 44, 106); and the angular harp, the *k'ung-hou* (*kugo*). Wind instruments include the *shakuhachi;* the transverse flute, or *heng-ti* (*yokobue*, Fig. 46); the Pandean pipes, or *hsiao* (*sho*); the *sheng* mouth organ (*sho*); and its close cousin, the *yu* (*u*, Fig. 186). Percussion instruments are the *kure no tsuzumi*, a double-headed horizontal drum (Fig. 105); the *ni no ko*, a small drum; and the *fang-hsiang* (*hokyo*) chimes.

Although the vast majority were used in Togaku, court music of Chinese and Indian origin, some instruments belong to the repertoire of Korean and Japanese music. *Koto*-like instruments, such as the *cheng* and *se*, are rare specimens, and the zither presumed to be a *jun* has been discovered in damaged state. The *hsiao*, which consists of a series of aligned long and short bamboo pipes; the *yu*, a larger version of the *sheng* mouth organ; and the *fang-hsiang*, which retains only nine of the ten or so metal bars once suspended from its upright wooden frame, are invaluable relics from a remote age. The Shoso-in also has accessories used by musicians, including Gigaku masks (Figs. 85, 86, 108, 109, 111, 112), thirty-two cloth masks (Fig. 110), and a few hundred dancers' and musicians' costumes.

GAMES AND GAME PIECES. The Shoso-in owns *go* boards, gameboards for *sugoroku*, *tan-kung* (*dankyu*) bows, and vases for "throwing jars." The *go* boards (Fig. 23) are the same as those in use today, each

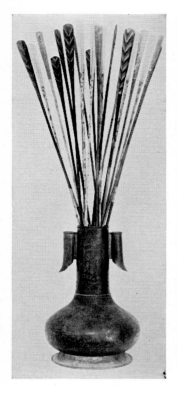

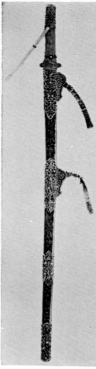

having 19 sectional lines with 361 points of intersection. *Go* stones and their containers with lids also survive. Five gameboards (Fig. 43) used for *sugoroku* remain, together with attached pieces and accessories, which include dice, stones, and dice holders. The Shoso-in *tan-kung* are bamboo bows with special sockets attached to the bowstring for firing bulletlike projectiles. The "throwing jar" was apparently a game in which blunted arrows were pitched into a jar from a distance; the rules, however, are not known in full detail (Fig. 188).

WEAPONRY AND ARMOR. The *Kokka Chimpo-cho* catalogues a large number of weapons and armor. At the time of donation, these included 100 long swords, 103 bows, 100 arrows, and 100 pieces of armor. Half of these were removed from the Shoso-in, however, and used in the civil uprising of 764 led by Emi no Oshikatsu. Today, only 49 long swords, 27 bows, 80 arrows, 33 quivers, and a few

halberds, short hand-halberds, and some horse trappings (Fig. 190) remain. The long swords include some magnificent specimens, such as the one mounted with solid gold and silver (Figs. 123, 189) and the cane sword, which displays stars and cloud motifs inlaid in gold. Not a single suit of armor survives.

MEDICINES AND AROMATICS. The *Shuju Yaku-cho* (Catalogue of Assorted Medicines) records that sixty varieties of medicines and medicinal herbs were presented to the Todai-ji as gifts, with this request: "Let all who suffer from illness and who find themselves in want of these apply to the high priest of the temple and be given according to their need." Thus, for nearly a century, medicines, unlike other offerings, were frequently removed from the treasury and dispensed free of charge to those in need of them. A survey of the remaining medicines undertaken recently identified thirty-nine varieties, including cinnamon, ginseng, and rhubarb. In addition, as many as seventeen kinds of aromatic plants, such as cloves and aloewood, and dyes and pigments have been distinguished.

REGALIA FOR ANNUAL OBSERVANCES. Annual T'ang court ceremonies appear to have been held in Tempyo Japan, and some of the ritual implements used on these occasions remain. Among these are a Chinese hand plow used by the emperor in cultivation rites on the First Day of the Rat, the broom (Fig. 191) employed by the empress in the silkworm ritual, a camelliawood staff for exorcising evil spirits on the First Day of the Hare, and silk *jen-sheng* cutouts (Figs. 5, 30) exchanged on People's Day at New Year. Other ceremonial implements of interest are the roller for the one hundred rope strands used to ensure luck and longevity in the Boys' Festival observed on the fifth day of the

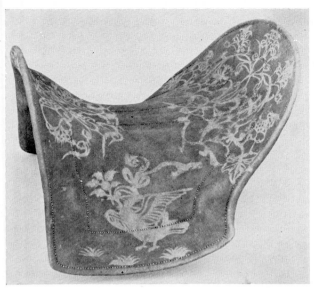

190. Saddle cover. Hide; height, 28 cm. Eighth century. Shoso-in.

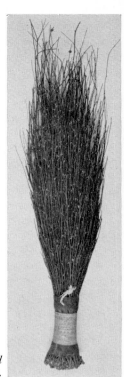

191. Brushwood broom with small glass beads amid the bristles. Length, 65 cm. Eighth century. Shoso-in.

fifth lunar month and the thread and needle used to pray for special skill in needlework at Tanabata, the festival of Vega, the weaver star, celebrated on the seventh day of the seventh month.

BUDDHIST REGALIA. Buddhist trappings are generally of three types: statues and other objects associated in some way with the Buddha or his ministry, ritual implements, and priestly regalia. Articles in the first class include a copper mold for casting Buddhist images (Fig. 197), the carved lotus pedestal of a Buddhist statue, the doors to a small Buddhist cabinet shrine, a marble stupa, a small stupa in three-color ware, and sutra boxes and covers (Fig. 178). Ritual accessories are canopies; ornate pendants; gilt bronze, twill and brocade banners (Figs. 48, 49, 62); pacifying bells (*chintaku*); silver bowls and jars (Figs. 54, 55); flower platters, incense tray pedestals (Fig. 60); thin chevron-shaped gongs; small bells; miniature

artificial lotus ponds; miniature mountains; and a diversity of offering stands and chests. Several banners feature the images of bodhisattvas (Figs. 24, 194) and, together with the Shoso-in's famous ink-on-hemp bodhisattva (Fig. 168), are thought to have been used to enhance the dignity of temple grounds. Priestly regalia include rosaries, curved scepters (Figs. 69, 70), long-haired fans (*shubi*), whisks (*hossu*), long-handled incense burners (Fig. 71), priests' staffs (*shakujo*, Fig. 67), and three-pronged *vajra* (Fig. 68). *Shubi* means literally "reindeer tail," and, as the herd follows the flashing tail of their leader, so were the commoners held to follow the lead of the priest with his *shubi*. The *vajra* is a fighting implement of Indian origin associated with esoteric Buddhist rites and should be mentioned for the role it played in the esoteric Buddhism practiced at the Nara court.

CRAFTSMEN'S TOOLS. The carpenter's workchest

192. *Folding-screen panel depicting Chinese lady under a tree. Colors on paper; height, 136 cm.; width, 56 cm. 752–56. Shoso-in. (See also Figures 75, 134, 135.)*

193. *Bodhisattva engraved on the side of a memorial stele to Zen master Ta-chih (rubbing). 736. Sian Museum, Shensi Province.*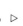

included saws, drills, files, burins, inking devices, and other tools.

PAINTINGS IN THE SHOSO-IN

Almost no paintings valued for viewing's sake alone are preserved in the Shoso-in, but this was not always so, and the *Kokka Chimpo-cho* records the donation of twenty-one folding screens decorated with painted scenes. The descriptions and titles give us some idea of the type of painting in question. Four were landscapes, and one of these, described as "old style," is believed to have been painted in an archaic style. All, however, were probably landscapes done in the T'ang manner. Four grand court paintings from the T'ang period are listed, and these were also described as old-style works. One other was a painting thought to depict an audience watching a Bugaku performance in front of a pavilion built by the emperor Ming Huang. Interestingly, one of the screens depicted the performance of a horse made to dance to music. Two paintings rendered in the old style and described as *pen-ts'ao hua* (*honzo-ga*), or "plant paintings," probably featured illustrations of flowers and herbs. Among the figure paintings is one listed as *Ku-jen hua* (*Kojin-ga*), "picture of an ancient," which was probably the portrait of an ancient Chinese dignitary. Others, known as *tzu-nu hua* (*shijo-ga*), appear to have portrayed palace ladies. The T'ang painters Chou Ku-yen and Chang Hsuan are known for their *tzu-nu hua* with landscape. A good example of this genre was recently discovered in the wall paintings (Fig. 137) of Prince Chang Huai's tomb in Shensi Province.

The famous screen paintings of full-cheeked Chinese beauties decorated with bird feathers (Figs. 75, 134, 135, 192) are the only Shoso-in paintings of

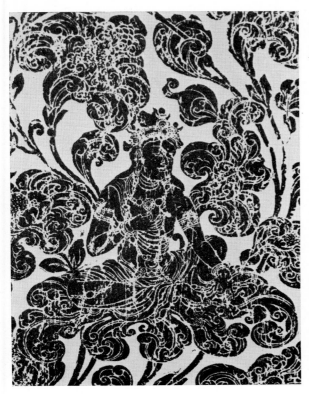

color the interior. The paintings of palace beauties are fully imbued with the gay mood of Tempyo and together with the painting of Kichijo Ten, the goddess of good fortune, at the Yakushi-ji in Nara, may be considered the work of a first-rate master of that period.

Two important Buddhist masterpieces among the few Shoso-in paintings must not be omitted. One is the celebrated ink-on-hemp drawing of a bodhisattva, better known in Japan as the Hemp-Cloth Bodhisattva (*Mafu Bosatsu*). The material on which the ethereal figure (Fig. 168), perched on mushroom-shaped clouds, is sketched consists of two lengths of hemp cloth sewn together, each measuring about 70 centimeters in width. The ink, which was liberally diluted with water, gave a varying thickness to the lines, but while there is some modulation in each stroke, the brushwork in general is steady and even. The similarity of this work to the figure of a bodhisattva engraved on the side of a memorial stele to the Zen master Ta-chih (Fig. 193), dated 736, located in the Sian Museum should be remarked. The *pai-hua* (*hakuga*), or fine drawing, resurrected by Wu Tao-tzu, the great genius who dominated T'ang art circles during the eighth century, may have resembled this style. The *Kokka Chimpo-cho* also records screen paintings of nocturnal merrymaking, good evidence that ink styles were known to that period. Wu Tao-tzu was a master at expressing the plastic solidity of form through line alone, and the figure of the bodhisattva recalls his manner, which was known as *wu-tai tang-feng*, "hanging ribbons blowing in the wind."

Another Buddhist painting is the *sai-e* bodhisattva banner (Figs. 24, 194), a rare work for its day. The tall banner features four bodhisattvas roughly sketched on a field of plainly woven silk dyed yellow. The contours of the figures are boldly outlined in vermilion, and although vermilion, red lead, blue, green, and purple have been added in, the fleshy parts of the bodies are left yellow, the background color. The lines are rather carelessly limned, and one senses that the painting is very likely the work of an amateur, but it retains a certain forceful appeal nonetheless. The bodhisattvas' jeweled crowns and *mudra* (ritual gestures) suggest the

real viewing interest that survive today. They probably belong to the *juka-bijin*, or beauty-under-a-tree, genre. We are most fortunate to still possess one set of six priceless antique panels, although they have since been restored in places. We know from an old document pasted to the backing and dating from the twenty-sixth day of the sixth month in the year 752 that these were completed sometime between this date and their presentation to the Todai-ji four years later. The screen panels, however, are known for the craft processes they employ rather than as masterpieces of purely pictorial art. For example, the fleshy parts of the ladies depicted in T'ang fashion standing or sitting in beauty-under-a-tree compositions are colored vermilion, red lead, and blue-green, but the outlines of the hair and costumes are roughly sketched in *sumi* ink with light brushstrokes, and pheasant feathers are applied to

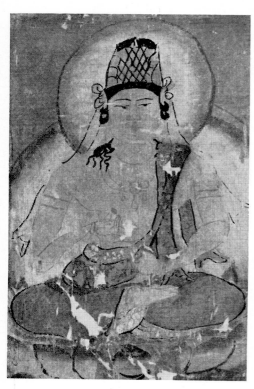

194 (left). Detail of bodhisattva banner. Plain-weave silk; height of banner, 237 cm.; height of bodhisattva, 22 cm. Eighth century. Shoso-in.

195 (right). Portrait of a man from Daidairon. Hemp paper; width, 29 cm. 745. Shoso-in.

iconography of esoteric Buddhism, and should the paintings have been in some way associated with the early esoteric Buddhist cult, then they are most valuable treasures indeed.

The ink lines added to the paintings evoke the famous *Daidairon* (The Great Dispute), a comic sketch drawn at the end of a document dating from 745 (Fig. 195). The brushstrokes that so cleverly capture the intent features of a man arguing heatedly, his coat sleeves rolled to the elbow, are the work of an unknown artist that puts the masters to shame. Because the *sai-e* bodhisattva banners had to be made in great numbers, these, too, may have been painted by amateur artists mobilized for this purpose. The possibility must certainly be considered when one realizes that painting was a highly specialized art in that age, relying on a division of labor.

Although not originally consigned to the Shoso-in, two ink-on-hemp landscapes (Fig. 196), which were transferred with other documents from Todai-ji's Tonan-in to the Shoso-in sometime in the early years of Meiji, also exist. These appear to be Japanese versions of T'ang landscapes, employing medium and distant perspectives, but it is not known what purpose they served. There is ample reason to think that this painting style gave rise to the indigenous *yamato-e* of the succeeding period.

We must not forget that a great many paintings used as ornamental designs on craft objects, as opposed to purer pictorial art, have been preserved in the Shoso-in and that many of these constitute veritable works of art in their own right. Among them are works accurately reflecting T'ang painting styles that long ago disappeared from the Chinese mainland. Here we might cite as a representative example the scene of musicians on elephantback painted on the plectrum guard of the

196. *Landscape on cloth. Ink on hemp; width, 59 cm. Eighth century. Shoso-in.*

sional, modeled quality to rocks with their clefts and fissures. Similar effects were created by a sparsely inked brush (the *k'o-pi*, or dry brush, technique). The plectrum-guard painting suggests both techniques, but two other works, the sapanned black-persimmonwood coffret decorated with gold and silver (Fig. 122), and the cover of the *Bommokyo*, the *Brahmajala Sutra*, embellished with a gold and silver landscape, attempt to reproduce this style with a brush dipped in *kingin-dei* and wielded on the broad side rather than its tip. These methods of representing rocks continued to be developed in landscape screens and paintings, like those on the doors of the Byodo-in's Phoenix Hall (Fig. 175), dating from the Heian period. The Shoso-in owns a red sandalwood lute with a plectrum guard showing scenes of a feast and a hunting party (Fig. 81). This painting is rendered in an archaic style similar to that on the wall frescoes found in the fifth- or sixth-century Koguryo tomb (Fig. 139) in Manchuria.

Paintings of an eagle attacking water birds, also on the plectrum guard of a lute, and of a peacock on the *mitsuda-e* plate in Figure 18, which recall the refined flower and bird paintings that had begun to appear during the T'ang, provide important insights into the T'ang mode of representation, although some may lack the rigorous brushwork characteristic of the Chinese masters. The scene of a dancing child and youthful musicians against a background of *hosoge* designs painted in gold and silver on the sapanned coffret in Figure 63 also illustrates the mastery Tempyo painters gained over the naturalist idiom that informed the T'ang style. Tempyo saw the flowering of Buddhist art in Japan, and, as might be expected, many Buddhist paintings were done during this period, but were it not for the treasures in the Shoso-in, a firsthand appreciation of many landscapes, flower and bird paintings, and other works of great visual interest would probably have been denied us. Indeed, we must count ourselves fortunate that the stylish masterpieces in the Shoso-in have enabled us to establish the high quality of Nara-period paintings, of which only too few survive, even when the Buddhist contributions are included.

raden and maplewood *biwa* (Fig. 121), a miniature said to resemble the brilliantly colored landscapes of the eighth-century T'ang master, Li Ssu-hsun. Chinese landscape painting made use of the laws of perspective, and we see in the foreground a troupe of four Iranian musicians riding atop a white elephant and in the middle distance, a hanging cliff of the kind commonly found in the loess region of north China. In the background, a flock of birds flying in V-formation disappears into the distant mountains where the sun is setting. Displaying a poetic charm, the painting clearly reflects the T'ang landscape style that heralded a new epoch in the representation of nature.

Wu Tao-tzu and his contemporary, the brilliant poet and painter Wang Wei, were the first landscape artists to employ techniques in which multiple strokes of varying intensity (the *p'o-mo*, or broken ink, style) were executed to impart a three-dimen-

CHAPTER EIGHT

＊

Materials and Techniques
of Manufacture

CONSTRUCTION MATERIALS The Shoso-in treasures employ in their construction a wide range of materials. Following the example of a survey conducted in recent years, we shall classify these as mineral, animal, and plant or plant-derived substances.

MINERAL SUBSTANCES. Jade and other substances formed of natural rock and minerals are: from China jadeite, amber, and white marble; from Afghanistan lapis lazuli; and from Persia turquoise, chalcedony, peridotite, agate, and rock crystal. Metals employed are gold, silver, copper, iron, and tin, in addition to such alloys as bronze; *shakudo,* an alloy of copper, gold, and silver; brass; *hakudo,* or "white bronze"; and *sahari,* an alloy of tin, copper and lead, known for its resonant qualities. Two types of glass were widely used, alkaline lime glass and lead glass. Ancient records tell us that red lead and quartz were used to manufacture lead glass beads. Cloisonné enamels and pottery glazes are also included in this class.

ANIMAL SUBSTANCES. Animal-derived substances include deer antler, water buffalo and rhinoceros horn, ivory from elephant tusks, whalebone, and animal bone; shells, such as wreath shells, pearl oysters, and *yakogai,* a native Japanese shell known for its iridescent mantle; natural pearls, coral, and tortoise shell; the tanned hides of deer, bear, wild boars, and cattle; sharkskin; sheep's wool; deer, badger, and rabbit fur; colorful feathers from the common pheasant, copper pheasant, and Japanese jay; and materials taken from insects, such as the iridescent wings of the *tamamushi* beetle and silk thread. Musk from Yunnan in south China and Tibet, and the hardened secretions of a small mealy-bug, from India and Persia, are animal byproducts also worthy of mention.

PLANT SUBSTANCES. Wood employed in the construction of the Shoso-in treasures includes varieties common to South Asia, such as red and white sandalwood, Chinese quince, and the betel palm. Other woods are the black persimmon, the boxtree, the paulownia, the zelkova, the Japanese cypress, the magnolia, the maple, and the mulberry. Every kind of bamboo found its use, as did arrowroot, rush, Indian rice plant, and hemp. Many different types of processed paper were also used. An array of plants was used in the preparation of aromatics and medicines, including cloves, aloewood, sandalwood, cinnamon, and pepper from South Asia; tulips from north India; pepper and *kotoritsu,* the hardened sap of the poplar tree, from Persia; and from China, ginseng, rhubarb, and other herbal plants.

197. *Mold for Buddhist image. Copper; length, 16.2 cm.; width, 11.5 cm. Eighth century. Shoso-in.*

PIGMENTS AND DYES　There are two types of red pigment, those producing bright colors, such as vermilion, and red clay, which produces somewhat darker tones. The Chinese *huang-tun* (red lead), known in Japan as *tan,* is a bright yellowish red, which is seen most frequently. Small amounts of red clay are often mixed with this color to produce a softer red, however. Bright yellows come from gamboge (*to-o*) and subdued brownish colors from such pigments as yellow ocher (*o-do*). Although most pigments are obtained from minerals, a few are produced from plants, such as wisteria yellow (*to-o*), a shade lighter than yellow ocher. Blue tones that are derived from mineral pigments include Prussian blue (*kon-jo*) and pale blue (*byakujo*), and from plant pigments include indigo (*ai*). Greens were sometimes obtained by mixing yellows and blues, but verdigris (*roku-sho*) and its lighter pigment tone, pale green (*byakuroku*), were used more often. Blue-green (*ao*) and minium were the two colors most favored by early Japanese craftsmen. Pale blue and pale green were obtained not by adding white to the pigment base but by grinding granules of Prussian blue and verdigris into finer particles, thereby producing the lighter tint. Black was acquired from *sumi,* an ink-cake made of solidified soot mixed with glue, and white pigments from white clay.

Of the red dyes, by far the most beautiful was crimson derived from the red roots of the madder plant. Although dark red dyestuff (*enji*) was once used to decorate Shoso-in treasures, the reds turned

198. Octagonal mirror box with gold and silver designs. Lacquer on hide; diameter, 31.7 cm. Eighth century. Shoso-in.

with time, fading into the reddish browns we see today, and the striking colors of the garment "dark-stained with crimson," extolled in the *Man'yoshu,* are seldom seen now. *Su-o,* a yellowish brown sapanwood, produces a reddish purple when diluted with lye of camellia. Mixed with alum, a dark red is obtained, and introducing an iron-rich additive, one arrives at purple. Purple dyes were normally taken from the gromwell plant (*murasaki* in Japanese), for which the color was named. Deep purple was produced by adding a strong lye concentration to the dye, and lighter tones by using a weaker solution. Adding rice vinegar created a reddish wine-colored dye. All blue dyes were derived from the indigo plant. Heavy dyeing yielded deep blue, light dyeing lighter tones. Primary yellow dyes came from *kariyasu,* a pampaslike member of the rice family. Bluish yellow dyes were taken from *Phellodendron* (*kihada*), reddish yellows from the gardenia, and brownish yellows from the magnolia. Mixing the yellows and indigo blues, green dyes were obtained. From very early times, green was called *ao,* the modern Japanese word for

blue. Black was produced by boiling acorns and chestnuts into a viscous liquid and fixing the resulting color with a ferric mordant. Chestnuts gave a black color, acorns a dark gray.

Among these dyes, purples and reds were used most extensively, followed in order of preference by indigo, yellow, and green. Browns such as "bark brown" (*hiwada-iro*) were used occasionally, but those seen today on Shoso-in antiques are nearly always the result of colors that have turned or faded with time.

TECHNIQUES OF MANUFACTURE The exceptional range of decorative techniques used to manufacture Shoso-in craft objects is as varied and ingenious as their shapes and designs, and in many instances, several processes have been combined to produce a single article.

METALWORK. Metal casting was the technique of pouring molten metal into molds to harden. Every manner of mold was used, and the results of a recent survey of mirrors inform us that some molds

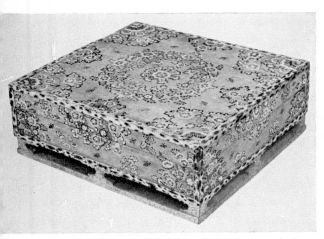

199. Coffret decorated with floral motifs on green ground. Japanese cedar; height, 14.2 cm.; length, 38.5 cm.; width, 35.2 cm. Eighth century. Shoso-in.

were made of wax and others of stone (Figs. 9, 143, 170, 206).

Metal-engraving techniques include hairline engraving (*ke-bori*), chisel engraving (*keri-bori*), and openwork (*sukashi-bori*) (Figs. 33, 116, 123, 181, 182). Related inlaying processes (*chogan*), such as bead setting (*gangyoku*) were used frequently as well. The raised bead technique, *nanako*, seen on the silver jar in Figures 54 and 55, was also used. Found on silver vessels of Sassanian make, the technique is believed to have been introduced from the West.

Another metalworking method was *tsuikin* (hammering), or embossing as it is better known, in which a metal strip was placed over a mold and hammered into shape, producing a raised pattern. The deer and flowers decorating the gilded silver tray in Figures 4 and 12 and Chinese floral patterns are good examples of such work. Two kinds of mold, male and female, were used, and we should mention here a copper plate in the Shoso-in with a figure executed in high relief (Fig. 197), which is thought to be the male mold for a Buddhist image. Silver-covered (*tengin*) mirrors also made use of this technique. After embossing a design on a silver sheet, a chalky substance was packed into the hollow formed by the raised motif, and the silver pressed onto the mirror back.

Tankin (tempering) was a method used by swordsmiths to fashion Chinese long swords, short swords, and other blades. Gilding techniques were applied to copper to produce gilded copper and to silver to obtain gilded silver, but sometimes only the individual details of motifs were gilded.

WOOD AND BAMBOO. Techniques for working wood and bamboo include *mokuga* marquetry, a type of mosaic inlay work (*yosegi-zaiku*, Figs. 113, 156). Craft objects decorated with pieces of natural wood, bamboo, ivory, and horn, untreated or dyed and inlaid in wood, often employed red sandalwood as a foundation material. This process was known from an early date in ancient Egypt and is believed to have been transmitted directly to Sui and T'ang China from western Asia and particularly from Sassanian Persia.

Mother-of-pearl (*raden*) is another *zogan*, or inlay, technique in which certain iridescent shells are ground flat, cut into patterns, and inlaid in red sandalwood and other wood surfaces. According to a recent study, most of the shells used for inlay purposes in the Shoso-in collection are mature *sazae*, or wreath, shells, but amber, tortoise shell, rock crystal, and glass are frequently used together with these. *Raden* mirrors have a foundation of a transparent, resinous substance sown with tiny rock fragments of malachite and blue tuff. *Raden* developed as a lacquer technique in Japan after the Heian period, but among Shoso-in treasures, only the chests decorated with *raden* and "jade garlands" make use of a lacquer foundation. The materials themselves would seem to point to a southern origin for mother-of-pearl inlay techniques (Figs. 25, 28, 162, 164, 165).

Tortoise-shell overlay was a technique in which transparent laminae of tortoise shell were superposed over a wooden foundation covered with gold leaf or decorated with *sai-e* motifs (Fig. 165).

Gold leafing consisted of pasting finely cut strips of gold leaf to wood or lacquer surfaces, a procedure also known as *kirigane*, or "cut gold." This tech-

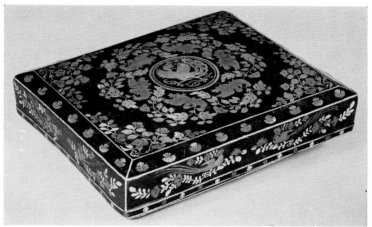

200. *Box with gold and silver* heidatsu *ornamentation. Lacquer on hide; height, 6.3 cm.; length, 33 cm.; width, 27 cm. Eighth century. Shoso-in.*

nique was extremely popular during the Heian period.

Gold and silver painting (*kingin-e* or *kingin-dei-e*) was a technique in which finely ground particles of gold and silver were dissolved in a gelatinous animal glue and applied to a surface with a brush (Fig. 198). The pastelike solution of gold, silver, and glue was known as *dei*, whence *dei-e*, another name for this method. Gold and silver painting produced an especially pleasing effect when combined with the dark, natural hues of such woods as red sandalwood, black persimmon, and sapan-dyed wood or of lacquered hide and similar materials. Gold and silver artistry applied to white woods like cypress and magnolia imparts a different but elegant flavor to objects thus treated.

Sai-e (literally, colored picture) were painted designs applied on a white-clay ground (Fig. 199). *Sai-e* motifs were often used to decorate boxes and tables, but a particularly striking example of its application is the *ungen* coloring found on *kesoku* legs (Fig. 160).

Either bamboo was used whole (Fig. 155) or the bark was removed and the wood split into long thin strips. Black bamboo, spotted bamboo, dwarf bamboo, and other varieties were taken whole to

fashion such articles as writing brushes and flutes. Vines, willows, and rushes were interwoven with split bamboo to make diverse kinds of baskets and other woven goods, including a broad variety of deep and shallow flower baskets. Sutra covers of matwork were composed of thin bamboo strips bound by thickly woven colored warp threads.

LACQUERWORK. Shoso-in lacquerware displays a full range of lacquer techniques, including lacquer applied to leather, which produces the hardened lacquer-on-hide (*shippi*), dry lacquer (*kanshitsu*), in which layers of hemp and lacquer are built up around a core, and lacquer applied to bulbous hemp-covered basket frames (*rantai*). Colored ornamental lacquers were black (*kokushitsu*), red (*sekishitsu*), and clear or natural (*ki-urushi*), fine vermilion (*shu-nuri*) not being in use yet. To produce red lacquer (Fig. 38), a wooden surface was stained red and covered with a coat of clear varnish (*suki-urushi*) in much the same way that Japan's distinctive *shunkei* ware is produced today.

The *Kokka Chimpo-cho*, describing the *makkinru* (literally, metal filings) ornamentation on a Chinese sword "inlaid with gold and silver" (Figs. 123 189), notes, "Scabbard made of *makkinru*," and the real treasure itself reveals motifs rendered in pow-

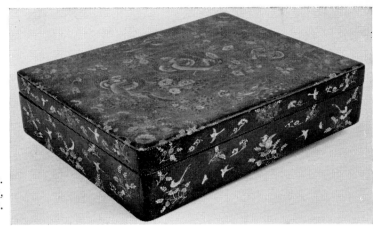

201. Mitsuda-e *box with colored motifs. Lacquer on wood; height, 14.6 cm.; length, 60.7 cm.; width, 46.5 cm. Eighth century. Shoso-in.*

dered gold against a black-lacquer ground. This process has been variously described as *neri-gaki* (literally, kneaded drawing), in which lacquer and gold particles are "kneaded" into a usable medium; and as *togidashi maki-e,* in which a surface decorated with gold filings sown on lacquer (*makie*) is given an additional coat of lacquer and polished to a smooth, glossy finish, so that the gold shows through. Recent studies point conclusively to the latter as the actual technique used.

Heidatsu inlay work employed strips of gold and silver leaf, cut to specific shapes and pasted over a lacquer foundation. After the entire surface had received a fresh coat of lacquer, either the lacquer membrane was peeled away from the motif, or the lacquered surface was ground down and burnished until the gold and silver elements of the design reappeared (Figs. 72, 127, 142, 163, 200). In addition to *heidatsu,* the *Kokka Chimpo-cho* makes mention of another gold and silver technique, *hyomon,* as in the gold and silver *hyomon kin* (Figs. 7, 10). Both are treated as separate techniques, and the problem of whether they are in fact different processes has been much discussed. Many scholars began to think of these as one technique, however, when it was pointed out that the word

hyomon (literally, flat design) was never used in Chinese and may have been a shorthand form of *heidatsu-mon,* which dropped the second character *datsu* and was read in Japanese as *hyomon.* But the results of a recent survey show clearly that in most cases, the lacquer has been peeled away from the design, since the threads of gold and silver are found embedded below the lacquered surface. In other examples, the gold and silver motifs are flush with the surface or even raised. As these latter may quite reasonably be considered *hyomon* in the literal sense of the term, the possibility that two distinct techniques are involved cannot be easily disregarded.

Mitsuda-e is the name given a type of painting that had its beginnings in the Momoyama period (1568–1603), in which lead oxide, or *mitsuda-so* (from the Persian *murdasang*), added to perilla oil to speed drying, was mixed with colored pigments to produce a kind of oil paint (Figs. 17, 87, 201). Although not completely unrelated, the oil-color technique known as *mitsuda-e* in the Shoso-in refers to a different process. Here, colors mixed with glue have been applied to lacquered surfaces over which a coat of oil has been spread. *Mitsuda-e* is not an appropriate term for this procedure, and because

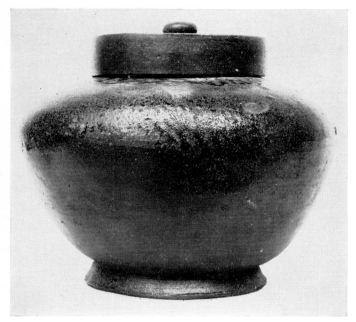

202. *Medicine jar. Ceramic; height, 20.5 cm. Eighth century. Shoso-in.*

such work (Fig. 19, 167) is described in the *Shoso-in Monjo* as *yushokuryo* (oil coloring material), some scholars prefer to call it simply *yushoku*.

BONE AND IVORY. The Shoso-in holds a rather considerable number of objects fashioned from animal horn, such as ivory, rhinoceros horn, and deer antler. The art objects include elegant flat ivory scepters, rhinoceros-horn receptacles, and rhinoceros-horn *nyoi*. The gold-mounted rhinoceros-horn *nyoi* in Figures 69 and 70, decorated with white ivory openwork and varicolored ivory *bachiru*, is an unusually gorgeous work of art. *Bachiru*, or "pick" ornamentation, was the technique of pick engraving (*hatsuri-bori*) a design on red, green, yellow, purple, blue, or brown stained ivory, after which a different color was added to the incised motif. Other outstanding examples of *bachiru* work are ivory *go* pieces and red and green footrules (Figs. 36, 37). Ivory tusks were very carefully selected for their fine-grained quality, and a fluent blade technique was required to work them.

CERAMICS. Unglazed *suè* pottery is a type of hard earthenware, which originated during the Tumulus period (250–552). The Shoso-in contains ten *suè* medicine jars (Fig. 202) and bowls, all fired a dark gray and, excepting those with natural glazes (an accidental effect caused by wood ashes), devoid of ornamentation.

While porcelain bowls are sometimes referred to, there is no true porcelain in the Shoso-in. Glazed ceramics include what is known as Shoso-in three-color ware (*shoso-in sansai*), an imitation form of the T'ang three-color variety. This pottery is of three kinds, monochromatic green glazed ware, green and white two-color glazed ware, and green, yellow, and white three-color glazed ware. There are more than fifty examples of Shoso-in *sansai* ceramics, including bowls, plates, crocks, miniature stupas, and other objects, but all are simple, and none exhibit the rich combination of light and dark glazes characteristic of T'ang three-color work (Figs. 15, 20, 21). Pottery clay appears crude

when compared to that found in China, and its ashen color leaves no mistake as to its Japanese origin.

GLASSWARE. Glass vessels were formed either by handblowing techniques, like the white *ruri* carafe in Figure 99, blue *ruri* jars, and the dark blue *ruri* goblet in Figure 16; or by blowing into molds, which turned out items such as the twelve-lobed oblong green *ruri* drinking cups (Fig. 78) and the white cut-glass bowl in Figure 91. The round facets were evidently cut after the white *ruri* bowl was formed in the mold. Fish-shaped pendants and scroll ends were also mold-formed, but glass beads appear to have been produced by rolling glass around copper wire, and hollow articles seem to have been blown on a blowpipe. Shoso-in glass containers are generally thought to have come from China or western Asia, but other glass objects were manufactured in Japan, as the existence of a notice describing materials for the fabrication of glass beads, found in a fragment of the *Zobutsu-sho Sakumotsu-cho* (Record of Things Produced in the Buddhist Construction Office, 734), would indicate.

TEXTILES. Textiles include woven and dyed fabrics, felt rugs, and fabrics to which ornamental designs have been added by such techniques as embroidery or appliqué. Among the woven fabrics are *nishiki* brocades, in which the ground and motif are woven with colored thread. *Nishiki* fabrics featuring patterns inserted along the ground warp are known as *tate-nishiki* (warp brocades, Fig. 158) and those with motifs following the ground weft as *nuki-nishiki* (welt brocades, Fig. 159). The warp-figured brocades are older, weft-figured brocades representing a more recent innovation, and the latter are exceptional for their bold, large-patterned designs (Figs. 13, 31, 118, 203). *Aya* is a diagonally ribbed silk twill, figured or plain, in which floats of warp are passed over and under the wefts in regular steps. *Ra*, a variety of gauze weave, consists of thin twists of warp entwined around weft threads to produce a chiffonlike fabric. *Sa*, another gauze weave, is a simpler variety of *ra*. *Tsuzure-nishiki* (literally, patched brocade) is a tapestry weave in which weft threads are simply passed back and forth over the necessary portions

of design, or "patches," without passing the whole width of the loom. Fabrics in which every other weft thread extends the full width of the cloth are known as *shokusei*.

Ashiginu (coarse silk) is not, as its name might imply, an inferior grade of fabric but a term for plain silk. *Katori* is a finer variety of the same weave. *Nuno* refers to plain-woven hemp cloth, and when boiled in lye, pounded in a mortar, and rinsed several times, it produces a white bleached fabric known as *sarashi* (Fig. 171).

Dyed textiles were produced either by applying a resist (*bosen*) to the patterned area of a fabric and dyeing the rest or by the direct application of dyes to the material. Three types of protective or resist dyeing are known: wax-resist dyeing (*rokechi*), stencil-dyeing (*kyokechi*), and tie-dyeing (*kokechi*). The wax-resist method (Fig. 120) utilizes molten wax, which is applied to a design with brush, or alternatively, a wooden stamp with the desired motif is pressed onto the material, after which the fabric is exposed to the dye. In stencil-dyeing, the fabric is tightly compressed between two wooden stencils in which a design has been cut, and dye is poured onto the stencil backs. Because the fabric is folded in half when dyed, the pattern is reproduced symmetrically on both halves of one side (Figs. 119, 130). Tie-dyeing is executed by bunching the fabric tightly in certain places and tying it with thread before immersing in dye. An undyed pattern emerges when the thread is removed.

There were several processes for applying dyes directly to textile motifs. *Suri-mon* (pressed design), a printed pattern technique, resembled textile printing in that pigment or dye was applied to the material via a wooden stamp with engraved motif or by means of paper patterns that were rubbed, transferring the design to the fabric. *Kaki-e* (hand-drawn pictures) employed pigments or dyes mixed with glue and applied directly to motifs on plain or figured textiles (Fig. 171). *Hsiao-chin* (in Japanese, *in-kin*) is a textile pattern technique executed by cutting gold leaf to the desired shape and pressing it directly onto the fabric. This process later came to be known as *suri-haku* (pressed foil). After the gold leaf is trimmed, a paper pattern of

203. *Detail of brocade with large flower motifs on light blue ground. Eighth century. Shoso-in.*

204. *Detail of felt rug showing a player of* dakyu, *a pololike game. Sheep's wool; length, 237 cm.; width, 124.5 cm. Eighth century. Shoso-in.*

the same shape, covered with a binding agent, is applied to the material. The pattern is removed, and before the glue dries the precut gold leaf is laid in its place, and the remaining particles are brushed away. This is a different procedure from the cut-gold (*kirigane*) method.

Mosen, which means rug in Japanese, was actually made of shrunken felt obtained by dipping woolen fibers set in a frame into an alkaline bath. A motif was executed by pressing colored woolen threads into the white felt ground (Figs. 14, 161, 204). The process of felting is thought to have originated with the nomadic peoples of North or Central Asia.

In addition to the felt rugs, embroidery (Fig. 26), consisting of motifs sewn directly into the fabric with colored thread, and appliqué work, executed by stitching precut pieces of one fabric onto another, other types of ornamental inlay techniques were in use. For example, the decorative pendants hanging from a silk parasol display Chinese floral motifs in *ungen* embroidery, and warp-patterned *ungen* brocade cut on the bias is sewn to the borders as trim. In the *ra* silk banners (Fig. 48), lozenge-shaped designs appear against a fine-mesh background, and flower-shaped cloth, edges stitched with gold thread, is added to enhance their appearance.

The Gallery of Horyu-ji Treasures

THE HORYU-JI DONATION The Daibutsuden at the Todai-ji was chosen as the site of the 1875 Nara Exposition, and the Horyu-ji, which also participated, placed its treasures on display alongside those of the Shoso-in. During the early years of Meiji, Western ideas and civilization enjoyed a considerable vogue, eclipsing native Japanese traditions, which suffered from increasing neglect, and the Nara Exposition was apparently conceived as a means of rekindling interest in Japan's ancient arts. The following year, the Horyu-ji requested permission to donate its inherited temple treasures, together with the recently exhibited articles and a few others, to the imperial household.

The reasons motivating this request are to be found in the period soon after the Meiji Restoration of 1868, a difficult and painful time for the Nara temples, when they lost all the income-producing property formerly accorded them, bringing about their financial ruin. The Horyu-ji, however, reacted by requesting an imperial grant of ¥10,000 in exchange for the holdings of its treasury, and it was decided to "first repair the temple edifice and develop a plan to maintain it in perpetuity." By this time, Horyu-ji's resources had been exhausted, and the temple was no longer capable of maintaining the collection of treasures "bequeathed from the time of Prince Shotoku," and like the Shoso-in, determined the best course was to entrust its treasures to the keeping of the state. The Meiji government therefore complied with the request, and the gift donation of the Horyu-ji treasures was made in the year 1878. These holdings, kept briefly in the Shoso-in following the exposition, were removed to a museum in Tokyo in 1882, where they became subject to the same controls as the Shoso-in material. The museum became the property of the Ministry of the Imperial Household in 1886, and the Horyu-ji offering was placed under the superintendent of treasures at this time and designated Horyu-ji Kenno Gyobutsu (Imperial Household Properties Donated by the Horyu-ji). After World War II, management of the Imperial Museum was transferred to the national government, and with the exception of those articles remaining in the possession of the Imperial Household Agency (the reorganized Ministry of the Imperial Household), the Tokyo National Museum (the former Imperial Museum) became the custodian of the Horyu-ji collection.

A repository to house the Horyu-ji treasures, which were supposed to have been treated like those of the Shoso-in, was not built immediately, and in fact it was not until 1962 that construction of the Gallery of Horyu-ji Treasures was completed

in Ueno as an annex to the Tokyo National Museum. The building was opened to the public in the autumn of 1964. The Gallery is a two-story, raised-floor structure made of reinforced concrete. The first floor is built to accommodate maintenance shops, a storage area, and a temperature-controlled room, while the second floor, modeled after the Shoso-in, is divided into northern, central, and southern repositories. The museum is intended to serve two purposes, to store the Horyu-ji treasures and to make them accessible to the public; and each room is provided with glass-enclosed display cases set against each wall, with one in the center. The automatic climate-control unit maintains room temperature at about twenty-three degrees centigrade and the relative humidity at between sixty and sixty-five percent, optimum conditions for a repository. In keeping with the gallery's visiting regulations, the doors are opened to the public

every Thursday, but should temperature conditions inside or outside the building become unsatisfactory, the museum remains closed on this day as well.

THE HORYU-JI TREASURES According to the catalogue of gift items prepared at the time of donation, the Horyu-ji collection includes 157 articles, but the inventory of treasures that traveled from Nara to Tokyo lists only 148. After the treasures had been sorted and arranged in the museum, the number of entries rose to 276, but these discrepancies are most likely due to different systems of enumeration. Excluding approximately ten objects in the keeping of the Imperial Household Agency, the Tokyo National Museum owns 319 items, of which 7 have been declared national treasures and 135 others important cultural properties. The treasures are a varied lot, including paintings, sculptures, such as Bud-

205. *Coffret decorated with wood marquetry. Zelkova wood; height, 17.5 cm. Seventh century, T'ang. Imperial Household Collection. (See also Figure 113.)*

206. *Mirror with seascape and mountain motifs. White bronze; diameter, 46.5 cm. Eighth century, T'ang. Gallery of Horyu-ji Treasures, Tokyo National Museum.*

dhist statues and masks, calligraphy, writing materials, household accessories, musical instruments, clothing and costumes, table utensils, weapons, and Buddhist regalia, ranging in time from the Asuka to Edo (1603–1868) periods.

Whereas most of the Shoso-in treasures date from the Tempyo period or thereabouts, the Horyu-ji collection is distinctive in that many relics trace their origins to the Asuka and Hakuho, or Early Nara (646–710), periods. Below, art objects have been grouped according to genre into paintings, sculptures, and craft arts, and the discussion is limited to treasures of the Hakuho and Tempyo periods.

Among the Horyu-ji paintings is a portrait of Prince Shotoku and two princes, presently kept in the Imperial Household Collection. The color-on-paper ornamental scroll depicting Shotoku, who stands flanked on either side by a young prince, is a variation of the triad arrangement favored by early

Chinese artists. As T'ang-style costumes were similar to those worn during the late seventh century, this portrait painting would seem to have been completed sometime during or after the Hakuho period. The paper size, too, is closer to that used for sutra copying during the Tempyo. Although some of the detail has been retouched, in contrast to the blue-green shading on the outer garments of the young attendants, the tones on the Prince's robe, rendered in dry-brush style, appear to preserve the manner of early T'ang painting.

Noteworthy examples of calligraphy in the gallery are the *Horyu-ji Kemmotsu-cho* (Catalogue of Gifts Dedicated to the Horyu-ji); the crown princess's report (747) to the emperor on the *gosai-e*, the annual lecture on the *Sutra of the Golden Light* held in the imperial palace at New Year's; and fragments of the *Sutra of Wisdom and Folly* (*Kengu-kyo*). Among the sculptured items are forty-

eight small gilt-bronze Buddhist statues, of which thirty, including one of a bodhisattva dated by inscription to 651, are believed to have been made after the Hakuho period; twenty nimbuses; and ten Buddhist images carved in relief. Each object is prized for the valuable insights it affords into the early history of sculpture in Japan. In addition, there are fourteen Gigaku masks, which, together with eighteen masks from the Asuka period, constitute the most important collection of masks outside the Shoso-in.

Among the craft and textile arts, we find as writing materials an ink set consisting of a tile inkstone in the form of a monkey's face, a gilt-bronze inkstick rest decorated with openwork arabesques, a gilt-bronze water dropper (for pouring water on the inkstone) decorated with phoenix motifs and arabesques, and a long-handled gilt-bronze spoon. No other examples of writing kits constitute a complete set. Daily accessories are a bamboo cabinet and lacquered hide box decorated with gold and silver *dei-e*, a jeweled box of betelwood adorned with glass beads and pearls, a wooden *mokuga* coffret presently in the Imperial Household Collection (Fig. 205), and similar articles. The *mokuga* coffret portrays a Chinese boy frolicking with a wild animal and lotus motifs enclosed inside pearl-studded roundels, executed in wood marquetry, and is thought to be an imported work dating from the early T'ang. The box merits special attention, as it slightly predates the Shoso-in treasures.

The Horyu-ji collection also includes a rare celadon "four-eared" jar, a survival of T'ang *yueh* ware, and an unusual gourd jar depicting the Eight Sages carved in relief around the outside of the vessel (Imperial Household Collection). Mirrors include those backed with bird, animal, and grapevine motifs, a "white bronze" mirror with ocean scenes (Fig. 206), and a mirror depicting Po Ya, the renowned musician of the Spring and Autumn era (722–481 B.C.), playing the *ch'in*. Any one of these is a match for the T'ang-style mirrors in the Shoso-in. Also counted among the Horyu-ji treasures are three knives complete with blue *ruri* ornamental handles and rhinoceros-horn scabbards (Imperial Household Collection).

Textiles include a white and scarlet wool felt rug, a small dyed cover decorated with wax-dyed parrot motifs, a round cushion of stencil-dyed *ra* silk gauze, and brocaded cushions featuring grape arabesques, hunting scenes, and flower, bird, and butterfly motifs. Coarse rush matting and colorfully figured mats are also a part of this group. Each of the red ivory *bachiru* footrules and the red, green, and dark blue ivory *bachiru* needle cases is believed to be a ritual object. The needle cases, employed in Tanabata celebrations, are not found among the Shoso-in belongings.

Musical instruments in the Horyu-ji collection are a seven-stringed *kin* of T'ang make with a *sumi* ink inscription giving a place name and date (724), either of production or presentation; a *shakuhachi;* a transverse flute (Imperial Household Collection); a horizontal drum (*kakko*) made of tile; and a drum body decorated with *sai-e* designs. Costumes and accessories include an *obi* with jade plaques, a colorful, flatly woven *obi* for formal wear, a broad ivory scepter, a silver hairpin with an ornamental piece in the form of auspicious clouds, and Buddhist garments, such as *kesa* and work robes. A considerable number of table utensils, each thought to have been used in Buddhist rites, remain. Among these are the dragon-headed ewer in Figure 102 and others, oval shaped or in the form of drinking cups; metal bowls with lids; self-contained bowl sets; flower-shaped dishes; bowls of silver, wood and dry lacquer; saucers; and spoons.

The dragon-headed Persian ewer is an outstanding example of T'ang art. Sassanian-style winged celestial horses are incised on the side of the vessel, and the dragon head, its body, and the horses are gilded (Fig. 102). A *sumi* ink legend inscribed on part of the ewer's body reads, "Hiso. Height, one *shaku*, six *sun* (47.47 centimeters) . . . ," indicating that it may have belonged to Hiso temple in Nara. Weapons in the Horyu-ji holdings include arrows, quivers, and bows of catalpawood, but the heavy iron pot-shaped stirrups common to the Asuka period are unusual here. Lastly, Buddhist paraphernalia include a long-handled "white bronze" incense burner counterweighted with a lion, a *nyoi* scepter of horn, a ritual brush (*shubi*), amber

beads, cymbals, a sutra stand adorned with a tortoise-shell veneer, a *mokuga* sutra box, *aya* and *nishiki* banners, and various metal pendants. The sutra stand is made of black persimmonwood stained with sapan juice, and thinly peeled bamboo has been affixed to the upper portion of the stand, forming a border around it. As if this were not enough, flying clouds and bird and flower motifs are painted in polychrome on the stand legs, which form a *gozama* and over which a transparent layer of tortoise shell has been superposed. This elaborately conceived work of art merits mention alongside its counterparts in the Shoso-in.

The art objects presented by the Horyu-ji as gifts are composed of articles from the Asuka period used personally, as legend would have it, by Empress Suiko (592–628) and Prince Shotoku, some of which, when compared to the relics believed to date from the Hakuho and Tempyo periods discussed above, are certainly more archaic in style. These treasures will doubtless play a leading role in revising the early history of Japanese craft arts as the comparative methods of modern research shed more light on the stylistic niche they occupy and we are able to put such legendary accounts behind us. Virtually everyone acknowledges that the forty-eight small bronze Buddhist icons in the Horyu-ji collection hold a valuable key for rewriting the history of ancient sculpture in Japan, and much is expected of the art objects bequeathed by the Horyu-ji, which, standing alongside and complementing those in the Shoso-in, promise a clearer understanding of Nara-period arts and crafts.

Major Historical and Cultural Events

JAPAN

710: Capital moved to Heijo (Nara).

717: Kibi no Makibi, Gembo reach T'ang China to study.

720: *Nihon Shoki* (Chronicles of Japan) completed by imperial decree.

Fujiwara Fubito dies.

724: Emperor Shomu ascends throne.

729: Fujiwara Komyoshi becomes imperial consort.

731: Emperor Shomu copies *Zasshu* (Fig. 42).

733: Lady Tachibana Michiyo dies.

736: Indian Bodhisena, Champan monk Buttetsu, Persian Li Mi-i arrive in Japan.

741: Edict to begin building provincial temples (*kokubunji*) promulgated.

742: Cover for the *Sutra of the Golden Light* (Fig. 178) made.

744: Empress Komyo copies *Gakki-ron* (Fig. 41).

747: Casting of the Todai-ji's Great Buddha begins.

CONTINENTAL ASIA

712: Emperor Hsuan-tsung (Ming Huang) ascends throne.

735: Cittern (Figs. 7, 10) made.

736: T'ai-chih memorial stele (Fig. 193) erected.

743: An Lu-shan enters T'ang court.

745: Yang T'ai-chen becomes *kuei-fei* (imperial concubine of first rank).

750: Abbassid caliphate established.

751: Screen with mouflon-and-tree motif (Fig. 120) made.

752: Eye-opening ceremony at the Todai-ji.

Eye-opening cords, *saimon* ornaments (Fig. 47) in Shoso-in.

754: Priest Ganjin arrives in Japan.

Beauty-under-the-tree screens (Figs. 75, 134, 135, 192) made.

756: Abdicated emperor Shomu dies.

Treasures and assorted medicines presented after 49 days of mourning for Shomu.

Flower-patterned carpets (Figs. 14, 161), silver censer (Fig. 33) presented to the Todai-ji.

757: *Jen-sheng* fragment (Figs. 5, 30) presented to the Todai-ji.

758: Broom (Fig. 191) and hand plow used for First Day of the Rat observances.

Folding screens with calligraphy of Fujiwara Fubito, Wang Hsi-chih, Wang Hsien-chih presented to the Todai-ji.

760: Empress Dowager Komyo dies.

761: Medicinal herbs transferred to intermediary space in *narabi-kura*.

764: Weapons, armor withdrawn during revolt of Emi no Oshikatsu.

767: Empress Shotoku (former Empress Koken) visits the Todai-ji.

Silver jar (Figs. 54, 55) presented to the Todai-ji.

784: Nagaoka capital constructed.

789: Office of the Commissioners for the Construction of the Todai-ji closes.

794: Capital moved to Heian (Kyoto).

751: T'ang army defeated by Saracens at the Talas River in Turkestan.

Gilded flower-shaped tray (Figs. 4, 12) made.

755: Revolt of An Lu-shan.

Yang Kuei-fei dies.

762: Baghdad, Abbassid capital, built.

Li Po, Ming Huang die.

770: Tu Fu dies.

TITLES IN THE SERIES

Although the individual books in the series are designed as self-contained units, so that readers may choose subjects according to their personal interests, the series itself constitutes a full survey of Japanese art and will be of increasing reference value as it progresses. The following titles are listed in the same order, roughly chronological, as those of the original Japanese editions. Those marked with an asterisk (*) have already been published or will appear shortly. It is planned to publish the remaining titles at about the rate of eight a year, so that the English-language series will be complete in 1976.

The "weathermark" identifies this book as a production of John Weatherhill, Inc., publishers of fine books on Asia and the Pacific. Supervising editor: Nina Raj. Book design and typography: Meredith Weatherby. Layout of illustrations: Akito Miyamoto. Production supervision: Yutaka Shimoji. Composition: General Printing Co., Yokohama. Engraving and printing of color plates: Mitsumura Printing Co., Tokyo, and Benrido, Kyoto. Monochrome letterpress platemaking and printing and text printing: Toyo Printing Co., Tokyo. Binding: Makoto Binderies, Tokyo. The typeface used is Monotype Baskerville, with hand-set Optima for display.